# Elements

*Chaos, order and the
five elemental forces*

Stephen
Ellcock

# Contents

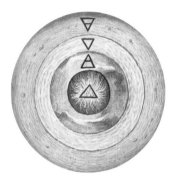

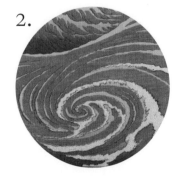

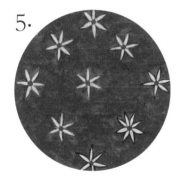

# Preface— The Properties of Things

Finding themselves in a hostile, unforgiving world, confronted by the chaos and complexity of physical matter, our distant ancestors sought answers to some fundamental questions: Where do we come from? How was the cosmos formed and what is it made of? Why do things constantly change and why does everything decay?

Many of the most ingenious, elegant answers to these questions could be found in the ancient Greek theory of the five elements: air, fire, earth, water and aether, or quintessence. The theory helped explain the complexity of nature by breaking down matter into its constituent parts. On a microcosmic level the elements represented discrete psychological, emotional and physiological states, while on a macrocosmic level they promised to reveal the inner workings of the cosmos and the mysteries of existence. The five classical elements remain universal symbols, omnipresent archetypes embedded deep within the collective unconscious and the popular imagination.

Above all else, the five elements symbolize the interrelation of all things. They are the violent, unpredictable forces that hold everything together, binding the material with the immaterial, the known with the unknown. They are in constant motion, a state of perpetual flux, locked together in an eternal cycle of destruction and creation. The health of our planet depends upon the precarious balance of such forces. If that delicate equilibrium is permanently sacrificed or sabotaged by human greed or hubris, then annihilation will surely follow.

Finding myself in a hostile, unforgiving world twenty-something years ago I found precious few ingenious answers to explain my situation and I definitely lost my balance. Literally and metaphorically. Hospital Emergency Rooms became a home from home as, hellbent on obliterating both past and future, I plummeted headlong into chaos. The gouges, scars and bruises healed over time, and indignities and embarrassments were soon forgotten, but it took a painful decade or two before I finally managed to regain my equilibrium and find my place in space again. I was a lost cause redeemed by a last-ditch reprieve, living proof that the forces of nature move in mysterious and unexpected ways.

The perpetually traumatized planet on which we are currently marooned is a world that is seriously out of balance, a world in the grip of an apparent death wish, trapped in a feedback loop of doom, the ultimate lost cause. Every day we witness multiple unfolding catastrophes, a slow-motion apocalypse. Watching in mute horror or blank indifference as everything degenerates, most of us feel disorientated, disenchanted, alienated from the rhythms of the dying world around us, our connection with every living thing brutally severed.

Only by recognizing that we are subject to the same elemental forces that control all creation, and by learning to live in harmony with these forces, can we re-establish our relationship with the natural world, recover balance and equilibrium, and avert looming disaster. Our future welfare, and probably our very survival, depends upon our next move. Let's remember our place in the universe and try not to fall flat on our faces.

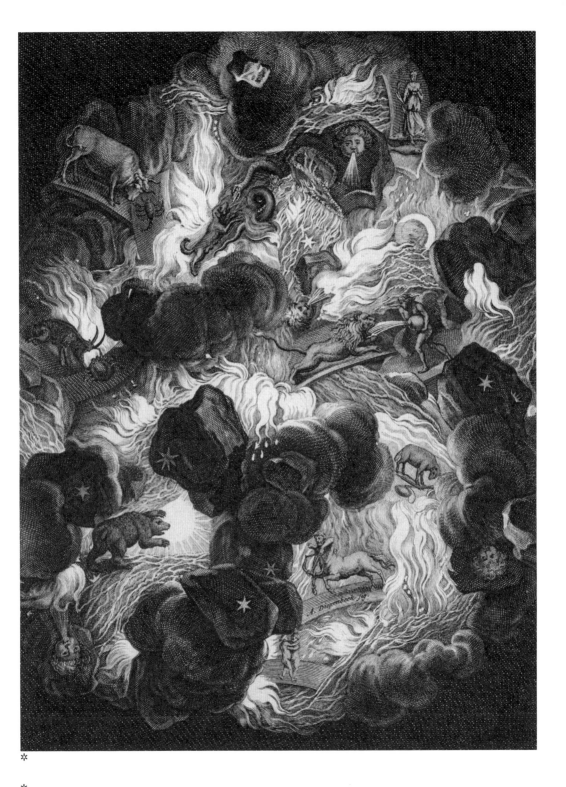

✻

✻
Illustration of chaos, from Michel de Marolle's
*Tableaux du Temple des Muses*, Cornelis Bloemaert
after Abraham van Diepenbeeck, 1655

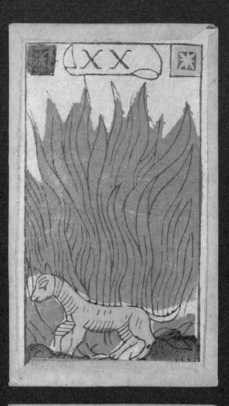

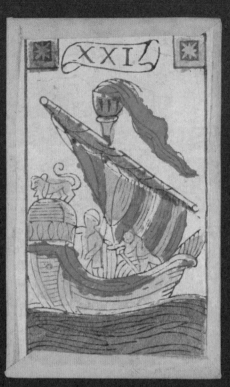

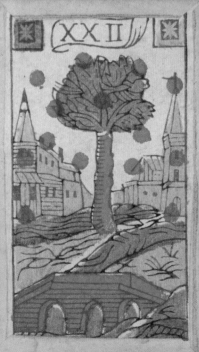

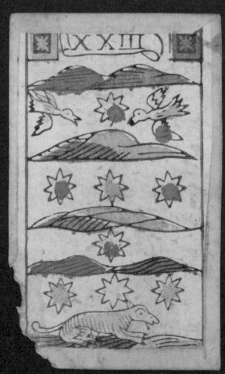

# Introduction

*'The Elements, therefore,
are the first of all things,
and all things are of and
according to them, and
they are in all things,
and diffuse their virtues
through all things.'* *

✷
Playing cards depicting the
four elements of fire, water,
earth and air, from a Minchiate
(closely related to tarot) deck,
Florence, Italy, 17th century

❊
Heinrich Cornelius Agrippa,
*Three Books of Occult Philosophy*,
Book I: Natural Magic, 1531,
translated by James Freake

Stela of Tatiaset, Deir el-Bahri, Thebes, Egypt,
paste and paint on wood, 825–712 BCE

In 'An Hymne in Honour of Love' (1596), the English poet Edmund Spenser describes a version of creation in which the elements conspire against each other, causing confusion and decay. Air hates earth, and water hates fire, until love places them in their natural order and commands them to mix with each other as living creatures in 'a kindly way'.

The idea that earth, water, air and fire were the first substances to emerge at the beginning of creation and were placed in an ordered structure by some divine force is as ancient as humankind. Creation mythologies around the world tell of a time when the cosmos emerged from primordial chaos, which was often embodied by water. The process commonly involved the separation of earth, air, water and sky from each other in order to impose form and order on the chaos.

Among Native Americans of the south-western United States, the dominant creation myth is that of the earth diver, in which a creature – in some myths a water insect, in others a turtle – descends into the primordial waters and brings up material from the ocean floor from which the earth forms or grows. In Polynesian mythology, the folk hero Māui fishes the North Island of New Zealand out of the ocean. In some traditions, his *waka* (canoe) becomes the South Island, known as *Te Waka a Māui*. In Egyptian mythology, as told in the Pyramid Texts (*c.* 2350 BCE), creation begins with the primal waters, which are sometimes personified as Nun, father of the gods. The god Atum arises as a pyramid-shaped mound out of the waters and produces Shu

and Tefnut, air and moisture, who give birth to the male god Geb (earth) and the female Nut (sky). This pair is then separated by Shu to create space between the two.

In ancient Greece, among early written accounts of creation was the poet Hesiod's *Theogony*, written around the 8th century BCE, in which he provided a genealogy of the primordial gods. Chaos was born first, followed by Earth, then the Sky, and finally by the inner Sea and the outer Ocean. Another early account told of three primordial air gods: Aether was god of the upper atmosphere, Chaos was god of air at earth level and Erebus was god of air in the underworld. Aether fathered Gaia, the Earth Mother; Thalassa, the primordial ocean goddess; and Uranus, god of heaven.

The ancient Greek belief in the five elements – earth, water, air, fire and aether – as the building blocks of all matter began

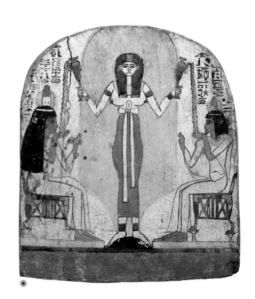

✻

Illustration from *Ein schöner kurtzer Extract der Geometriae vnnd Perspectiuae* ('A nice, short Extract of Geometry and Perspective'), Paul Pfinzing von Henfenfeld, 1599

with the pre-Socratic philosophers of the 6th century BCE, who sought explanations for the nature of matter and the workings of the cosmos. According to Aristotle (384–322 BCE), Thales of Miletus (in present-day Turkey) was the first to propose that all things were made of matter, and that water was its primary ingredient. He is reported to have said that the world floated on water like a log. He was followed by Anaximenes of Miletus, who argued that *pneuma* – air, breath or spirit – was the primary constituent of matter, whereas Heraclitus of Ephesus believed that fire was the primary element. He suggested that the cosmos was not made by gods or men, but that it was a fire dying down and flaring up again eternally. In the 5th century BCE, Empedocles of Acragas (*c.* 490–*c.* 430 BCE), in *On Nature*, proposed that four elements, or 'roots' – earth, water, air and fire – were the basic constituents of matter. They were everlasting and were mixed in different proportions, being brought together by the forces of Love (attraction) and separated by those of Strife (repulsion), to produce the ever-changing substances seen in the world.

In the *Timaeus* Plato (*c.* 427–347 BCE) referred to these four elements as primary bodies and argued that they were formed from geometrically shaped solid particles. Each body was associated with a solid form – earth with the cube, air with the octahedron, water with the icosahedron and fire with the tetrahedron. Plato held that a fifth solid, the dodecahedron, was used by the creator god for arranging the constellations. The solids associated with fire, air and water were

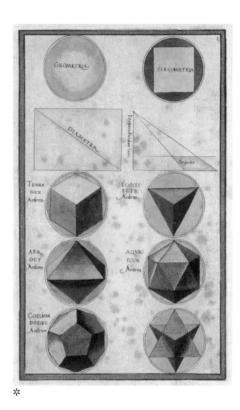

✻

composed of similarly shaped triangles, and intertransformations took place between them, but earth was excluded from this process. Plato also believed that humans live in an imperfect shadow world that is a copy of an eternal idealized one, and that they are unable to see the divine pattern underlying the perfect world.

Aristotle, who was Plato's pupil, did not believe the world consisted of a shadow version of an idealized world, preferring to explain the universe according to his own observations. He agreed with Empedocles on the existence of the four elements and

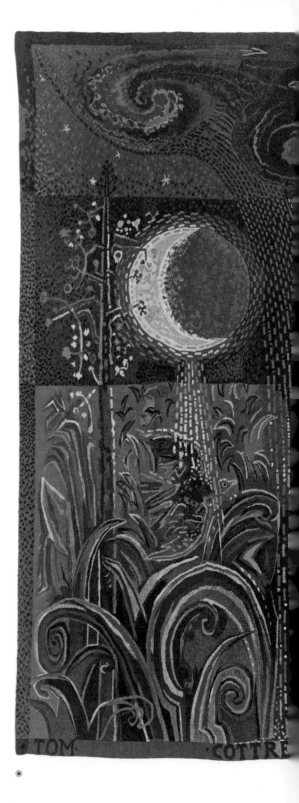

*Landscape with the Elements*, tapestry,
John Craxton, 1975–76

RINCIPAL·VICE·CHANCELLOR·STIRLING·UNIVERSITY·1965·1973·

# 'The elements have no forbearance.'

Henry Wadsworth Longfellow, *Drift-Wood*, 1857

✳

✳
Illustration from *Alchymia naturalis*
*occultissima vera* ('The True, Natural,
Hidden Alchemy'), Hermes, 18th century

✳
*Cosmic Snakes*, Yasmin Hayat, 2021

added a fifth element, aether, from which everything in the heavens was made. In *On the Heavens*, Aristotle argued that the Earth is a solid immobile sphere at the centre of the universe, and that the universe was divided into two regions, the terrestrial and the celestial. The terrestrial, or sublunary, world was everything that existed below the level of the moon. This is where earth, water, air and fire were found. He placed them in order of purity, fire being the purest, then air and water, with earth as the heaviest and basest. Everything was made from two or more elements. He assigned specific characteristics to each based on the perceptible qualities: hot, cold, wet, dry. Earth was cold and dry; water cold and wet; air was hot and wet; fire, hot and dry. The natural movement of the elements was in straight lines, either towards or away from the centre of the Earth: earth and water, being heavy, moved downwards; air and fire, being light, moved upwards. The

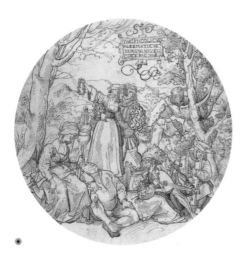

elements were not eternal, rather, they were constantly regenerated out of each other.

The fifth element, aether, filled the celestial realm, which consisted of the planets and stars and was bounded by an outer, fixed sphere of stars. Aether was pure and incorruptible, and its natural motion was circular. The circular movement of the celestial spheres and the linear movements of the sublunary elements caused the terrestrial elements to change. Through a change in one of its properties, one element changed into another. As water in the air was heated by the sun, it moved nearer to the sun through the process of evaporation and further from Earth. At some point condensation occurred, air turned back to water, which fell back to Earth as rain.

The fourfold nature of the earthly elements described by Aristotle was extended by other classical thinkers to several areas of knowledge. In particular, it was applied to medicine. The Greek physician Hippocrates (*c.* 460–*c.* 377 BCE) proposed that the body contained four essential fluids, or humours, that defined people's health and personality: blood, which was warm and moist and associated with air and spring; yellow bile, which was warm and dry and associated with fire and summer; black bile, which was cold and dry and associated with earth and autumn; and phlegm, which was cold and moist and associated with water and winter. Good health depended on maintaining a balance between the bodily humours. The Greeks also associated four temperaments, or personality types, with a preponderance of one of the four humours: the sanguine

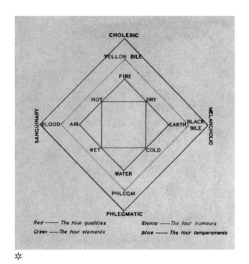

❋

the legendary ancient Egyptian-Hellenistic figure Hermes Trismegistus and popularized in the Renaissance. One section, the *Kore Kosmou* ('Virgin of the World') describes the four elements by saying that some creatures are friends with one of the elements, some with two or three and some with all four, whereas some creatures are enemies of certain elements. Locusts and flies flee fire, and birds flee water; snakes love earth, and flying things love the air. Each soul, while in its body, is constrained by the four elements.

In the first book of *Three Books of Occult Philosophy* (1533), the Renaissance physician and occult writer Heinrich Cornelius Agrippa (1486–1535) included the elements and their combination as an essential part of natural magic. He stated that the compounds of these elements form four perfect bodies, each with a dominant elemental quality: stones are 'earthy', metals are 'waterish', plants 'have an affinity with air' and all animals 'have in their natures a most fiery force'. Like Trismegistus he related the elements to animals, and even suggested their association with angels, listing fiery seraphim, earthy cherubim, watery archangels and airy principalities.

Much of the learning of the Greek and classical world reached Renaissance Europe via Islamic scholars and philosophers such as Abu Nasr al-Farabi (d. *c.* 950 CE). Like Plato, he believed that creation took the form of a chain of being that emanated from the Logos, or Divine Reason, in a series of ten intellects, an idea that first appeared in Plato's dialogue *Timaeus*. In the human world, a Platonic chain exists that reaches from the

(blood), the choleric (yellow bile), the melancholy (black bile) and the phlegmatic (phlegm). The Graeco-Roman physician Galen (*c.* 130–*c.* 216 CE) wrote extensively about the theory of the four humours and his writing remained the basis of medical thinking until the Renaissance. He also expanded on the idea of correspondences between the humours and seasons by linking them to the four ages of man: spring was linked to childhood, summer to youth, autumn to maturity, and winter to old age. The planetary gods were also added: air was associated with Zeus (Jupiter), water with Poseidon (Neptune), earth with Hades (Pluto) and fire with Hephaestus (Vulcan). Through this system of associations, humanity was seen as a microcosm, or small world, that reflected the macrocosm, or larger world, of the cosmos.

The elements also appeared in the *Corpus Hermeticum*, a collection of texts attributed to

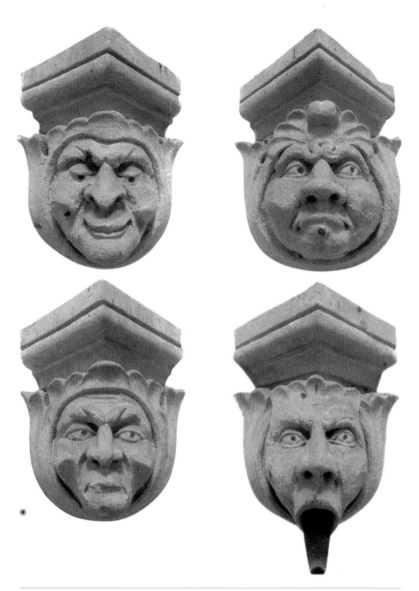

THE PRACTICE OF ACUPUNCTURE originated in China 3,000 years ago. It derives from the theory that the opposing forces of yin and yang must be kept in perfect balance. An imbalance within the body results in disease, or physical disharmony, obstructing the flow of the vital energy or life force, *Qi*, through the body's network of channels. Acupuncture unblocks the channels and restores health through the insertion of small needles into the skin at points along the channels thought to be opening points. An organized system of diagnosis and treatment, describing 365 acupuncture points, was published in *The Great Compendium of Acupuncture and Maxibustion* during the Ming dynasty (1368–1644), and forms the basis of modern acupuncture.

Gargoyles depicting the four temperaments (*clockwise from top left*: sanguine, phlegmatic, choleric, melancholic), St. Marien Church, Schladen, Germany, photograph by Rabanus Flavus

Wooden acupuncture model, Japan, 1681

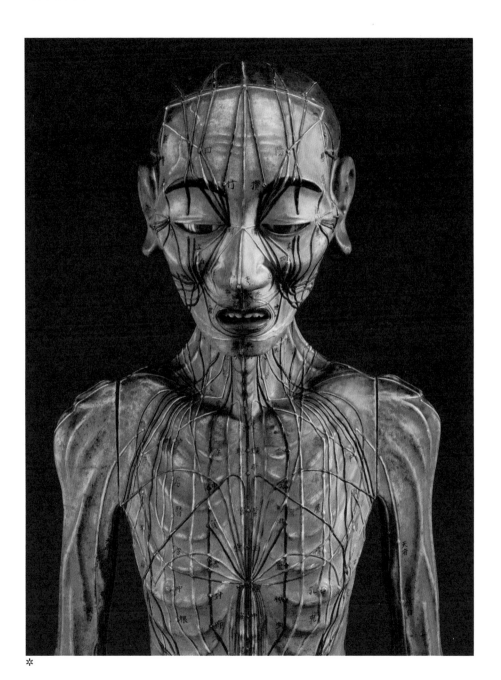

✳

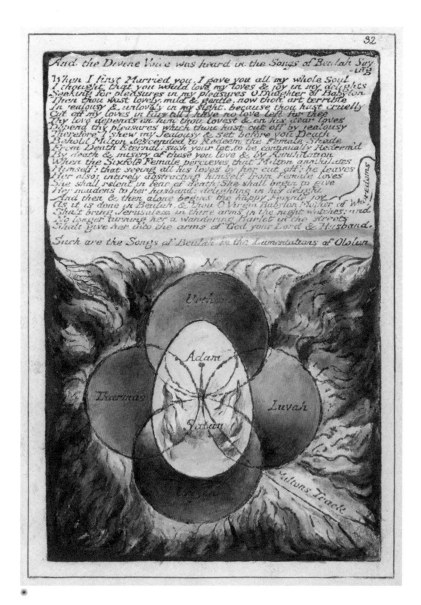

'And the Four Zoa's who are
the Four Eternal Senses of Man
Became Four Elements separating
from the Limbs of Albion.'

William Blake, *Jerusalem: The Emanation of the Giant Albion*, 1815

✳ Plate 32 depicting the relationship
of the four Zoas, from *Milton: A Poem*
(copy C), William Blake, 1811

✳ *Namaste,* Kour Pour, 2023

✳

lower beings to the possibility of humans being reunited with Divine Reason.

In Renaissance Europe, the idea of a link between the lower forms of being and God developed into a concept known as the chain of being, which embraced all creation. The elements were the basis of divine order, and their harmonious functioning was necessary for the orderly running of society and the fertility of nature. The universe seemed to be organized according to a divine pattern. All levels in the heavens and on Earth were linked by the chain of being, which brought God into contact, through the angels, with humans, animals, plants and minerals on Earth. At the bottom of the chain was the inanimate class, which had existence, and included liquids and metals. Then came the vegetative class, which had existence and life. Next was the sensitive, or animal, class, which had existence, life and feeling. Humanity was next, having existence, life, feeling and understanding. Angels, who were spiritual beings with intellectual understanding, were ranked between humanity and God. Each class was also ordered in a hierarchy: gold was nobler than brass, the lion was nobler than the mouse, fire was nobler than earth. As all things in the chain were made up of the four elements, the elements had their own chain, which was connected to the main one.

Another cornerstone in European Renaissance thinking, related to the chain of being, was the theory of correspondences that linked things across the different categories of creation. Associations between elements and humours, seasons and the ages of man was gradually extended to apply to many more categories, including the signs of the zodiac, metals and gemstones. The most important of the correspondences was that between the macrocosm and the microcosm, the belief in an analogy between humans and the universe.

The four elements played a part in the ancient practice of alchemy. Plato had proposed the existence of primordial matter, or first matter, that was the source of the elements. Each element could transmutate into another if the proportions of their qualities – hot, cold, wet, dry – were changed. Alchemists applied the same principle of transmutation in their search for a way to turn base metals such as lead into gold and silver.

✳

The system of elements used in medieval and Renaissance alchemy was first described by the Arab alchemist Jābir ibn Hayyān (*c.* 721–*c.* 815). He accepted the four Aristotelian elements and their qualities, which he called 'natures', and added two more, sulphur and mercury. He argued that metals form in the earth through the mixing of sulphur and mercury. Which metal is formed depends on the quality of the sulphur, gold being formed from the best quality. These two elements were also essential to the process of transmutation, sulphur being combustible and mercury being fluid. By re-arranging the nature of one metal, a different metal would be produced. This process required a catalyst, an *al-iksir*, or elixir, that would bring about the transmutation.

The German-Swiss physician and alchemist Paracelsus (1493–1541), born Theophrastus Bombastus von Hohenheim, built on the work of Ibn Hayyān by adding a third substance to sulphur and mercury. Paracelsus accepted the concept of the four earthly elements described by Aristotle. In his view, the elements were the basis, or 'mothers', of all matter as all things come from them. Plants and trees come from the earth, minerals from water, dew from the air, thunder and rain from fire. He explained the nature of medicine using the *tria prima* – the three primes, or principles – which he thought existed in the elements. To Ibn Hayyān's sulphur, which was combustible, and mercury, which was fluid and changeable, he added salt, which was solid and permanent. He believed that medicines consisted of the *tria prima*. If the physician could understand the nature of medicines in terms of these three principles, they would understand how to cure disease. He also used the *tria prima* to describe the whole human being. Salt represented the body; sulphur represented the soul (emotions); and mercury represented the spirit (imagination and reasoning).

Although Paracelsus accepted the role of the Aristotelian elements in alchemy, he rejected the traditional view, based on Galen, that disease was caused by an imbalance between the four bodily humours. Instead, he favoured the theory that disease had external causes. In 1527, he went as far as to publicly burn the books of his predecessors, including Galen, in Basel, where he was a professor of medicine at the time, an act that earned him the nickname 'the Luther of medicine'. Paracelsus believed that health relied on harmony between the human body (the microcosm) and nature (the macrocosm). He argued for an alchemical approach to medicine based on restoring a proper balance

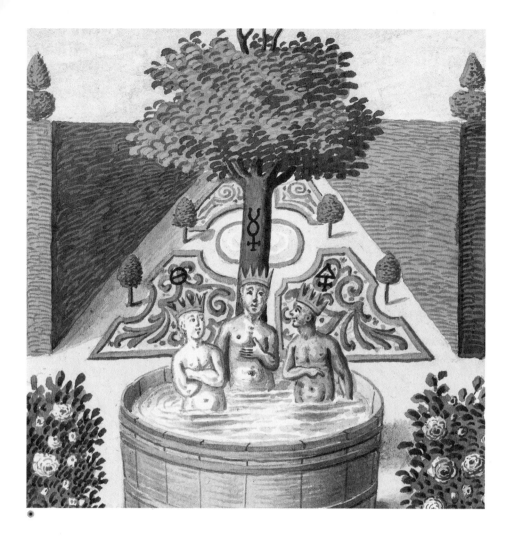

THE THREE PRINCIPLES, or *tria prima*, sulphur, mercury and salt,
were held by the physician Paracelsus in his *Opus paramirum* (1530)
to be present in each of the classical elements of earth, water, air and
fire. Together, he proposed, they enabled the creation of all natural
things. The three principles could also be found in every individual
body as three humours. Paracelsus believed that disease was the
result of an external poison entering the body and settling into a
specific organ, affecting the natural balance of the three humours in
that area. He believed that the cure for disease lay in nature itself and
advised physicians to examine the poison causing a disease and use
that substance in combination with the *tria prima* to create an antidote.
He maintained that mercury was the only effective cure for syphilis.

Illustration depicting the three
Paracelsian principles, from *Alchymia
naturalis occultissima vera* ('The True,
Natural, Hidden Alchemy'), Hermes,
18th century

Illustration from *Solidonius dominator
elementorum, author rarissimus et excellentissimus
philosophus* ('Solidonius, master of the
elements, remarkable author and most
excellent philosopher'), 18th century

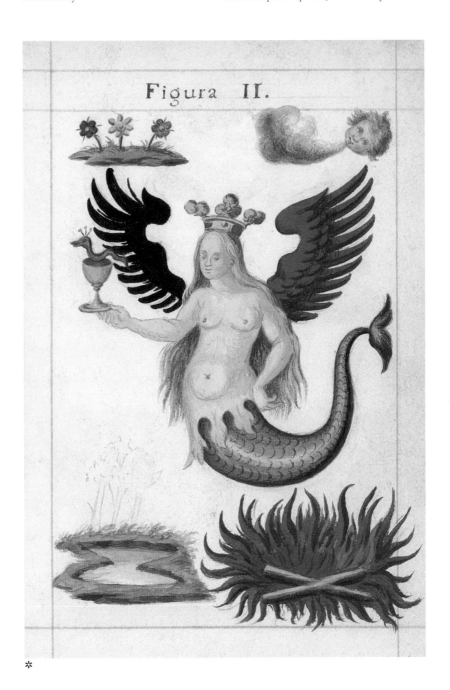

ELEMENTS

✻

*God the Father Separating the Elements*,
Jean Joubert, *c.* 1725

✻

between the human body and nature. In his books, he referred to the body's internal alchemist, by which he meant its ability to sort what is useful from what is harmful.

Ibn Hayyān's *al-iksir* and Paracelsus's *tria prima* have both been linked to the philosophers' stone, the most sought-after prize in medieval and Renaissance alchemy. This elusive and unknown substance was thought to turn ordinary metals, such as lead and copper, into precious ones, such as silver and gold. Some alchemists also thought that it could act as a medicine for both curing diseases and preventing ageing, and ultimately granting eternal life.

The English physician and alchemist Robert Fludd (1574–1637) agreed with Paracelsus on the nature of disease and attacked the work of both Aristotle and Galen. However, he disagreed with Paracelsus that the *tria prima* represented the body, soul and spirit. Fludd recognized three cosmic elements – God (*archetypus*), the world (*macrocosmos*) and man (*microcosmos*). An astrologer and mystical philosopher, he had a particular interest in the elements. In his interpretation of the Book of Genesis, darkness (chaos) existed first, then light, and from light came water. He regarded these three as the primary elements. Aristotle's five elements and Paracelsus's three principles were secondary elements. The macrocosm–microcosm theory was central to Fludd's work. Writing about the circulation of the blood, he compared the heart to the sun and blood to the planets and asserted that as the planets circulate around the sun so the blood circulates around the body.

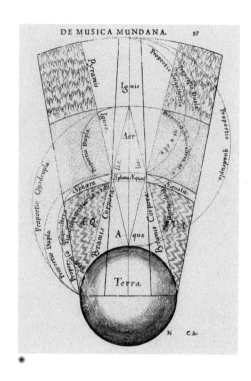

✷

The Hindu Vedas, sacred texts dating from *c.* 1500–1200 BCE, set out a system of five elements that provide the basis for all creation. These are *prithvi* (earth), *apas* (water), *agni* (fire), *vayu* (air) and *akasha* (sky, ether or space). In Ayurvedic medicine the human body consists of all five elements, which combine in unique proportions to create three *doshas* (humours), the balance of which determines an individual's physiological, mental and emotional health.

Buddhism accepts only four elements, and rejects *akasha*. Any disorder indicates an imbalance between the elements. The first mention of chakras also appeared in the Vedas. Chakras are energy hubs and

the focus for meditation in the body and are linked by a network of energy pathways. In the most common system seven main chakras are associated with the five elements: the *muladhara* chakra with earth, the *svadhisthana* with water, the *manipura* with fire, the *anahata* with air, and the *vishuddha*, *ajna* and *sahasrara* chakras with the sky.

The Chinese philosophical tradition of Wuxing is also based on the idea of five elements, although they differ from the classical Greek elements. Known more accurately as the five processes, or five phases, they are types of energy rather than substances. The five elements are created by the continuous interaction of yin and yang. Yin represents shadow, is feminine and passive, and is associated with the moon, Earth and wetness. Yang represents light, and is masculine and active, and is associated with the sun, heavens and dryness. These opposite energies interact to produce the five phases. The origins of the system dates to a collection of writings called the *Shujing, or Classic of History* (*c.* 2400–*c.* 660–620 BCE). The chapter titled 'Hong Fan' ('The Order of Everything') lists the elements as wood (*mu*), fire (*huo*), earth (*tu*), metal (*jin*) and water (*shui*), and describes how they work together to bring about the harmonious operation of nature. Water moistens and sinks, fire burns and ascends, wood bends and straightens, metal yields and changes, and earth receives and gives. The phases interact according to either the *sheng* (generating) cycle or the *ke* (controlling) cycle. If the Wuxing are in disorder, chaos will ensue. Human behaviour can aid the system's harmonious operation or disrupt it.

During the Han dynasty (202 BCE–220 CE), the Wuxing system evolved into a major philosophical tradition. It was used to explain the cycle of change in the natural world. Two of the main areas to which it has been applied are medicine and cosmology. In the 1st century BCE, the *Huangdi Neijing* ('The Yellow Emperor's Inner Classic') described how Wuxing should be applied to medicine. For example, it proposed that a disease classified as fiery should be treated with a medicine associated with water. In Chinese astrology, each of the twelve signs of the zodiac is ruled by one or more of the five elements depending on the exact year that the sign occurs.

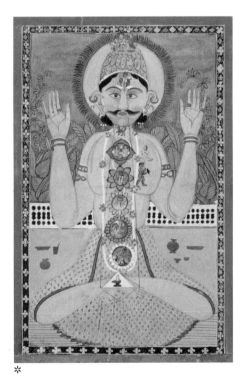

✳

*'[The alchemists'] doctrine was no mere chemical fantasy, but a philosophy they applied to the world, to the elements, and to man himself.'*

W. B. Yeats, 'Rosa Alchemica', 1896

ELEMENTS

❊
*Group IX/UW, The Dove, No. 14,*
Hilma af Klint, 1915

✳
Illustrations of nine alchemical processes,
from *Praetiosissimum donum dei*
('The Most Precious Gift of God'),
George Anrach, *c.* 1473

*'[The elements] are mutually bound together ...
each of them remains in its appropriate place, bound
together by the never-ceasing revolution of the world.'*

Pliny the Elder, *The Natural History*, 77–79 CE, translated by John Bostock
and Henry T. Riley

※
Illustration from *Geometria et perspectiva*
('Geometry and Perspective'),
Lorenz Stör, 1567

✳
'Region elementaire ou sublunaire'
('Elementary or Sublunary Region'),
Gregoire Mariette, 1697

# 1. Earth

*'As for the earth, out of it comes bread, but underneath it is turned up as by fire. Its stones are the place of sapphires, and it has dust of gold.'* \*

＊
Illustration from *Le secret de l'histoire naturelle contenant les merveilles et choses mémorables du monde* ('The Secret of Natural History Containing the Wonders and Memorable Things of the World'), Robinet Testard, 15th century

\*
The Bible, Job 28:5–6

✳

*Talatat* (small sandstone block) depicting men hoeing earth and clay, once part of a scene portraying the production of mud bricks, Karnak, Egypt, *c.* 1353–1347 BCE

In world mythologies, Earth is the primordial mother, or Earth Mother, who brought life to all things. In early societies, the link between childbearing and the fertility of nature gave rise to female deities who embodied Earth itself. In ancient Greek mythology, the goddess Gaia, the first being to emerge from the pre-creation chaos, embodied the Earth – its soil, rocks, mountain ranges and lowlands – which sprang into life.

The Okanaga people of Washington state, USA, call the Earth the 'Old One'. Her flesh is the soil, her hair plants, her bones are rocks and her breath the wind. According to Hopi mythology in the south-western USA, Spider Woman fashioned the first animals and humans out of clay and taught them how to grow crops. The Incan Earth Mother, Pachamama, was also the Corn Mother, presiding over the planting and harvesting of crops. In Norse mythology, the Earth was formed from the body of the giant Ymir, who was killed by the gods Odin, Vili and Vé.

They surrounded his corpse with the sea, which they made from his blood. They used his flesh to make soil and they made rocks from his bones.

Some fertility myths revolve around a sacrifice and resurrection, such as the story of the Egyptian god Osiris. In the most common version, Osiris, an ancient ruler of Egypt, was killed by his brother Seth, who cut the body into pieces and spread them across the land. Isis, the wife of Osiris, found the pieces and reformed the body, and then buried it. Osiris descended to the underworld, where he had the power to grant new life, including to crops and plants through the annual flooding of the Nile.

Other fertility myths involve a descent into the underworld and a return from it. Greek goddess of the harvest Demeter was responsible for ensuring that plants grew and crops ripened, assisted by her daughter Persephone. One day Hades, god of the underworld, kidnapped Persephone and took her to his realm as his wife. A distraught

✳

Demeter roamed the land searching for her while the crops died. To resolve the situation, Zeus decreed that Persephone should return above ground in spring and summer to help her mother, before going back to the underworld for the rest of the year. As a result, Persephone became goddess of the changing seasons.

All aspects of the Earth were represented by their own deities. The Celtic goddess Abnoba personified nature, mountains and the hunt; the Hindu goddess Aranyani forests, woods and animals. Aja, a Yoruba nature goddess, or *Orisha*, was associated with forests, animals and medicinal plants. Konohanasakuya-hime was the Japanese goddess of cherry blossom and Mount Fuji.

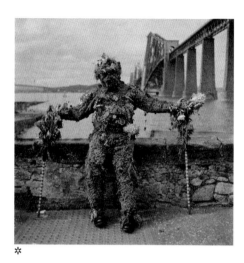

✳

Since ancient times, people have created rituals relating to the regeneration of nature. Most crucial were those devoted to the return of life in the spring and to harvesting and planting in the autumn. In April ancient Romans celebrated Cerelia, a seven-day festival devoted to Ceres, the grain goddess. Autumn festivals were also important. In ancient Greece, the Thesmophoria festival dedicated to Demeter was held in October, when the crops were sown.

In ancient Celtic society, the changing seasons were marked by eight festivals that are known in modern paganism and Wicca as the Wheel of the Year. They occur at the summer and winter solstices, the spring and autumn equinoxes, and the midpoints between them. Fertility and the prospect of summer were celebrated at Beltane (30 April–1 May) with a bonfire and dancing. May Day festivals are descended from Beltane. The harvest was celebrated at

Lughnasadh, at the beginning of August. Mabon, at the autumn equinox, marked the loss of a god or goddess, who goes into the underworld and returns the following spring, bringing new life. Yule was celebrated at the winter solstice by decorating trees, thought to be the homes of deities and spirits, in honour of the sun god and by burning the Yule log to mark the return of the light.

According to Aristotle, earth was the least pure of the elements and occupied the lowest position in the sublunar realm. Its qualities are cold and dry. It is associated with the melancholic humour, autumn and adulthood. Its Platonic solid is the cube, four-square and regular. In Hindu tantrism, the earth element is associated with *muladhara*, the root chakra related to stability and being grounded. The root chakra is symbolized by the four-petalled lotus, the petals representing the four elements that together make up the physical world.

THE GREEN MAN is one of the most popular and enduring folkloric figures. The decorative design of a human face, shrouded with leaves and sometimes sprouting other vegetation, has been associated with nature deities and interpreted as a symbol of fertility and rebirth. Examples of the Green Man motif have been found in Roman architecture, medieval Christian churches, and the 6th-century Byzantine palace of Constantinople. The lack of a definitive meaning has allowed the Green Man to be reinterpreted across cultures and over time. In 18th-century England the figure of Jack in the Green formed part of the traditional annual May Day celebrations. A person encased in a wicker framework covered entirely in foliage with a slot cut in for the eyes would form part of the procession, usually accompanied by musicians. Though the tradition had waned by the early 20th century, the 70s and 80s saw the revival of several Jack in the Green parades which continue today. The Green Man endures in pagan belief as a symbol of humanity's spiritual fusion with nature.

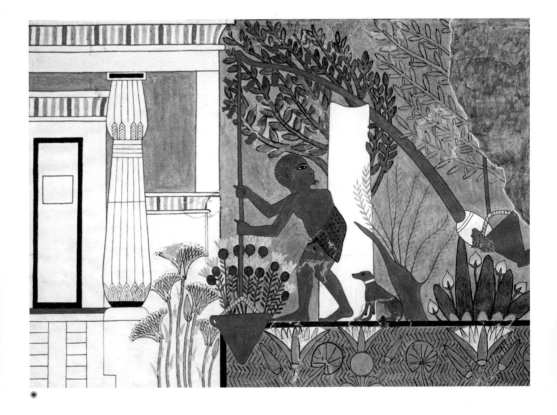

✳

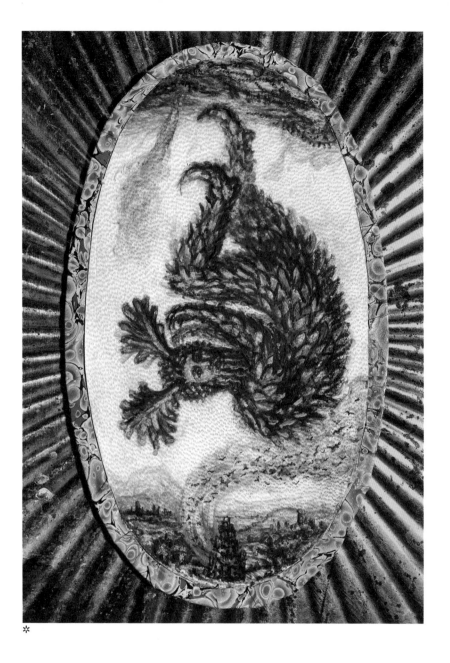

✳

✳ Garden scene from the Tomb of
Ipuy, Deir el-Medina, Thebes, Egypt,
*c.* 1295–1213 BCE, copy painted by
Norman de Garis Davies, 1924

✱ 'Greenman Falling', from
*The Oval Oraculum*, painted
vellum, Kahn & Selesnick, 2023

CERES was the Roman goddess of agriculture, fertility, grains and harvest, counterpart to the Greek goddess Demeter. Credited with the discovery of spelt wheat, ploughing, sowing and nourishing seed, her laws and rites protected the agricultural cycle. She is generally depicted adorned with edible cereals and fruits and vegetables, representing her ability to provide food from the earth. In early Roman myths, her son is Liber (counterpart to the Greek god Bacchus), the god of wine.

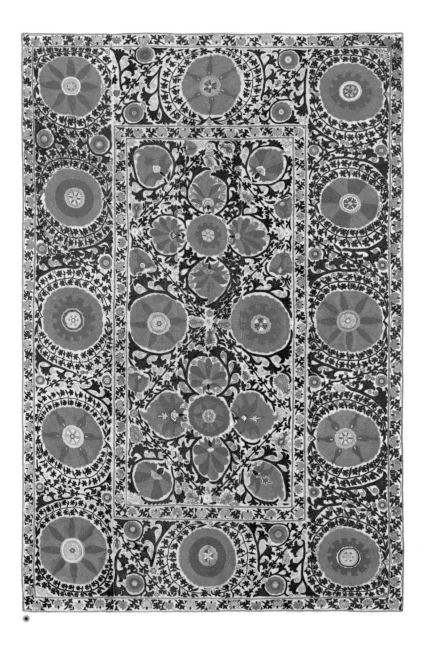

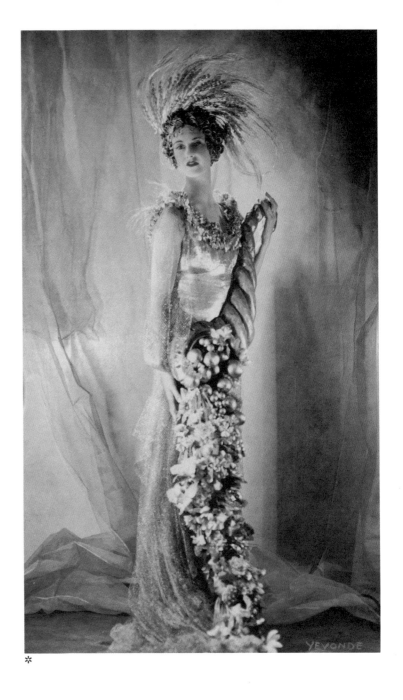

✳

✱
Kermina Suzani (a type of
embroidered textile) depicting
blossoms, Uzbekistan, 1800–50

✳
Dorothy Etta Warrender (née
Rawson), Lady Bruntisfield, as
Ceres, Madame Yevonde, 1935

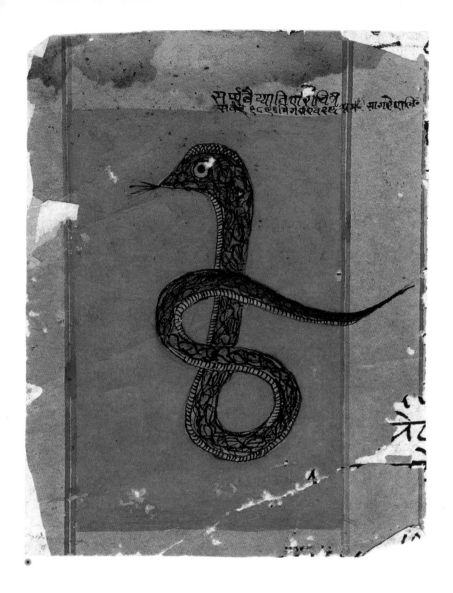

'Whatever the earth feeds and grows
Is restored to earth. And since she surely is
The womb of all things and their common grave,
Earth must dwindle, you see, and take on growth again.'

Titus Lucretius Carus, *On the Nature of Things*, c. 99–c. 55 BCE,
translated by Anthony M. Esolen

✳

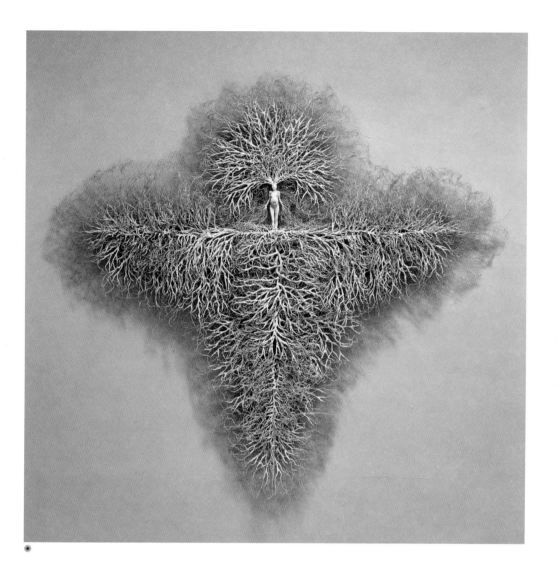

*

'That part of the world ... which is the most solid support of nature, as bones are in a living creature, is called the earth.'

Thomas Stanley, *The History of Philosophy*, 1656

✳

*'Ah! sleep not, O unreflecting fatalists,*
*Till ye have reached that fruit-laden*
*Tree of Life.'*

Jalāl al-Dīn Muḥammad Rūmī, 'Story V: The Lion and the Beasts', 13th century

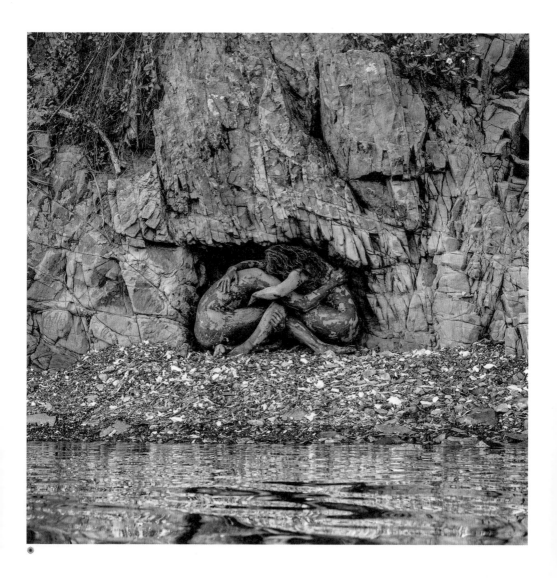

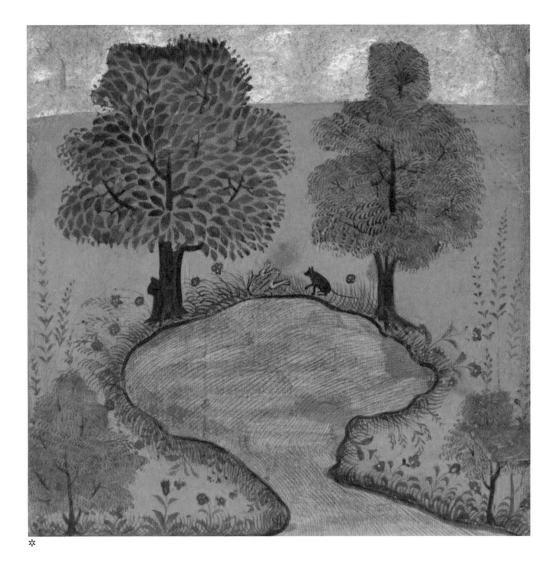

✳

*Nested*, Reborn-Art Festival, Miyagi, Japan, Damien Jalet and Kohei Nawa, featuring dancers Aimilios Arapoglou and Mayumu Minakawa, photograph by Yoshikazu Inoue, 2019

✲

Illustration of a mouse and a frog near a pond, from an illuminated 1663 manuscript of Jalāl al-Dīn Muḥammad Rūmī's *Masnavi*

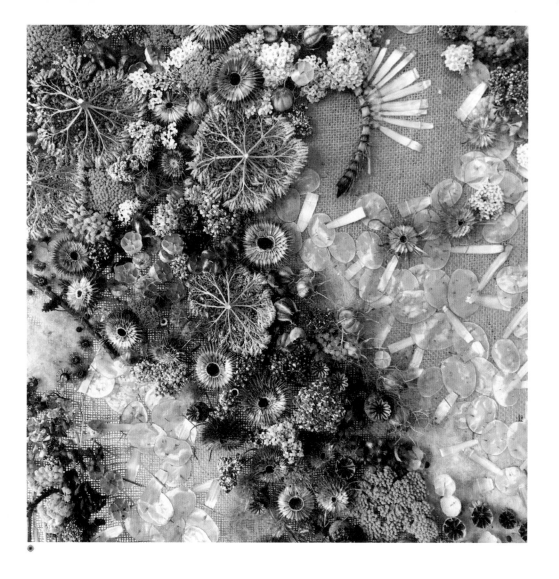

*

'New feet within my garden go,
New fingers stir the sod.'

Emily Dickinson, *Poems by Emily Dickinson*, Section III: Nature,
poem 1, published 1890

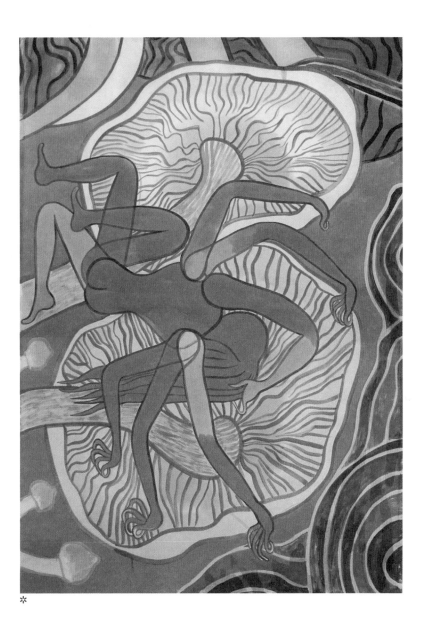

✽

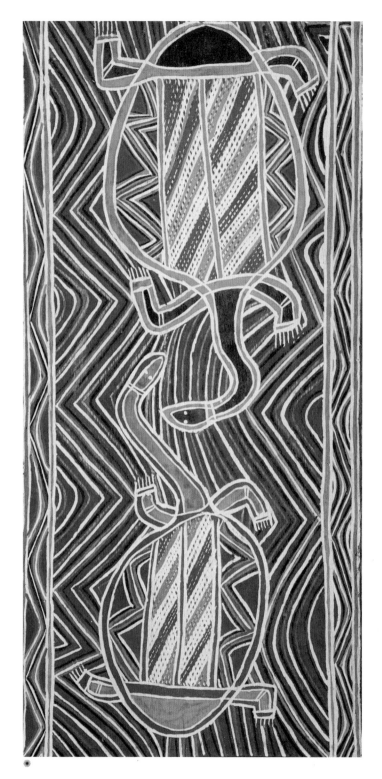

Aboriginal painting depicting
turtles, paint on bark, Australia

✳
*Life Cycles*, acrylic on linen,
Minna Leunig, 2022

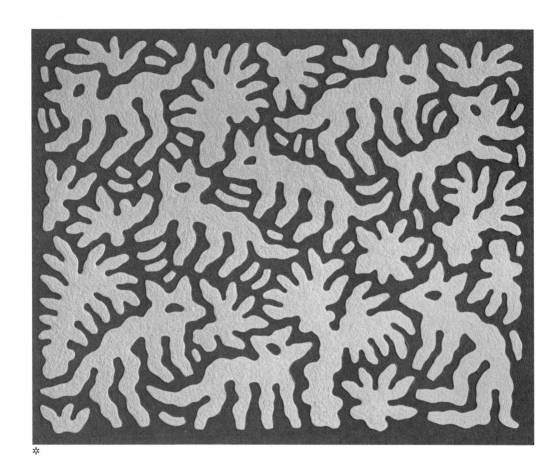

*

'*The land owns us. The land grows all of us
up. ... No human is older than the land itself ...
and no living marsupial is as old as the land
itself. Everything that's been and gone, with life
in the flesh, has died. But the land is still here.*'

Bob Randall, a Yankunytjatjara elder and custodian of Uluru (Ayer's Rock),
'The Land Owns Us', 2009

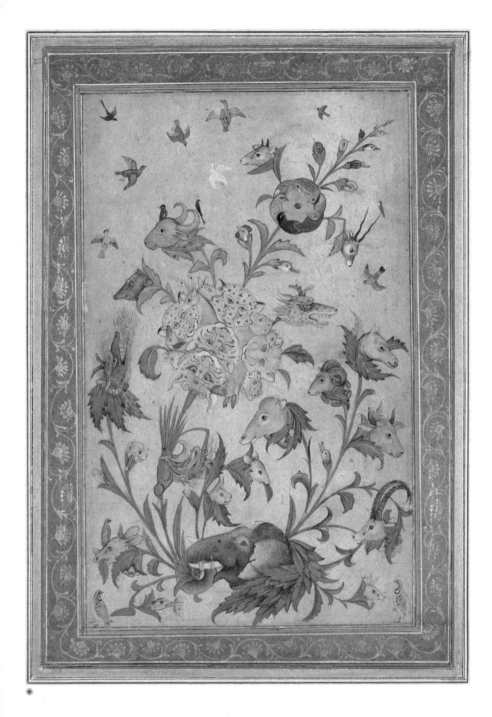

\*
Painting depicting half-plants and
half-animals, India, gum tempera
and gold on paper, early 17th century

\*
*The Last Judgment*, detail of the
altarpiece of Basilica di San Marco,
Florence, Italy, Fra Angelico, 1425–30

PARADISE is synonymous with heaven – an idyllic, lush and peaceful land that is promised to the virtuous after death for all eternity. The word 'paradise' is derived from an Old Iranian word meaning 'walled garden'. The expansive walled gardens of the Achaemenid Empire (550–330 BCE) featured four quadrants separated by waterways, and filled with scented flowers and fruit-bearing trees, creating a perfect harmonious, protected space.

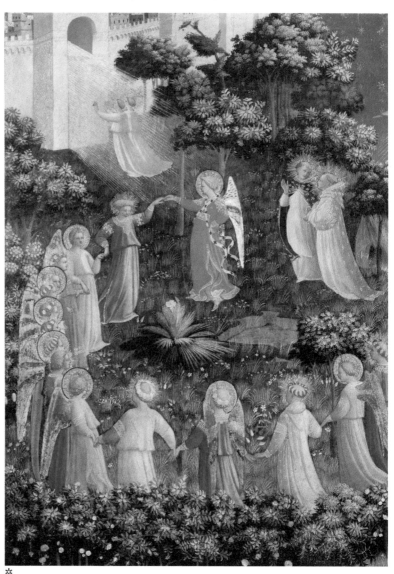

*

※ Still from short film *Guardians of the Soil* featuring Mulch Guardian, Holland Otik and Sophie Ferrier, 2021

✽ *Grapnel*, William Cobbing, 2023

☀

\*

'Earth, my likeness,
Though you look so impassive, ample and spheric there,
I now suspect that is not all;
I now suspect there is something fierce in you eligible
to burst forth.'

Walt Whitman, 'Earth, My Likeness', *Leaves of Grass*, 1891–92

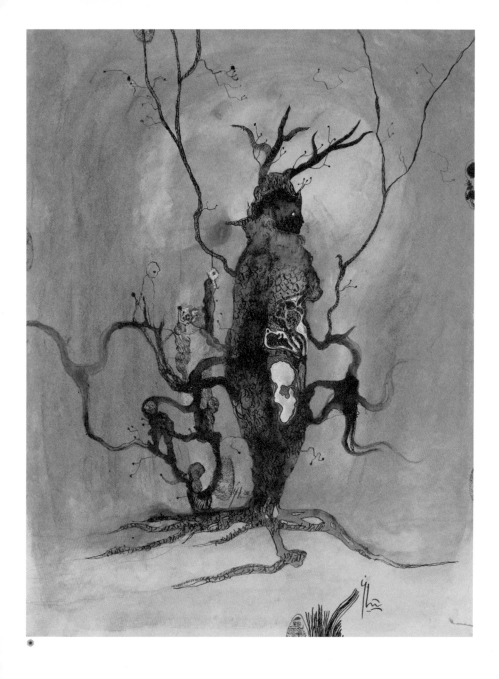

*

*The Wheel of Fortune*, Ghalia Benali,
2013, revised 2022

✳
*Mues de Loba*, Izabella Ortiz, 2015

'What are the roots that clutch, what branches grow
Out of this stony rubbish?'

T. S. Eliot, *The Waste Land*, 1922

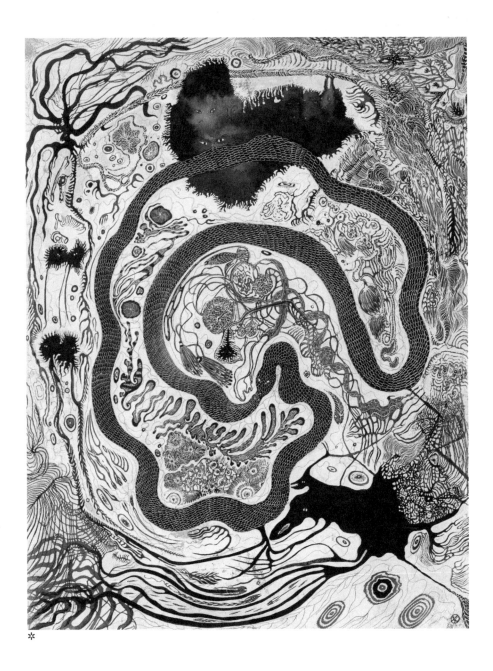

*Earth*

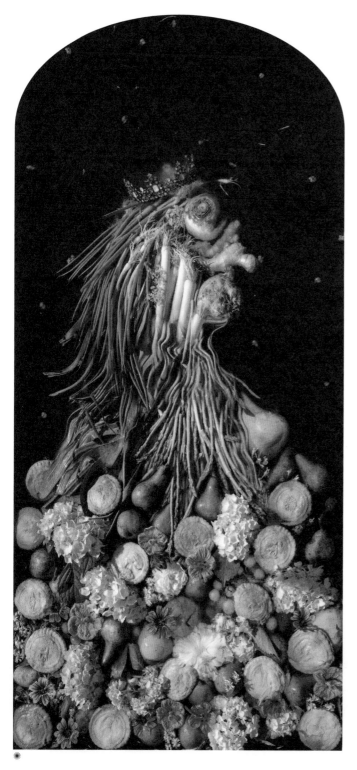

✳

'Queen of Pentacles', from
*The Tarot of the Drowning World,*
Kahn & Selesnick, 2021

✱

*William, Hastings, Jack in the Green,*
Jeff Pitcher, 2023

*'The force that through
the green fuse drives
the flower
Drives my green age;
that blasts the roots
of trees
Is my destroyer.'*

Dylan Thomas, 'The force
that through the green fuse ...',
*18 Poems,* 1934

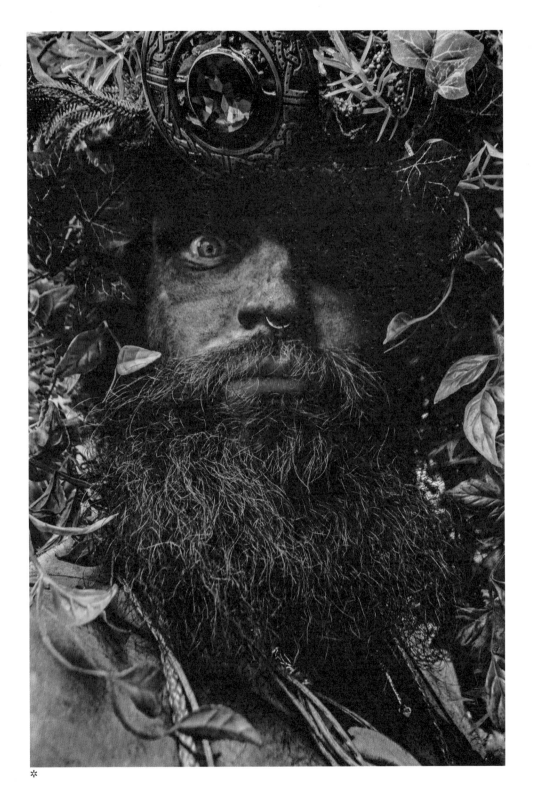

*

*'I bequeath myself to the dirt to grow from the grass I love,*
*If you want me again look for me under your boot-soles.'*

Walt Whitman, 'Song of Myself', *Leaves of Grass*, 1891–92

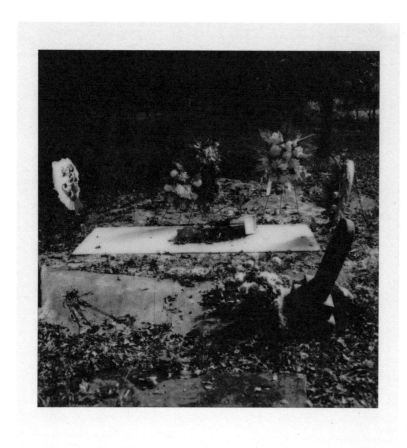

❋

❋
Photograph of graveyard with
floral arrangements, Walker Evans,
October 1973

�֍
*Sand Fountain*, Joseph Cornell,
*c.* 1961

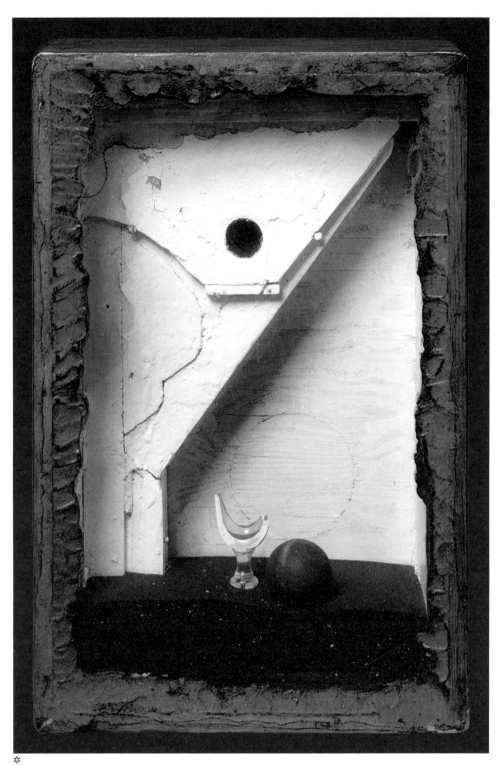

*

Illustrations of British mineral samples, from *British Mineralogy or, the Coloured Figures Intended to Elucidate the Mineralogy of Great Britain*, James Sowerby, 1802–17

*Cerne Abbas Giant*, Eric Ravilious, *c.* 1939

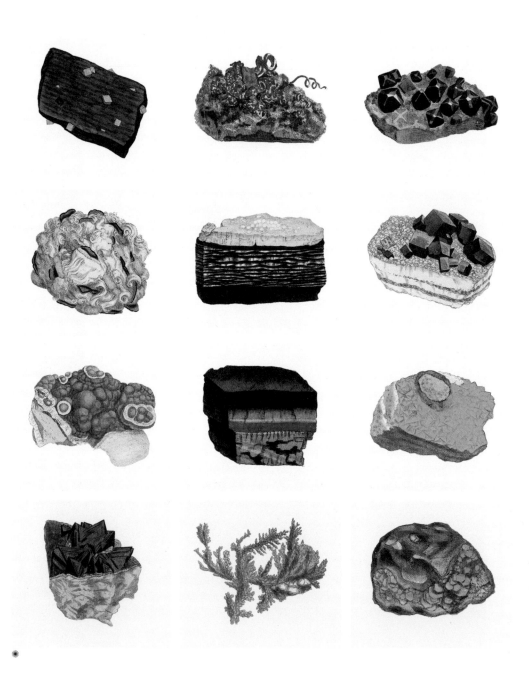

ELEMENTS

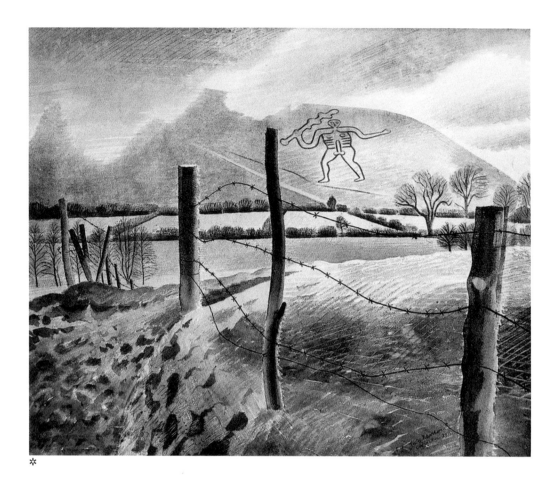

*

HILL FIGURES are a type of geoglyph carved into a steep hillside. They are created by cutting away turf to reveal bare bedrock, before filling the trenches with high-contrast chalk or limestone. In England, hill figures have been created for more than 3,000 years. One of the most famous is the Cerne Abbas Giant in Dorset, a 55-m- (60-yd-) tall human figure dating from the Anglo-Saxon period (450–1066). It is now believed that the giant was created as a muster point for West Saxon troops, although according to some folktales the figure outlines the corpse of a real giant slain by the people of Cerne Abbas.

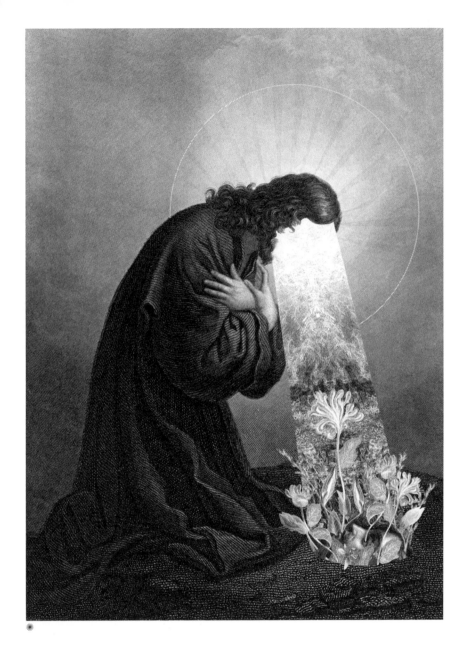

*

'*Heaven thunders above us, earth quivers under our feet,
For Geb, the Earth God, is trembling, and the sacrifice
is complete.*'

'The Sacrifice of the King', *Pyramid Texts*, *c.* 2613–2181 BCE,
translated by Margaret A. Murray

✲

'I will sing of well-founded Earth, mother of all, eldest
of all beings. She feeds all creatures that are in the world,
all that go upon the goodly land, and all that are in the paths
of the seas, and all that fly: all these are fed of her store.'

'To Earth the Mother of All', *The Homeric Hymns*, translated by Hugh G. Evelyn-White

✳

Photograph of a Kwakwa̱ka̱'wakw
ghost dancer, USA, gelatin silver
print, Edward S. Curtis, 1910–14

*Wildeman op een eenhoorn* ('Wodwo or
Green Man riding a Unicorn'), Master
of the Amsterdam Cabinet, 1473–77

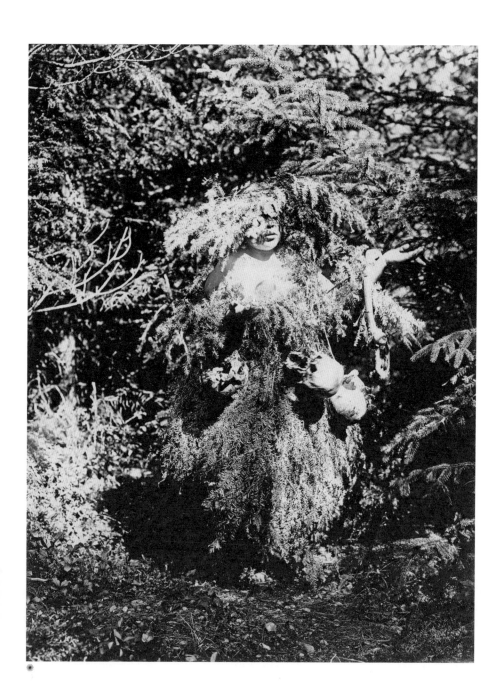

*

'Arise; and put on your Foliage,
and be seene
To come forth, like the Spring-time,
fresh and greene.'

Robert Herrick, 'Corinna's Going a Maying', *Hesperides*, 1648

❋
*Garden*, design for a carpet,
Gunta Stölzl, undated

✳
*Rooting*, Reborn-Art Festival, Miyagi,
Japan, Damien Jalet, featuring dancer
Aimilios Arapoglou, photograph by
Yoshikazu Inoue, 2019

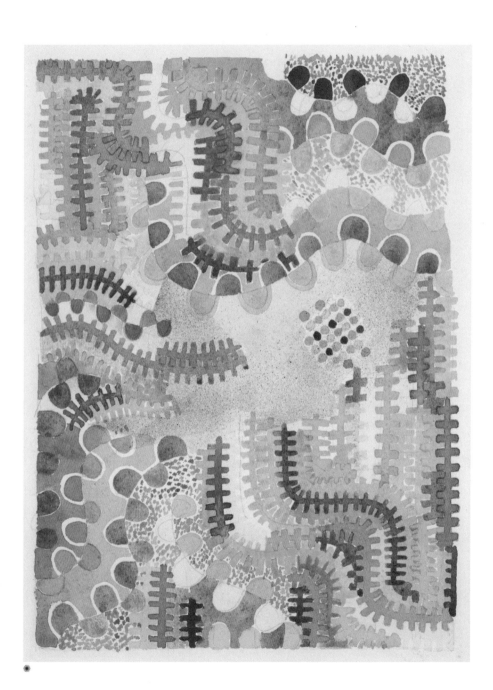

❋

ELEMENTS

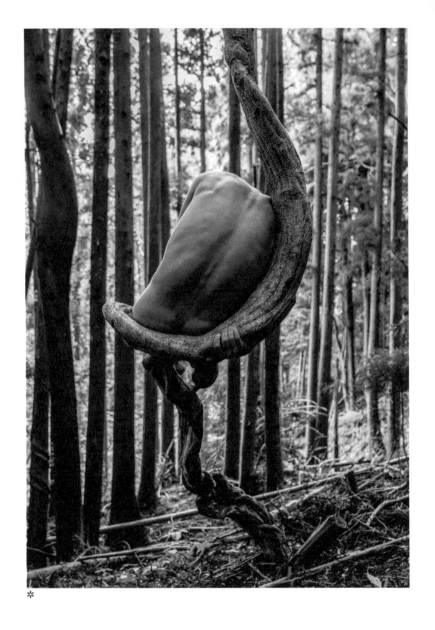

\*

*'Ah who shall soothe these feverish children?*
*Who justify these restless explorations?*
*Who speak the secret of impassive earth?'*

Walt Whitman, 'Passage to India', *Leaves of Grass*, 1891–92

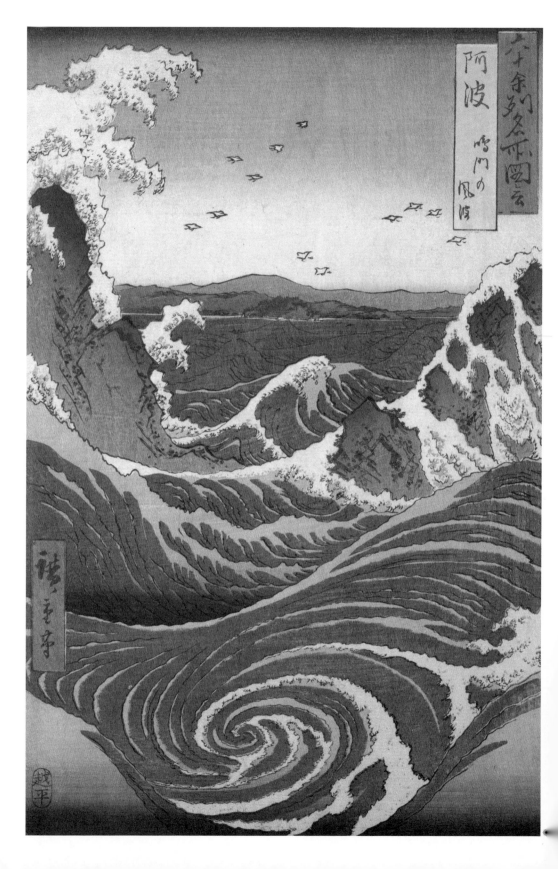

# 2. Water

'There is nothing softer
and weaker than water,
And yet there is nothing
better for attacking hard
and strong things.
For this reason there
is no substitute for it.'*

---

❋
'Naruto Whirlpool, Awa Province',
from the series *Rokujūyoshū meisho
zue* ('Views of Famous Places
in the Sixty-Odd Provinces'),
Utagawa Hiroshige, *c.* 1853

❋
Lao Tzu, *Tao-te Ching*,
6th century BCE, translated
by Wing-Tsit Chan

❉

'La terre, ses fleuves et ses rivières' ('The Earth,
its Rivers and its Streams') from a French translation
of Bartholomew the Englishman's *Livre des propriétés
des choses* ('Book of the Properties of Things'),
illuminated by Evrard d'Espinque, 1479–80

One of the most powerful forces on Earth, water can destroy all in its path in minutes, yet it is also the origin and sustainer of all life. Covering more than 70 per cent of the planet, water has the strength to sculpt the landscape, while also being a yielding substance that adapts to the shape of any vessel. Its Aristotelian qualities are wet and cold, and in the theory of correspondences it is associated with winter and with the wisdom that comes with age; the phlegmatic temperament, which is calm and unemotional; and the Roman god of the sea, Neptune. It is linked to the sacral chakra, or *svadhisthana*, whose qualities are fluidity, adaptability and creativity. In alchemy, it is a feminine energy and represents intuition.

In world mythologies, water represented the chaos that existed at the beginning of creation. From this primordial water, creator gods formed the world, a process that represented the emergence of order out of the chaos. In early Greek mythology, the Earth was a disc surrounded by a cosmic river called Oceanus. As the primordial water, Oceanus was the inexhaustible source of all life. Among the Olympian gods, Poseidon, a brother of Zeus, ruled the oceans. He was thought to have been raised by Cephira, the daughter of Oceanus. He could stir up the waves, raise storms and cause earthquakes. He also had power over lakes and springs, but not rivers, which had their own deities.

The 6th-century BCE Greek philosopher Thales of Miletus thought that water was the basic element underlying all matter. He observed an island that appeared to rise and fall on the horizon and concluded that earth condensed out of water and could be dissolved by it. He also believed that rivers and oceans were linked by the clouds, through water vapour, which moved around the Earth, producing rain, hail and snow.

Flood myths are common globally. Some form part of a creation story, while others represent a new start or second chance for humankind. Angry at the sinfulness of humans, God sends a destructive flood but saves one person – Noah in the Book of Genesis, Utnapishtim in the *Epic of Gilgamesh*, Deucalion in Greek mythology – and his family so that humankind can begin again. Echoes of these flood myths survive in the cleansing and purification rites of many religions. In Hinduism, the River Ganges is represented by the goddess Ganga, and

❉

all who bathe in the river are cleansed of
their sins. The sacrament of baptism in the
Christian faith includes being anointed with
or immersed in water. In the Shinto and
Muslim faiths, visitors must wash before
entering a place of worship.

Rain gods brought life-giving water for
crops, but they could also cause destructive
floods. Many weather gods were also fertility
gods. Zeus was the Greek god of the sky,
associated with rain, thunder and lightning.
Tlaloc was the Aztec god of rain and fertility.
The Aztecs believed that he would send
floods if displeased, and they made human
sacrifices to appease him. The Navajo people
of the south-western USA have a god,
Tonenili, who brings rain, snow and ice.

In Chinese mythology, all water was
controlled by dragons, who could also breathe
out clouds. One, Yinglong, was thought
responsible for rain. It slept all winter and
woke during the rainy season. As early as
the 6th century BCE, Chinese rain rituals
included a model dragon, made from paper
or cloth over a wooden frame, being carried
in procession by a group of dancers.

Many dangers, real and imagined, awaited
seafarers in the ancient world. In Homer's
*Odyssey*, Odysseus and his crew are
threatened by Scylla and Charybdis, who
guarded the straits of Messina between
mainland Italy and Sicily. Scylla was a
six-headed monster who ate sailors and
Charybdis was a giant whirlpool that
dragged them to their deaths. Ships had
to plot a course between the two. They
were not the only perceived dangers. In
some mythologies, the separation of earth
and water involved the defeat of an ocean-

*

dwelling creature who resisted the births of
the new worlds and remained lurking in the
ocean depths. Sea serpent and sea dragon
myths have existed in many seafaring nations.
Several, such as the kraken of Scandinavian
folklore and the Lusca of the Caribbean,
featured a giant octopus-like creature that
attacked and capsized ships.

One of the most enduring of these fabled
creatures is the mermaid, based on the myth
of Atargatis, the Syrian goddess of the moon,
fertility and water. She was famed for her
beauty, and Greek merchants travelling the
Mediterranean spread her cult all around the
Greek world, where she was seen as a form of
Aphrodite. It was said that Atargatis dived into
a lake, wanting to take the form of a fish, but
the gods would not let her give up her beauty,
so she retained a human body with a fish-like
tail. Such was the belief in these creatures
that in January 1493, the explorer Christopher
Columbus reported seeing three mermaids
off the coast of the island of Hispañola
(present-day Hispaniola in the West Indies)
during his first voyage to the Americas.
In reality, they were probably manatees.

# 'These landscapes of water and reflections have become an obsession.'

Claude Monet, letter to Gustave Geffroy, 11 August 1908

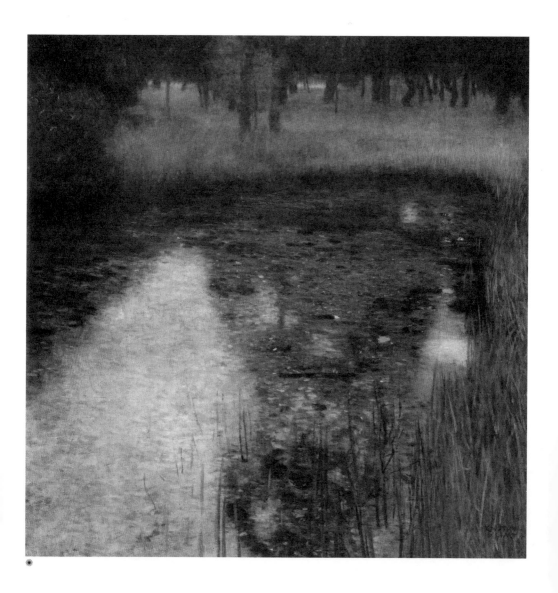

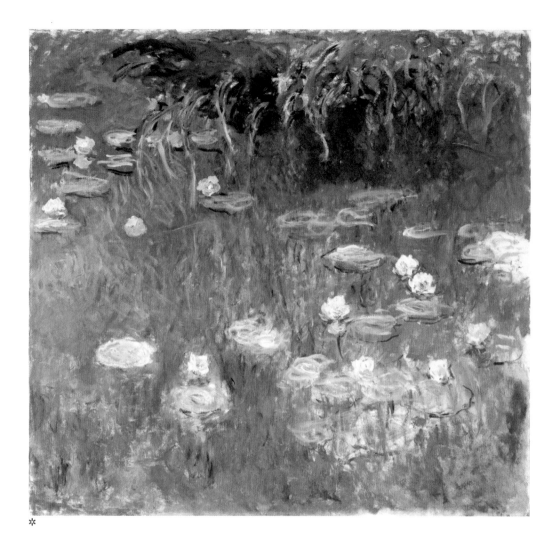

✳

※ *The Swamp*, Gustav Klimt, 1900 ✳ *Water Lilies*, Claude Monet, 1922

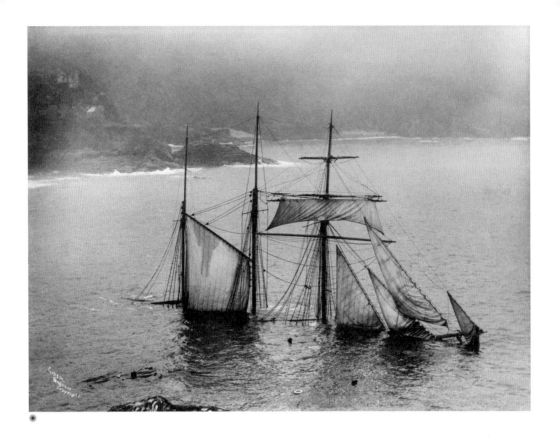

WATERSPOUTS DEVELOP in moisture-laden environments and mostly occur within 100 km (60 miles) of the coast, although some have been spotted over lakes. They are most common in tropical and subtropical regions but have also been recorded in temperate zones, generally in late summer. The life cycle of a waterspout has five stages. A waterspout begins as a circular, light-coloured disc on the surface of the water surrounded by a darker area; these two areas mutate into light and dark spiral bands less than 2 km (1¼ miles) in diameter; next a dense spray ring forms out of the spiral bands; then a visible funnel takes shape as air rotates up from the surface of the water towards a cumulus, cumuliform or cumulonimbus cloud that is developing directly overhead. Finally, as warm air flowing into the vortex weakens, the funnel begins to dissipate and, after about 20 minutes, the waterspout collapses back down to the surface of the water and disappears.

Photograph of *Mildred* (1889),
wrecked off Gurnard's Head,
Cornwall, England, 1912

❋ Waterspout photographed by the crew
of USS *Pittsburgh* by the mouth of the
Yangtze River, China, published in
*Flug und Wolken* ('Flight and Clouds'),
Manfred Curry, 1932

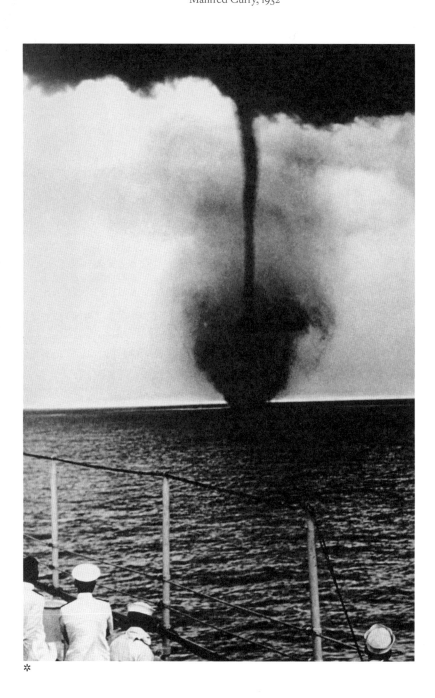

❋

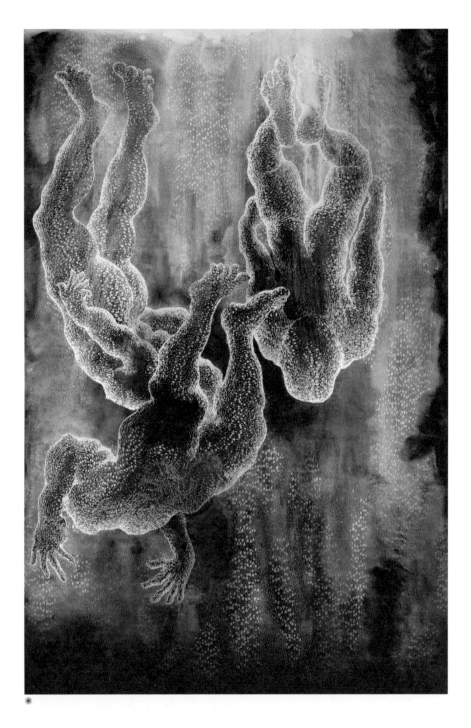

✳

❋
*Plonge*, Didier William,
2023

✳
*Sea Form (Atlantic)*,
Barbara Hepworth, 1964

*'His delights
Were dolphin-like; they showed his back above
The element they lived in.'*

William Shakespeare, *Antony and Cleopatra*,
Act V, scene ii, lines 108–10, 1607

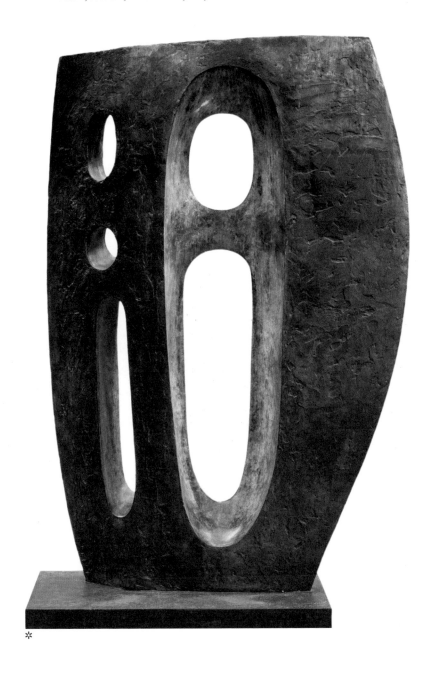

*

# 'Oh, is thy wrath against the rivers?
# Oh, is thy rage against the sea ...?'

Psalm 93 from The Baʿal Cycle of the Ugarit texts, discovered at
Ras Shamra, Syria, *c.* 1500–1300 BCE, translated by Theodor H. Gaster

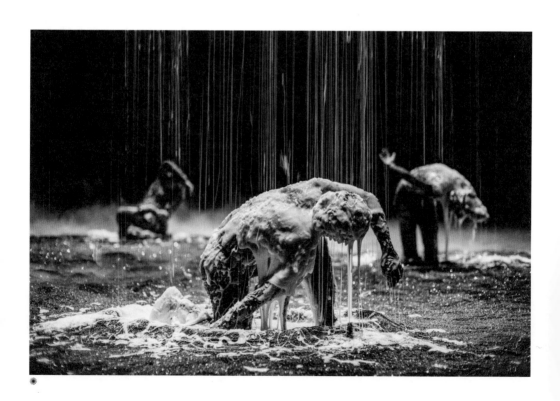

ELEMENTS

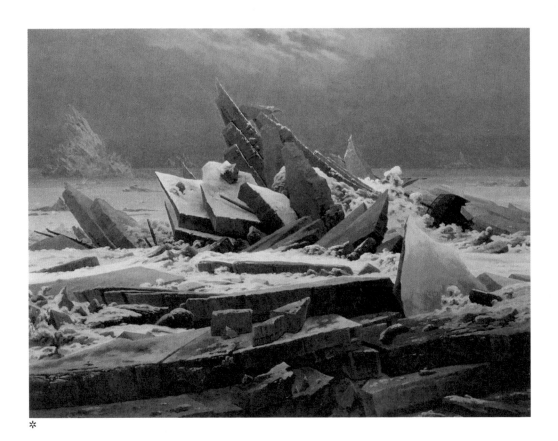

✳

✳
*Planet (wanderer)*, Damien Jalet and Kohei
Nawa, featuring dancers Christina Guieb,
Francesco Ferrari and Astrid Sweeney,
photograph by Rahi Rezvani, 2021

✳
*Das Eismeer* ('The Sea of Ice'),
Caspar David Friedrich, 1823–24

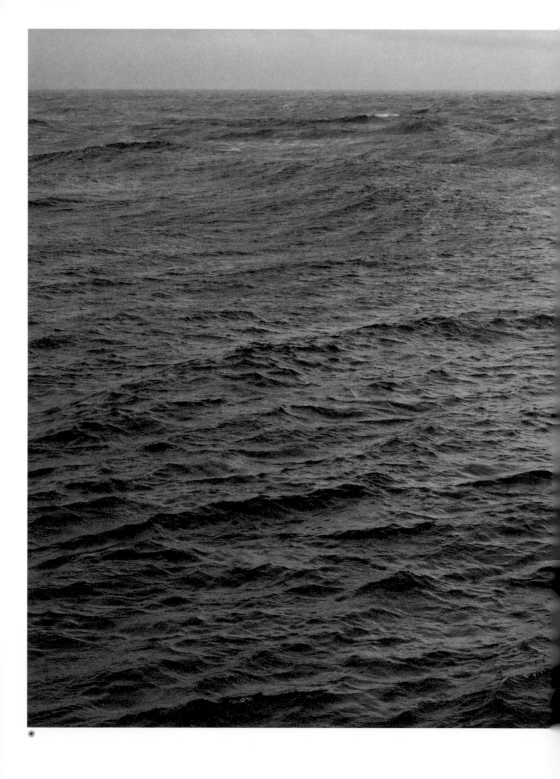

ELEMENTS

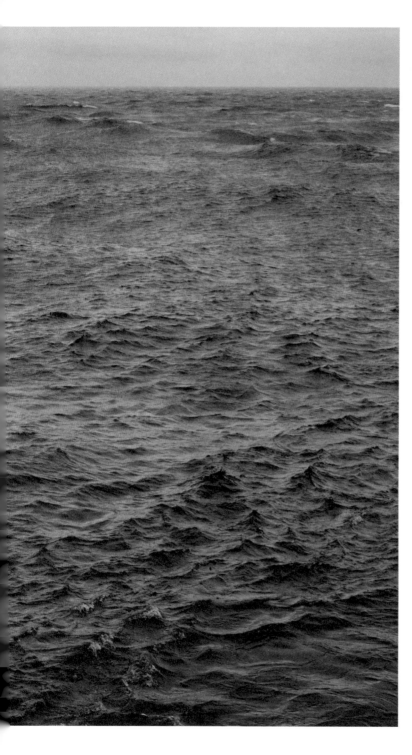

＊
*The State We're In, A,*
Wolfgang Tillmans,
2015

PHOTOGRAPHER NICK BRANDT unveiled his SINK/RISE photo series
of underwater portraits in 2023. Shooting in the ocean off the coast
of the Fijian islands, Brandt highlights the devastating prospects
of South Pacific Island communities in the face of rising sea levels
caused by climate change. With sea levels in the Pacific Ocean
predicted to rise between 25 and 58 cm (10–23 in.) by the middle
of the 21st century, the low-lying Pacific Islands will be threatened
with severe flooding and groundwater sources will be lost. If global
temperatures rise to 2° C (35.6° F) above pre-industrial levels, the
waters in the region will warm to such a degree that 90 per cent of
the coral reefs will become bleached, threatening the survival of the
marine species that depend on them.

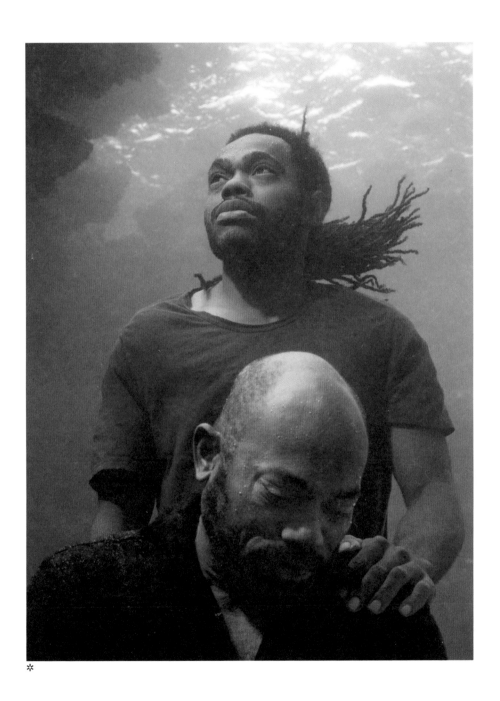

❋

❋

'Water is the most extraordinary substance!
Practically all its properties are anomalous, which
enabled life to use it as a building material for its
machinery. Life is water dancing to the tune of solids.'

Albert Szent-Gyorgyi, *The Living State: With Observations on Cancer*, 1972

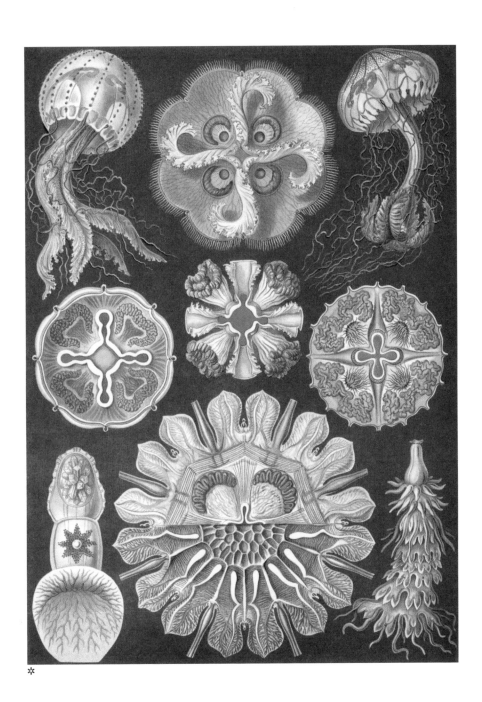

✻

*The Yerres, Rain*,
Gustave Caillebotte, 1875

*Jeux d'enfants dans la neige*
('Children Playing in the Snow'),
Pierre Bonnard, 1907

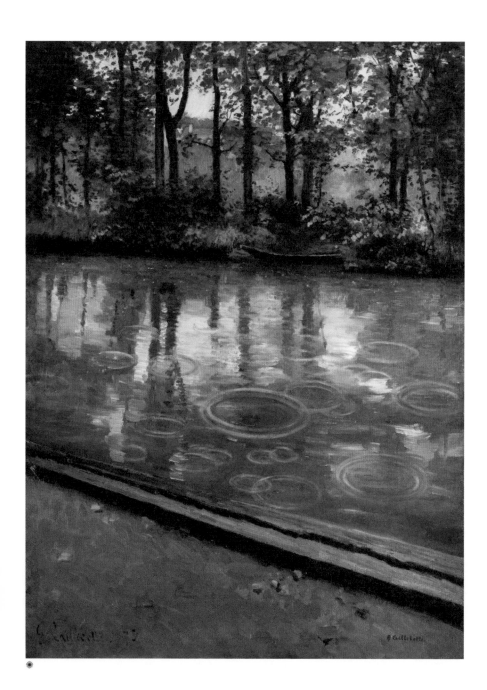

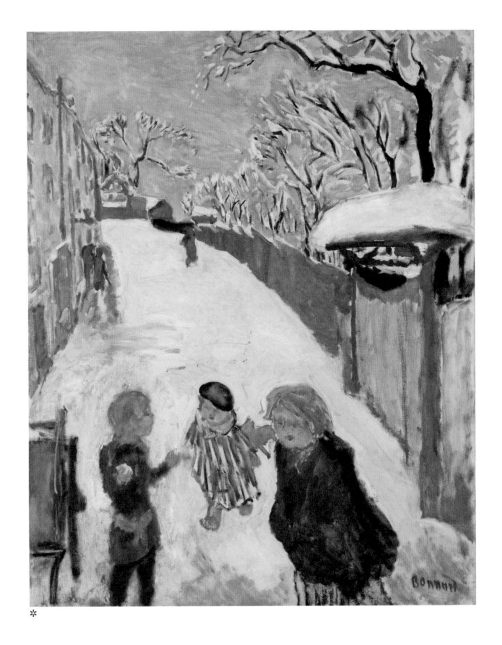

\*

*'Every leaf and twig was this morning covered with
a sparkling ice armor; even the grasses in exposed fields
were hung with innumerable diamond pendants ...
It was literally the wreck of jewels and the crash of gems.'*

Henry David Thoreau, 'Hoar Frost' journal entry, 21 January 1838

'The river is at the same time, at the source and at
the mouth, at the waterfall, at the ferry, at the current,
in the ocean and in the mountains, everywhere.'

Hermann Hesse, *Siddhartha*, 1922, translated by Hilda Rosner

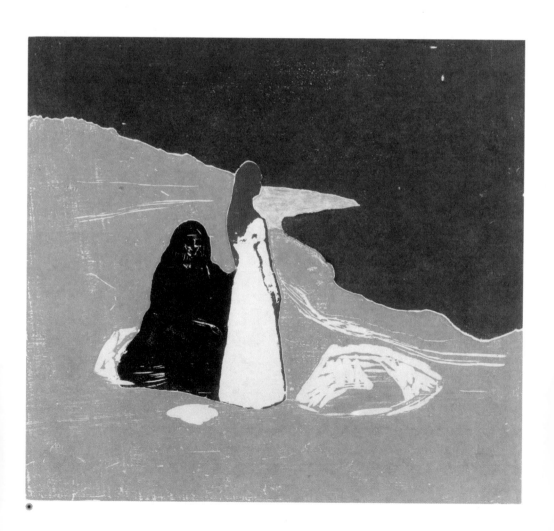

ELEMENTS

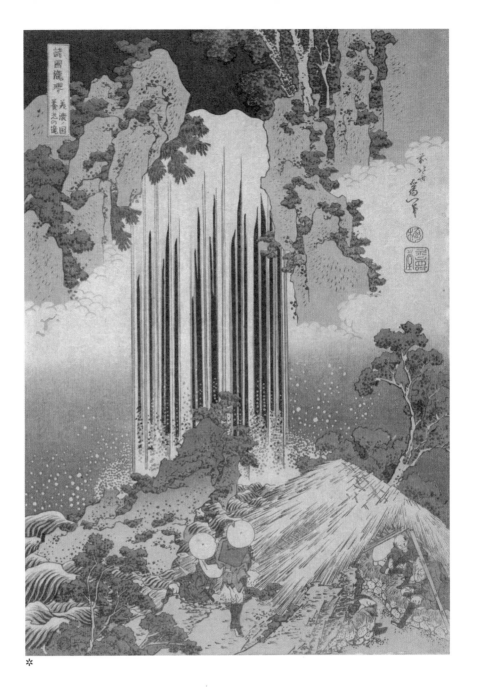

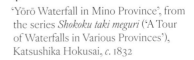

✳
*Two Women on the Shore*,
Edvard Munch, 1898

✳
'Yōrō Waterfall in Mino Province', from
the series *Shokoku taki meguri* ('A Tour
of Waterfalls in Various Provinces'),
Katsushika Hokusai, *c.* 1832

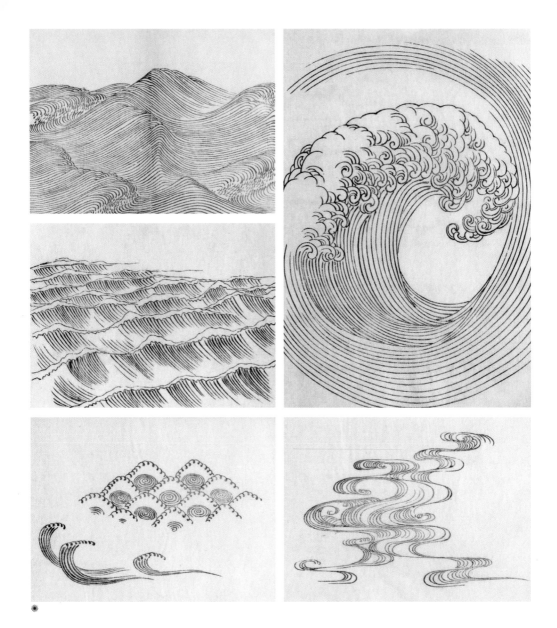

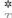 Wave and ripple designs, from
*Ha Bun Shu*, Mori Yūzan, 1919

❋ *The Wave*, Christopher
Richard Wynne Nevinson, 1917

*'I have seen them riding seaward on the waves*
*Combing the white hair of the waves blown back*
*When the wind blows the water white and black.'*

T. S. Eliot, 'The Love Song of J. Alfred Prufrock', 1915

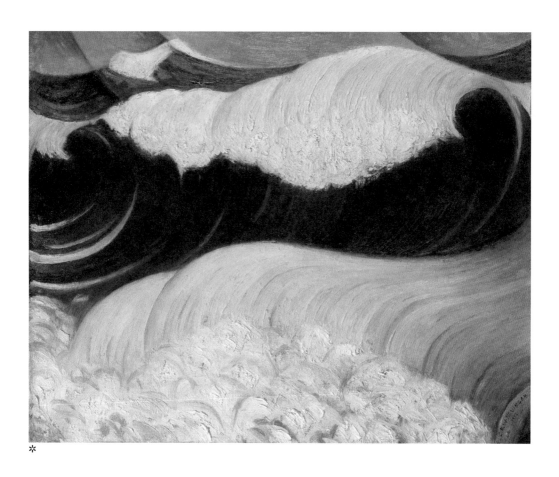

✳

STEAM ENGINES, using fossil fuels such as coal, wood and oil, powered the Industrial Revolution in Europe and the United States between 1760 and 1840. James Watt's steam engine design of 1776 significantly improved upon Thomas Newcomen's atmospheric engine of 1712 by introducing a rotary mechanism and doubling fuel efficiency. From 1801 high-pressure steam engines designed by Richard Trevithick and Oliver Evans transformed the effectiveness of steam-driven machinery and steam-powered locomotives and steamboats. Factories needed constant access to water, so were built on the water's edge. Paddle steamers were built to transport mail, passengers and freight down rivers and over seas. By 1811 regular steamboats travelled from Pittsburgh down the Ohio River to the Mississippi and on to New Orleans. After the California gold rush began in 1848, paddle steamers made regular trips from New York City to San Francisco via Panama City. Smaller steam-powered tugboats worked in the San Francisco Bay to carry miners closer to the gold fields near Sacramento, California.

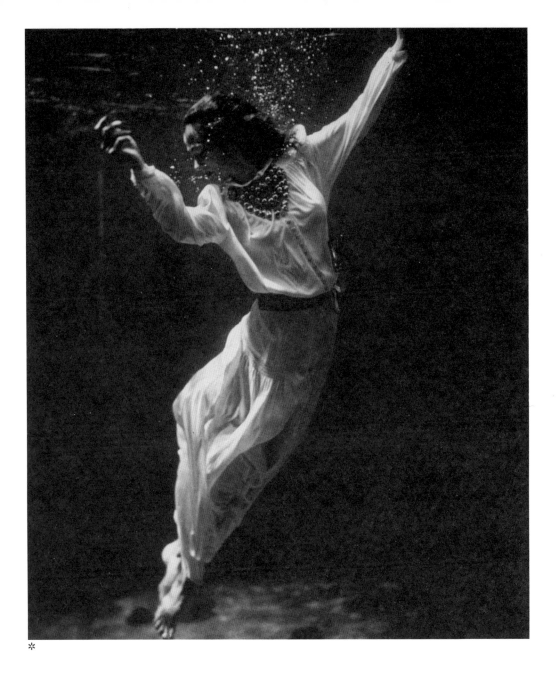

*

*
*The Tugboat*, or *Le Vapeur*
('The Steamship'), albumen silver
print, Gustave Le Gray, 1857

*
Fashion model underwater
in a dolphin tank, Marineland,
Florida, USA, Toni Frissell, 1939

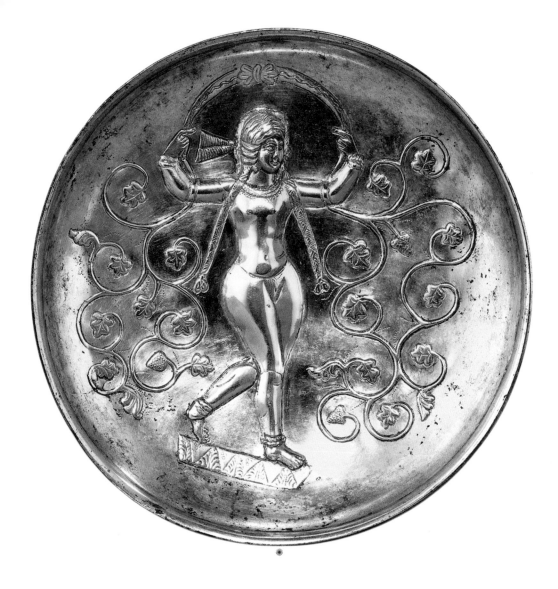

*'Why did the old Persians hold the sea holy?*
*Why did the Greeks give it a separate deity, and*
*own brother of Jove? ... We ourselves see in all*
*rivers and oceans. It is the image of the ungraspable*
*phantom of life; and this is the key to it all.'*

Herman Melville, *Moby-Dick, or The Whale,* 1851

Silver gilt dish depicting the
Zoroastrian goddess Anahita, Iran,
400–600 CE

Palette depicting a sea nymph
riding on a sea monster, Gandhara
(now north-west Pakistan and north-
east Afghanistan), 99 BCE–100 CE

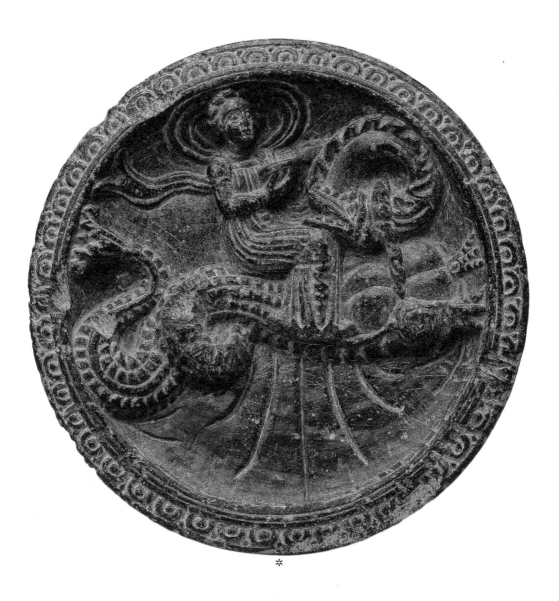

✷ Photograph of waves caused
by Typhoon Cimaron in Japan,
photograph by Chika Oshima, 2018

✳ *Moon and Sea No. II*, Arthur Dove,
1923

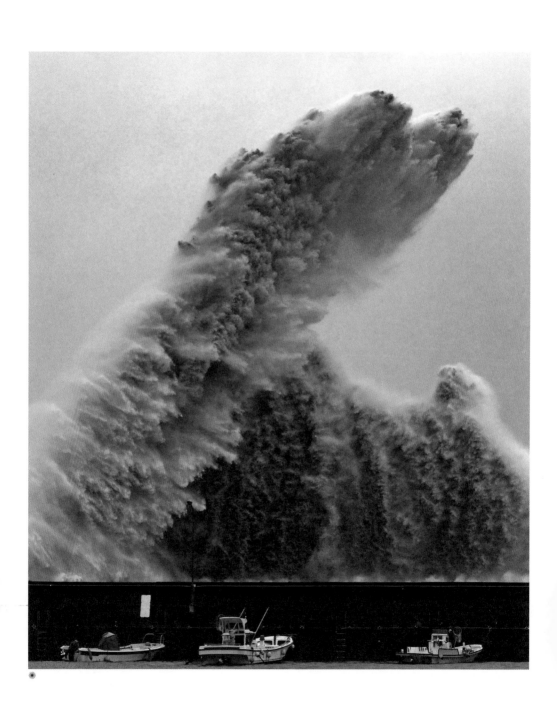

*'On looking out to sea they beheld a great wall of water,
varying in height from thirty to ninety feet, approaching
the land. It destroyed everything in its path ... and
retired, charged with a vast freight of death and ruin.'*

Report on the eruption of Krakatoa, *The San Diego Union*, 2 September 1883

*

SURFING is believed to have originated in Polynesia, where it was enjoyed by men, women and children at all levels of society. Cave paintings from as early as the 12th century depict people riding the waves there. In the 17th and 18th centuries European explorers praised the skills of the surfers they encountered. In 1778 Captain James Cook's ship's doctor, William J. Anderson, commented, 'I could not help concluding that this man felt the most supreme pleasure, while he was driven on, so fast and so smoothly, by the sea.' In the first two decades of the 20th century, the Olympic swimmer Duke Kahanamoku demonstrated the sport during exhibition tours and is credited with popularizing surfing in America and Australia.

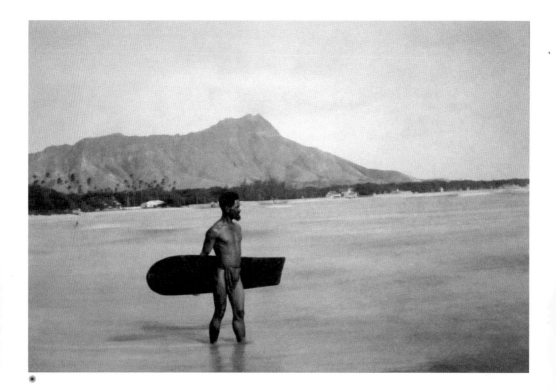

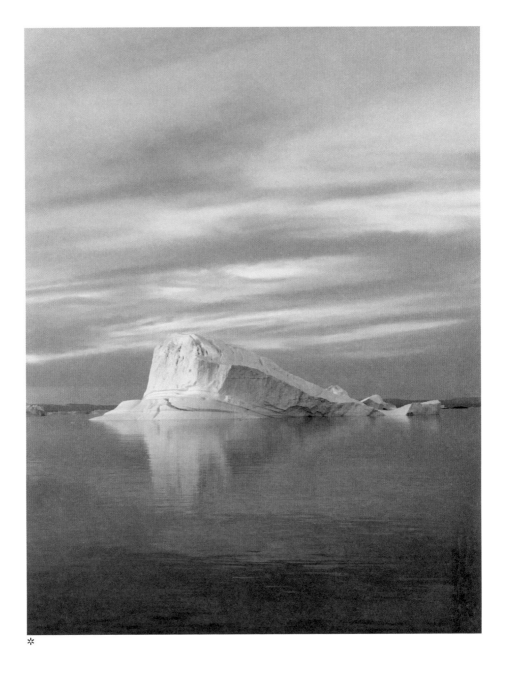

✳

✳
Photograph of Charles Kauha
carrying an alaia surf board,
Waikiki Beach, Hawaii, USA,
Frank Davey, *c.* 1898

✳
Hall Bredning's iceberg, Greenland,
photographed from the polar
supplying schooner *Persévérance*,
Elsa Guillaume, 21 August 2023

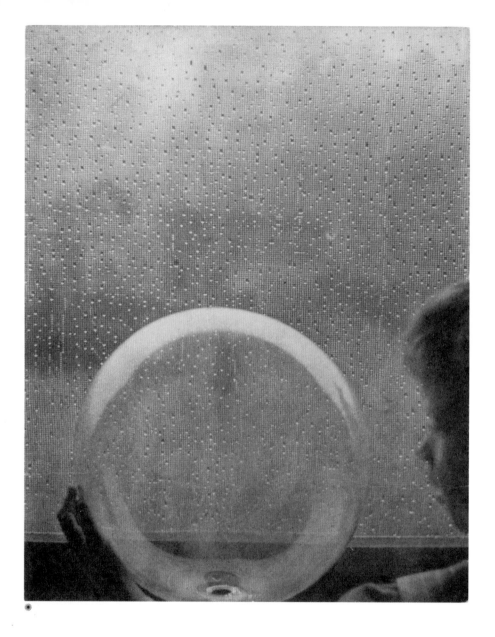

✴

*Drops of Rain*, platinum-palladium print,
Clarence H. White, *c.* 1903

✳

*Larmes* ('Tears'), gelatin silver print,
Man Ray, *c.* 1932

# 'The splash of a drop is a transaction which is accomplished in the twinkling of an eye.'

A. M. Worthington, *The Splash of a Drop*, 1895

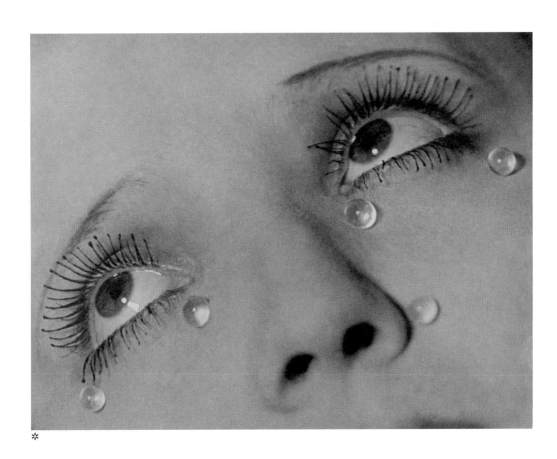

*

'Nine months those clouds have borne the load
Conceived from sunbeams as they glowed,
And, having drunk the seas, give birth,
And drop their offspring on the earth.'

Valmiki, *Ramayana*, Book 4, canto XXVIII, *c*. 4th century BCE,
translated by Ralph T. H. Griffith

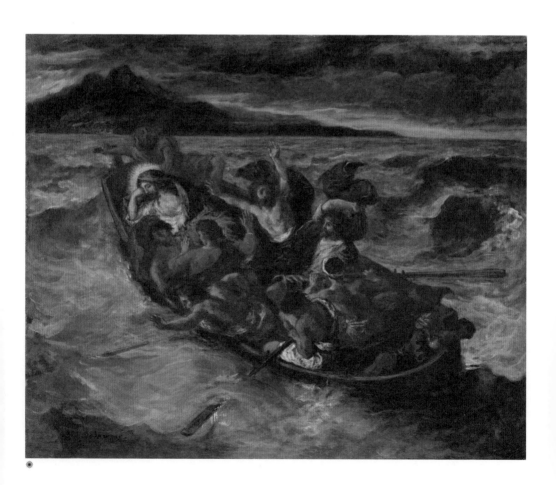

ELEMENTS

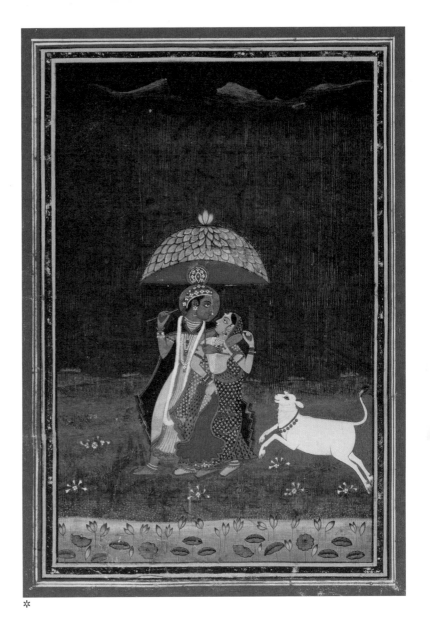

*

✳ *Christ Asleep During the Tempest*,
Eugène Delacroix, *c.* 1853

✱ *Krishna and Radha Strolling in the Rain*,
Jaipur, Rajasthan, India, *c.* 1775

'Map of the City of Ferrara with the Six
Rivers Flowing into the Gulf of Venice',
17th–18th-century copy of Piri Reis's 16th-
century *Kitāb-i baḥriye* ('Book on Navigation')

*The Baptism of Christ*, Simon Bening,
1525–30

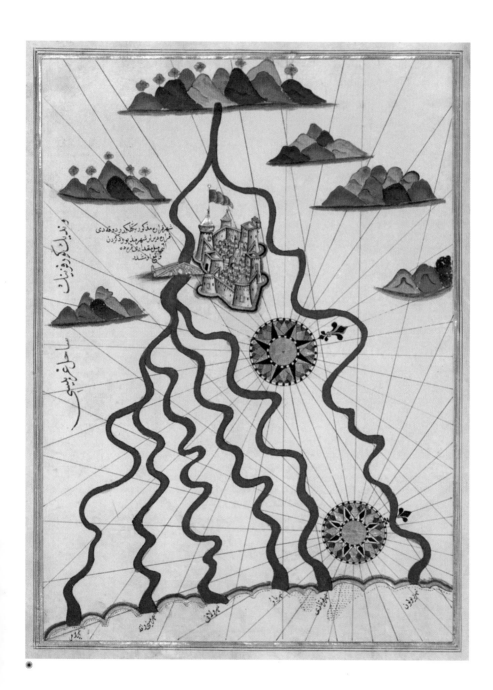

\*

'For, as the element of water lies in the middle of the globe, so, the branches run out from the root in its circuit on all sides towards the plains and towards the light. From this root very many branches are born.'

Paracelsus, 'Concerning the Element of Water', *The Philosophy of the Generation of the Elements*, 16th century, translated by A. E. Waite

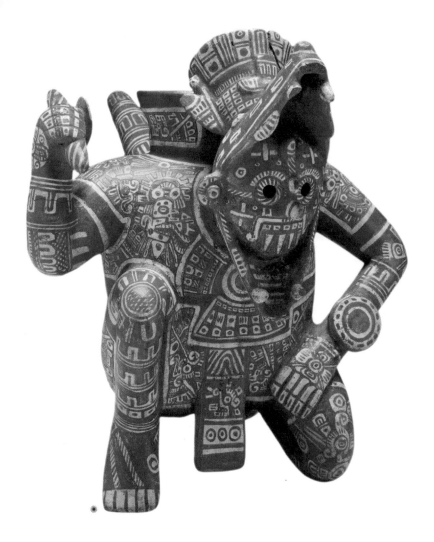

THE JAPANESE DRAGON GOD RYŪJIN, god of the sea, personifies
the power of the ocean. Ryūjin is believed to have lived in a red
and white coral palace built on the seabed with his daughters and
other water spirits. From there he was able to control the tides with
magical tide jewels, and was served by the creatures of the sea. Jingū,
a semi-legendary warrior queen who, according to legend, ruled
as empress-regent of Japan following the death of her husband,
Emperor Chūai, in 200 CE, carried out an invasion of the Korean
Peninsula using a pair of tide jewels borrowed from Ryūjin. The
jewels allowed Jingū to establish Japanese dominance over Korea
by controlling the rise and fall of the tides.

✳

Rain god vessel, Mixtec,
El Chanal, Colima, Mexico,
*c.* 1100–1400

✱

Woodcut depicting one of the
daughters of the underwater
dragon king, Japan, Utagawa
Kuniyoshi, 1832

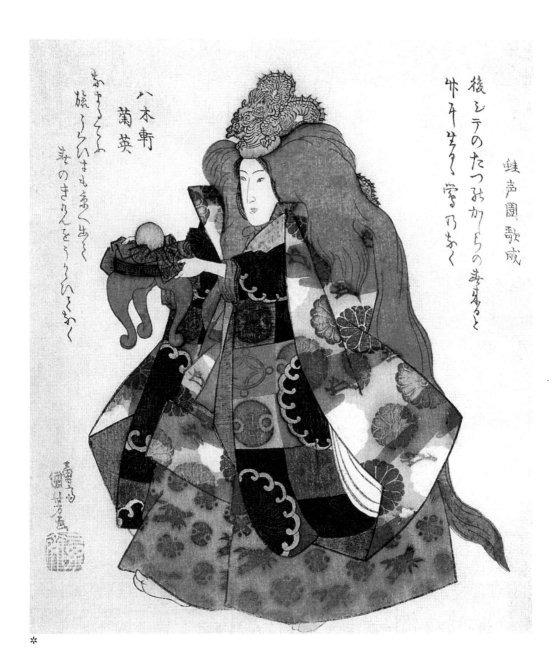

✱

'In an age when man has forgotten his origins
and is blind even to his most essential needs
for survival, water along with other resources
has become the victim of his indifference.'

Rachel Carson, *Silent Spring*, 1962

✳

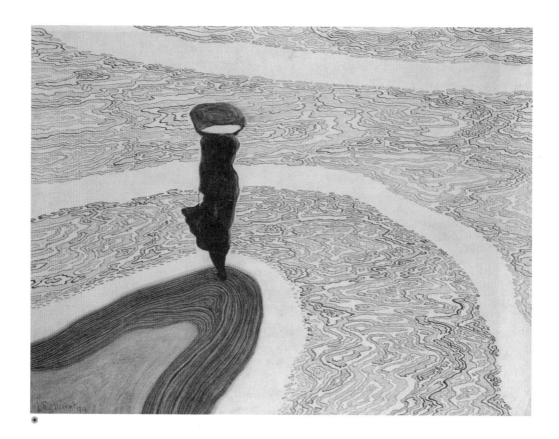

\*

'*When the spirit moves, I wander alone*
*Amid beauty that is all for me ...*
*I walk until the water checks my path,*
*Then sit and watch the rising clouds–*'

Wang Wei, 'My Retreat at Mount Chung-nan', 8th century,
translated by Witter Bynner

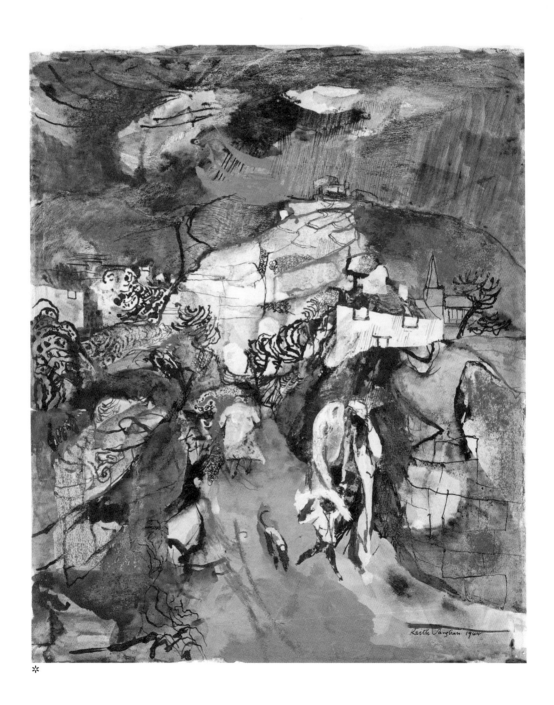

❋

'Thus did I by the water's brink
Another world beneath me think;
And while the lofty spacious skies
Reversèd there, abused mine eyes,
    I fancied other feet
    Came mine to touch or meet.'

Thomas Traherne, 'Shadows in the Water', 17th century

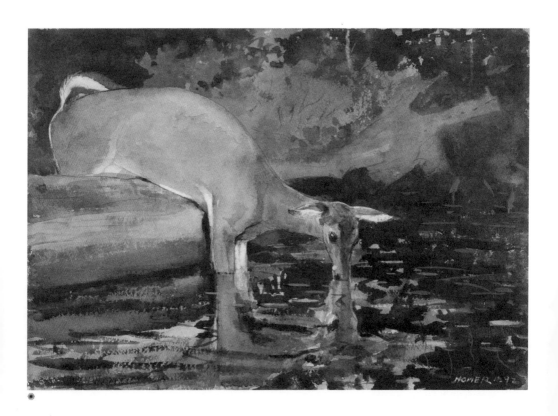

ELEMENTS

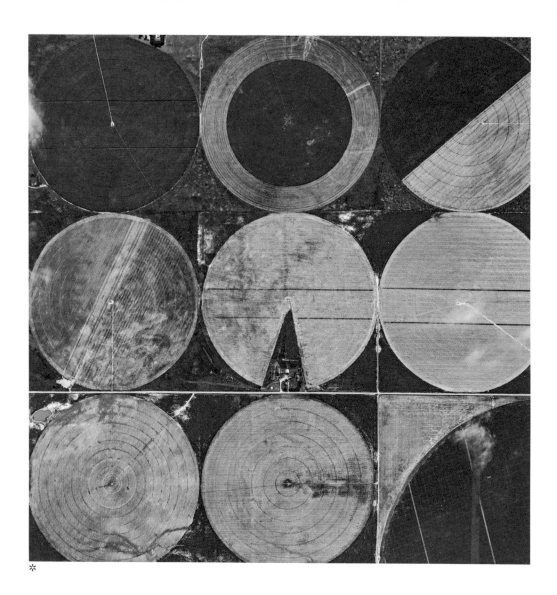

✹
*Deer Drinking,*
Winslow Homer, 1892

✽
*AV_Central_Irrigation_008,*
Bernhard Lang, 2015

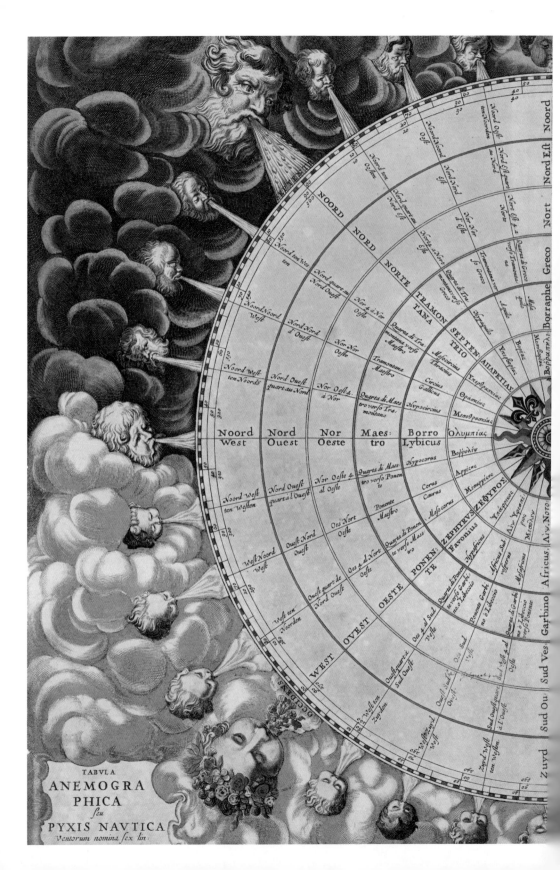

TABVLA
ANEMOGRA
PHICA
seu
PYXIS NAVTICA
Ventorum nomina sex lin.

# 3.   Air

*"In their grueling travels across trackless lands in prehistoric times, [our ancestors] looked enviously on the birds soaring freely through space, at full speed, above all obstacles, on the infinite highway of the air."* \*

※
*Tabula Anemographica*
(Anemographic chart, or map
of the winds), Jan Jansson, 1652

\*
Wilbur Wright in a letter
to the Aéro-Club de France,
Paris, 5 November 1908

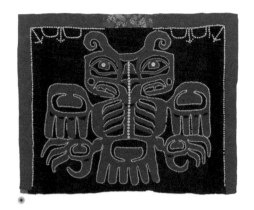

In Chinese philosophy, the concept Qi or Chi is similar to that of air. Meaning energy flow, air or breath, Qi is the life force that flows through all things. In Buddhism air is *Om*, which provides focus for meditation, and in Hinduism it is *prana*, the life-giving breath. It is associated with the heart chakra, *anahata*, meaning 'unstruck' or indestructible. The Greek word *spiro*, meaning breath, is also connected with a stormy wind and a medium for movement. According to Aristotle, air's qualities are moisture and heat, and it occupies a place between fire and water among the elemental spheres, being purer than earth and water, but less pure than fire. In the theory of correspondences, it is associated with spring and the sanguine temperament, and its planetary god is Zeus. In alchemy, it represents the mind and soul of humankind. It is mobile, transparent, invisible except in the form of clouds, and formless. The light-scattering quality of water vapour in the air produces blue skies and rainbows.

According to Aëtius, the 1st-century CE Greek philosopher Anaximander of Miletus (*c.* 611–*c.* 547 BCE) stated that thunder and lightning, typhoons and whirlwinds, were created by what he called *pneuma*, a term that included breath, wind, spirit and moving air, although he did not regard air as the underlying element. Anaximander's successor, Anaximenes (*c.* 546–528/5 BCE), went further. The philosopher Theophrastus (*c.* 372–286 BCE), a contemporary of Aristotle, related that Anaximenes believed air was a limitless substance that enveloped the Earth and was the primary element. Anaximenes observed that air underwent

changes. Through rarefication it became fire, and through condensation it became water and clouds. He believed that through further condensation, air became earth and then stones. In short, it could change into the other elements, from which all natural forms derive. Air could also assume qualities such as humidity, movement, smell and colour. Anaximenes also considered air as divine, drawing a parallel between the way air works in the physical world and the way the human soul, also consisting of air, works in the body.

Air is most characterized by the wind. In Norse mythology, Thor was god of the air, wind and rain, thunder and lightning, and crops. In Hindu myths, Rudra is god of the roaring storm and father of a group of storm gods known as the Rudras, usually portrayed as fierce and destructive. In Yoruba belief the *Orisha* (spirit) Sàngó is venerated as the god of thunder and lightning, simultaneously feared for his destructive powers and revered for his courage. In Greek mythology, Zeus was god of the sky. Referred to as the 'cloud-gatherer' in Homer's *The Odyssey*, he was

responsible for the weather, creating thunder, hurling lightning bolts and causing storms. He also positioned rainbows in the clouds as signs for humans. The Greek pantheon included several wind gods, including Boreas, who personified the north wind, and Zephyros, the west wind. Old maritime maps of the Mediterranean identified the winds according to their Greek names and the compass point from which they blew.

In Norse creation mythology, clouds are the thoughts of the first being, a *jotunn* (giant) called Ymir. The ancient Greeks believed that the gods resided in the clouds, although Thales of Miletus described a version of the water cycle, by which water evaporates from the Earth's surface and rises to condense into clouds. The Greek playwright Aristophanes, in his comedy *The Clouds*, first performed in 423 BCE, asks 'Have you ever seen it rain when a cloud wasn't in the sky?'

In the *Meghadūta* ('Cloud Messenger'), a poem written in the 5th century CE by the Sanskrit poet Kālidāsa, a banished *yaksha* (nature spirit) sits on a mountaintop lamenting separation from his loved one. When a cloud settles nearby, he asks it to take a message to his love in the faraway city of Alaka. He advises it to drink the river's spray and water, so as to produce lightning to light its way, and to ensure that it is not so light that it will be buffeted by the winds.

Since ancient times, humans have dreamed of taking to the air and flying. The idea of constructing wings to emulate bird flight first appears in the Greek legend of Daedalus and his son Icarus, who were trapped on the island of Crete by King Minos. To escape, Daedalus constructed two pairs of wings made from feathers and attached with wax. As Icarus soared through the air, he came too close to the sun, the wax melted and his wings came apart, and he fell into the sea. The kite, made of a split bamboo frame covered in silk and designed to resemble a bird or mythical flying creature, was invented in the 5th century BCE in China. There the use of human-carrying kites for civil and military purposes and for punishment are first recorded in the 6th century CE. The Renaissance polymath, Leonardo da Vinci (1452–1519), produced more than 500 sketches and extensive notes covering the nature of air, studies of birds in flight and plans for flying machines. He produced designs for a parachute, a hang glider and an ornithopter – a flying machine consisting of a large platform on which men would stand and move huge wings up and down. However, the designs were never tested, and his *Codex on the Flight of Birds* (1505–6) was not published until 1893.

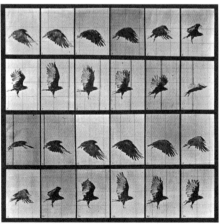

✳

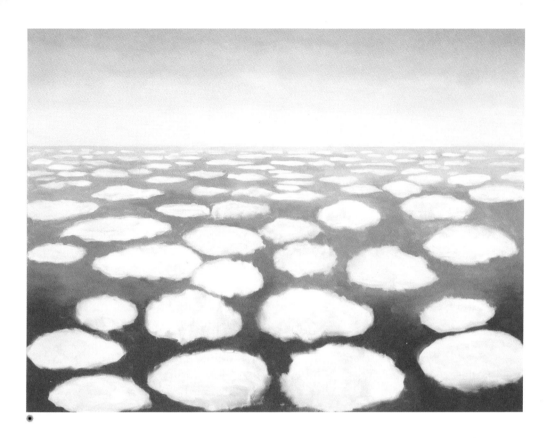

✳

'After this, the Empress asked them, what kind of substance
or creature the air was? ... Some would have it a flowing
water of the air; and others again a flowing air moved
by the blaze of the stars.'

Margaret Cavendish, Duchess of Newcastle, *The Description of a New World,
Called The Blazing World*, 1666

*Above the Clouds I,*
Georgia O'Keeffe, 1962–63

‘The new-born cloud leaps up
from the Earth’ (detail), *Das Buch
der natürlichen Weisheit* (‘The Book
of Natural Wisdom’), Ulrich von
Pottenstein, *c.* 1430

FOG LADEN WITH POLLUTION became an occasional unpleasant feature of the air in London as early as the 13th century, gradually worsening as the city expanded and more coal was burnt. Water vapour stuck to particles released from the burning coal to create a polluted haze over the city. From the late 18th century, with the rapid increase of industrialization, the incidence of what became known as peasoupers increased and its impact on health became more serious. By the early 19th century fog-related deaths were recorded on gravestones. The term 'smog' was first used in the early 20th century to describe the mix of smoke and fog. In December 1952, over a period of five days, a particularly devastating smog occurred in London. An anticyclone (a phenomenon where winds circulate around a centre of high atmospheric pressure) hanging over the region trapped heavily polluted air just above ground level, seriously impairing visibility and causing increased incidents of pneumonia and bronchitis, resulting in the deaths of about 4,000 inhabitants.

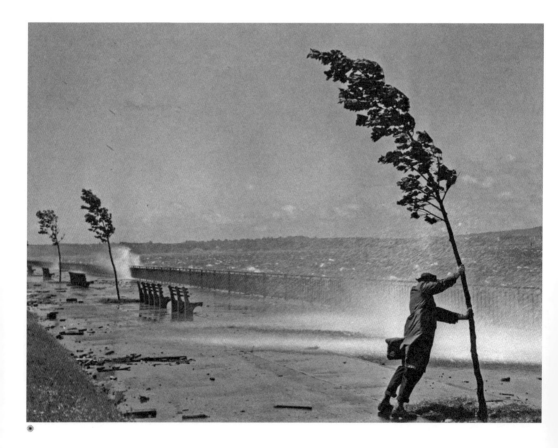

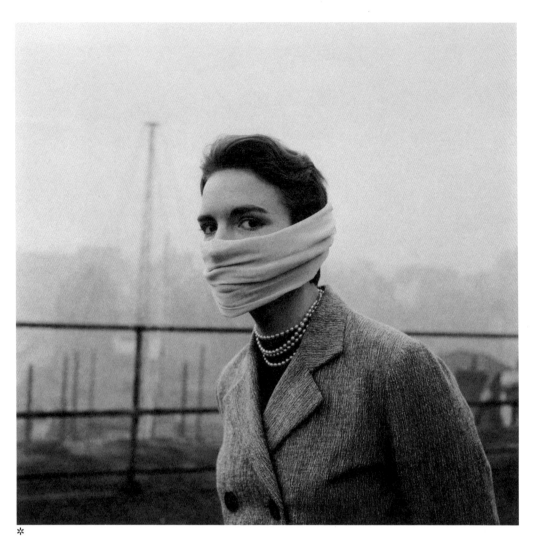

✳

✳
Photograph of a man holding onto a
tree during Hurricane Carol, Brooklyn,
New York, USA, 31 August 1954

✻
Julie Harrison of the Hulton Press tries
out a protective mask to combat the
effects of London's smog, photograph
by Carl Sutton, November 1953

*Air*

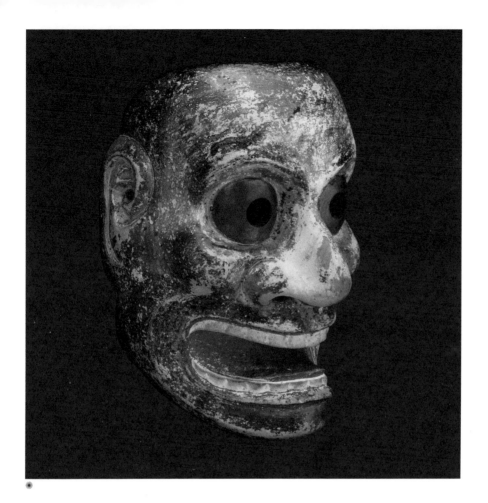

*

IN POLYTHEISTIC TRADITION, THUNDER GODS are the personification or the source of thunder. The Japanese god of thunder, Raijin, is represented as a fierce and powerful demon, orbited by a ring of drums. Sometimes he is portrayed with only three fingers, representing the past, present and future. He beats the drums with large mallets to produce the sound of thunder. He is frequently depicted with Fūjin, the god of wind. Similarly, in Chinese mythology, the thunder deity Lei Gong carries a drum and hammer to create thunder, as well as a chisel to punish wrongdoers.

✳ Otobide shrine mask, possibly representing the god of thunder, Japan, 19th century or earlier

✳ Sculpture of Raijin (god of thunder, lightning and storms), Japan, 17th–19th century

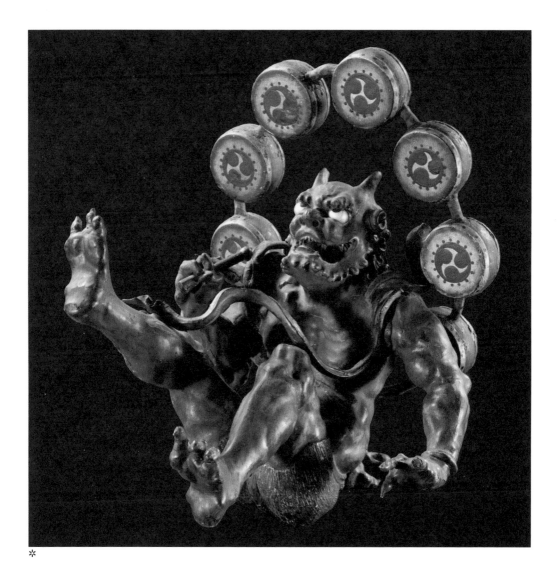

✳

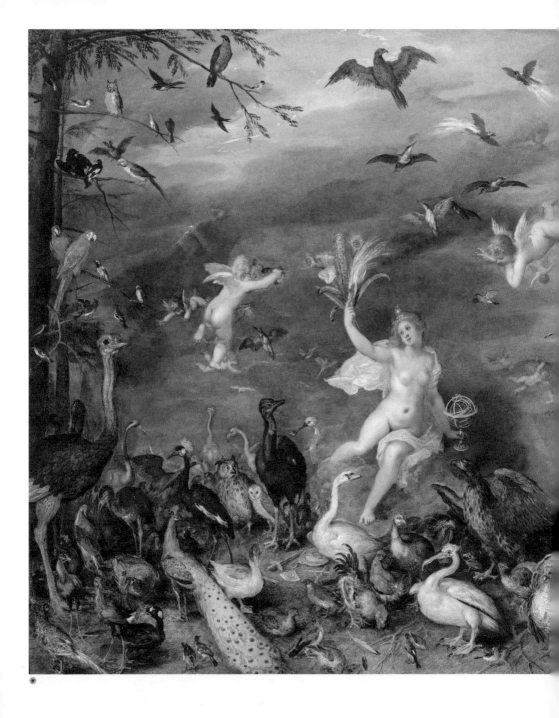

*Allegory of Air*, Jan Brueghel the Elder, 1611

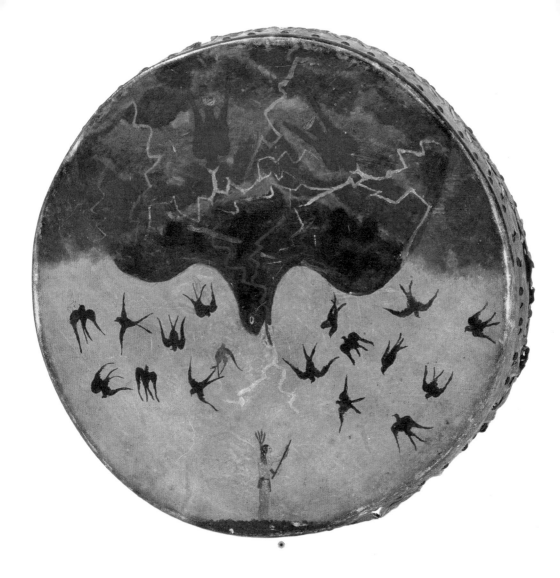

'A thunder storm was coming from where the sun goes down ...
I looked up at the clouds, and two men were coming here,
headfirst like arrows slanting down; and as they came,
they sang a sacred song and the thunder was like drumming.'

Black Elk, as told through John G. Neihardt, *Black Elk Speaks:
Being the Life Story of a Holy Man of the Oglala Sioux*, 1932

✱
Ghost dance drum depicting
Thunderer, ruler of the sky world,
Pawnee, Oklahoma, USA,
George Beaver, 1891–92

✽
Detail of a furisode
(long-sleeved kimono)
depicting flying cranes,
Japan, 1910–30

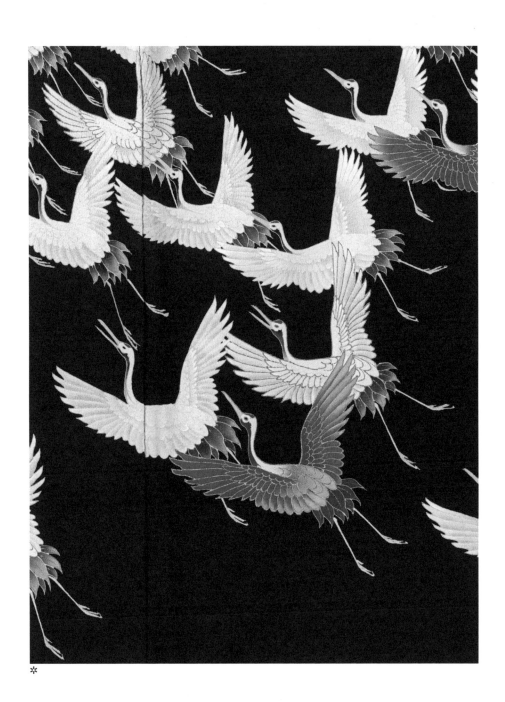

✽

❋
*Wind Tunnel Construction,*
*Fort Peck Dam, Montana,*
Margaret Bourke-White, 1936

✳
*Wind Fire, Thérèse*
*Duncan on the Acropolis,*
Edward Steichen, 1921

'*For the breath of life is in the sunlight
and the hand of life is in the wind.*'

Kahlil Gibran, 'On Clothes', *The Prophet*, 1923

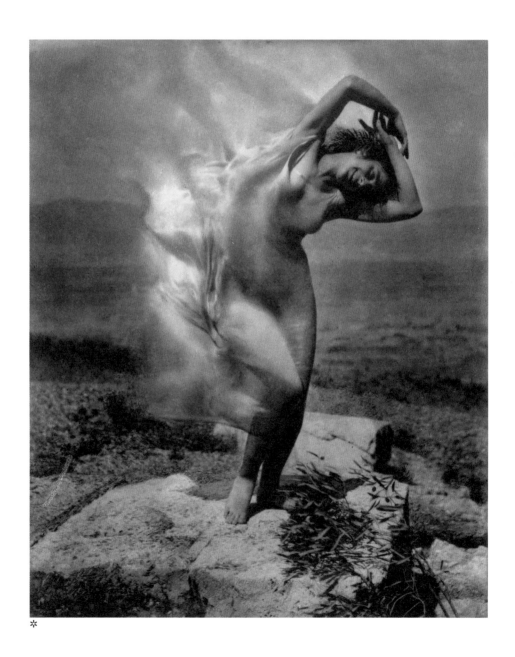

✳

*'The nursling of the sky; I pass through the pores of the ocean and shores; I change, but I cannot die.'*

Percy Bysshe Shelley, 'The Cloud', 1820

ELEMENTS

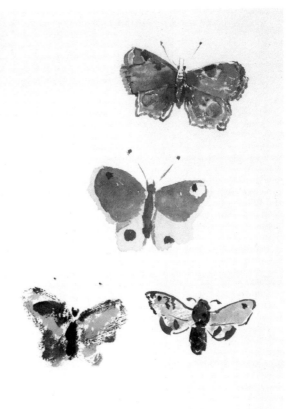

※

*The Mouth of Krishna #212*,
Albarrán Cabrera, 2013

✳

*Five Butterflies*, Odilon Redon, 1912

'Skywind, skillful disorder,
Strong tumult walking over there ...
Hurler of mad-masted, foaming sea.'

Dafydd ap Gwilym, 'The Wind', 14th century, translated by Gwyneth Lewis

❋
Contact sheet of ultrasonic wave
photographs, from acoustic experiments
at the Institute of Applied Acoustics
at ETH, Zurich, Switzerland,
Franz Max Osswald, *c.* 1930

✳
*Flying Spinnakers,*
Long Island Sound, USA,
silver gelatin print,
Morris Rosenfeld, *c.* 1938

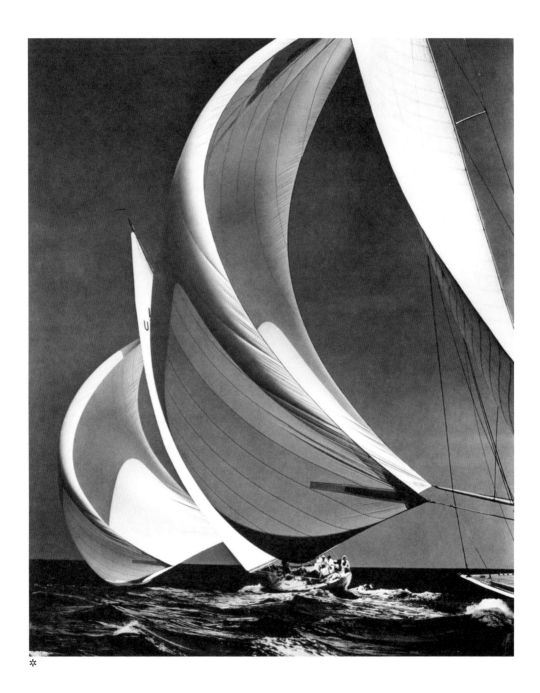

✳

'For our ancestors have given the name of heavens,
or, sometimes, another name, air, to all the seemingly
void space, which diffuses around us this vital spirit.'

Pliny the Elder, *The Natural History*, 77–79 CE, translated by John Bostock
and Henry Thomas Riley

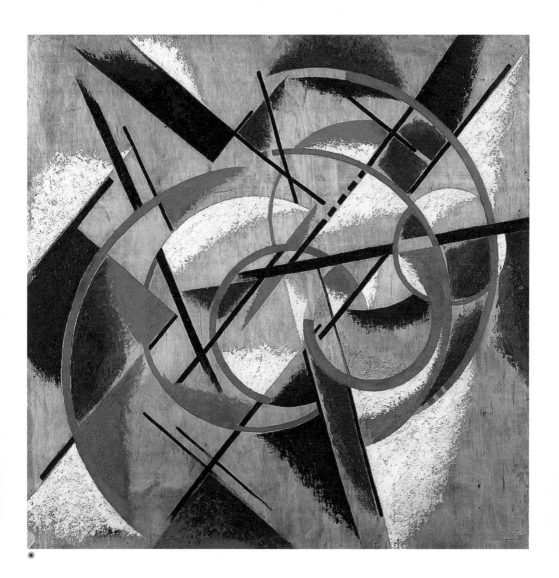

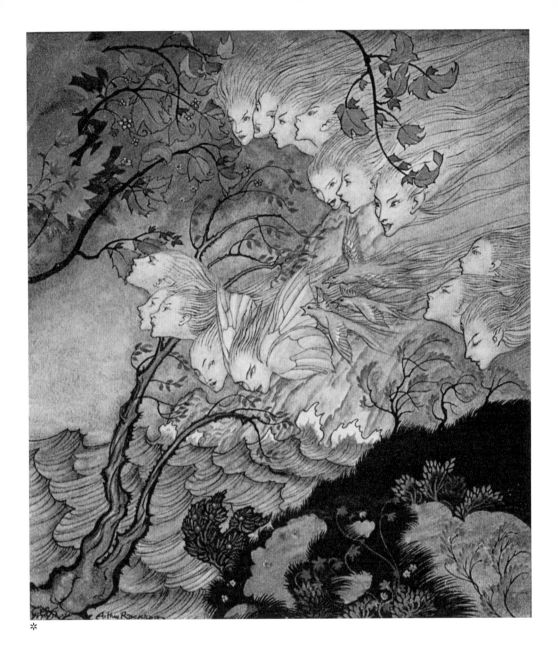

✳

＊ *Spatial Force Construction*,
Liubov Popova, 1920–21

✳ Illustration from William
Shakespeare's *The Tempest*,
Arthur Rackham, 1926

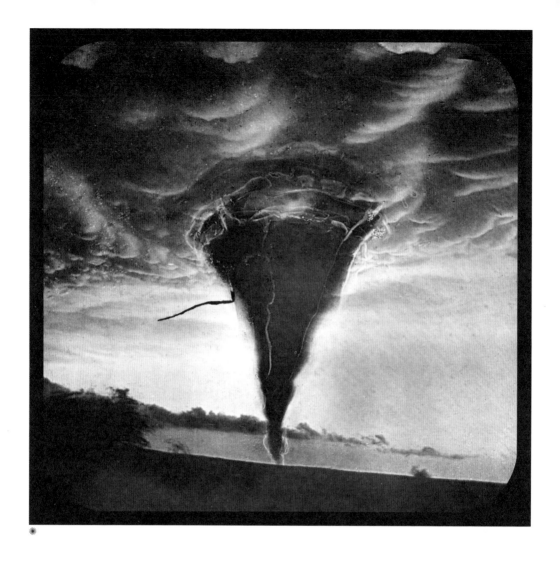

'Blow winds, and crack your cheeks! Rage, blow!
You cataracts and hurricanoes, spout
Till you have drenched our steeples, drowned the cocks. ...
Crack nature's moulds, all germens spill at once
That makes ingrateful man.'

William Shakespeare, *King Lear*, Act III, scene ii, lines 1–11, 1606

ELEMENTS

✳

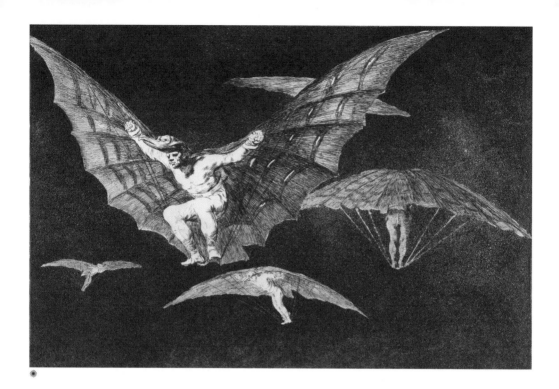

*

THE DREAM OF HUMAN FLIGHT began with the observation of
birds, which led aviation pioneers to imitate the mechanics of bird
flight. According to Greek mythology, Daedalus and Icarus strapped
huge wings constructed from feathers, osier branches and threads
glued together with beeswax to their arms in order to fly. Medieval
and early modern scientists who leapt from high structures wearing
strap-on wings usually broke bones – or worse – upon landing.
Leonardo da Vinci designed an ornithopter – a flying machine
with flapping wings – after studying bird flight. An ornithopter
capable of flying but not of carrying a person was first constructed
in France in 1871 by Jobert, using a rubber band to turn a crank to
propel the aircraft forwards. Modern aeroplane designers continue
to take inspiration from birds, with Airbus unveiling a 'Bird of Prey'
concept aircraft in 2019.

✹
'Modo de volar' ('A Way
of Flying'), from the series
*Los disparates* ('The Follies'),
Francisco de Goya, *c.* 1815–16

✽
*A Good Day for Cyclists*,
Jeremy Deller, wall painting
by Sarah Tynan, 2013

✽

'Now I have felt it—
something that exceeds storm winds.'

Emperor Fushimi, 'Pines at Evening', compiled in *Fūgashū*
('Collection of Elegance'), 1346, translated by Steven D. Carter

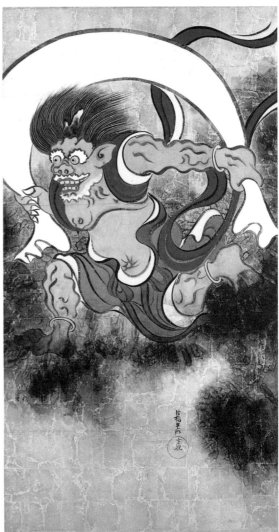

Four-panel paper folding screen depicting
Raijin (god of thunder, lightning and storms)
and Fūjin (god of wind), Japan, Ogata Korin,
c. 1700, replica of Tawaraya Sotatsu's early
17th-century folding screen

THE DUST BOWL occurred in the south-western Great Plains region of the United States during the 1930s when the area suffered several waves of severe drought. Homesteaders, encouraged from 1904 by the US government to settle in the semi-arid land and cultivate it, had immediately set about converting grassland to cropland by deep ploughing the topsoil over wide areas, using combine harvesters. During the droughts of the 1930s the strong winds of the region lifted the loose dry soil and blew the black dust in huge clouds across the plains, reducing visibility to 1 m (3 ft) and turning nineteen states into a vast dust bowl. Unable to grow crops, tens of thousands of families were forced to abandon their farms and become migrant labourers. The area eventually recovered with the assistance of windbreaks, formed from tree plantations.

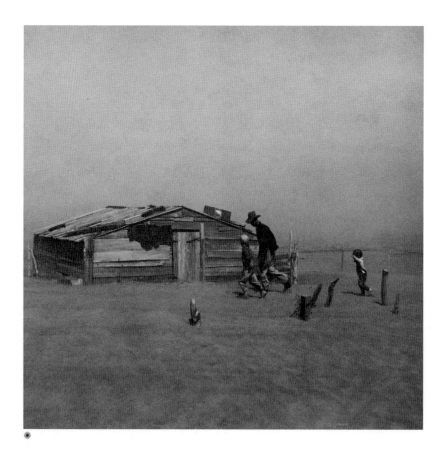

ELEMENTS

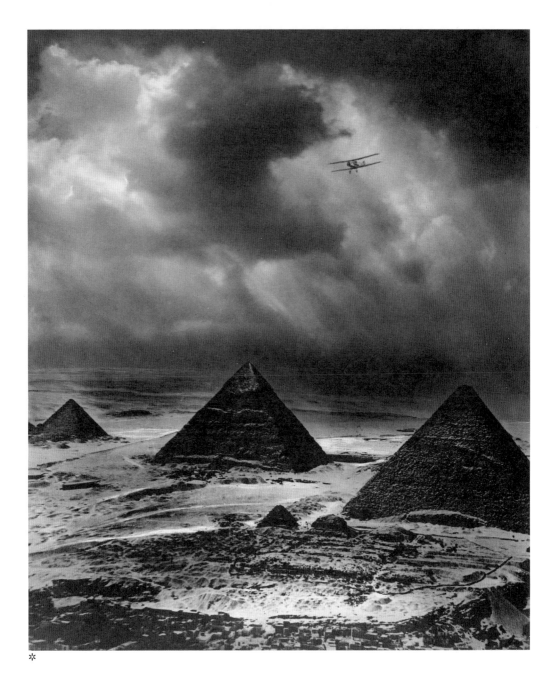

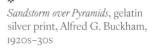

Photograph of a farmer and his sons
walking in the face of a dust storm,
Cimarron County, Oklahoma, USA,
Arthur Rothstein, April 1936

*Sandstorm over Pyramids*, gelatin
silver print, Alfred G. Buckham,
1920s–30s

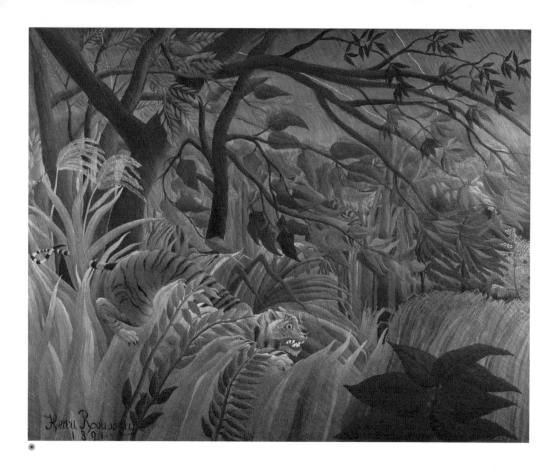

*'Who has seen the wind?*
*Neither you nor I:*
*But when the trees bow down their heads*
*The wind is passing by.'*

Christina Rossetti, 'Who Has Seen the Wind?',
*Sing-Song: A Nursery Rhyme Book*, 1872

❋

*Tiger in a Tropical Storm*,
Henri Rousseau, 1891

✳

*The Wind*, Félix Vallotton, 1910

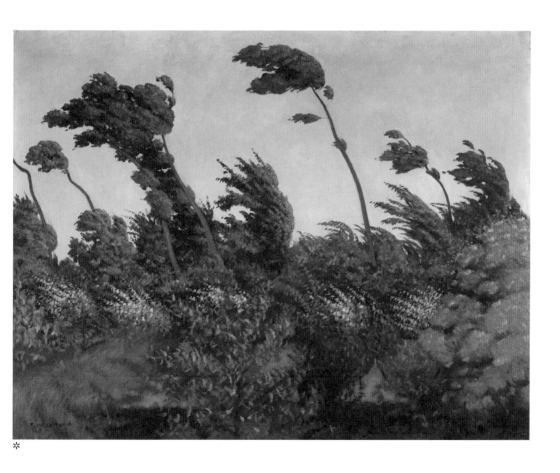

✳

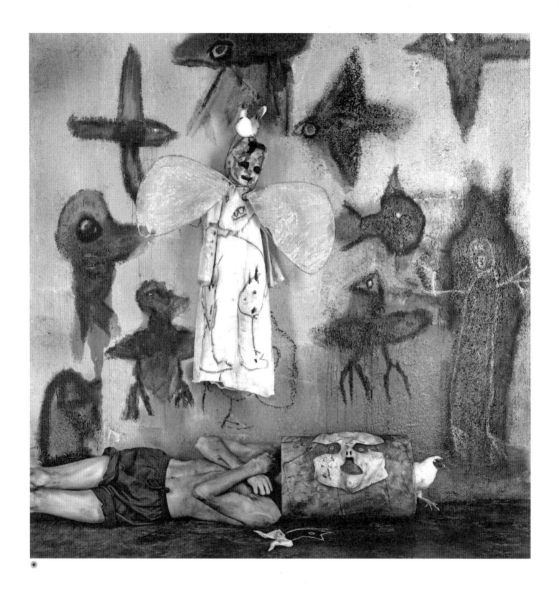

✳

'With a crescented moon at her back, the great ship,
first like a ghost out of the North and then appearing
to be a mighty silver fish swimming through the sky's
sea of blue, hovered.'

'Zep set to hop from L.A.; flies over city tonight', *Los Angeles Evening Express*,
26 August 1929

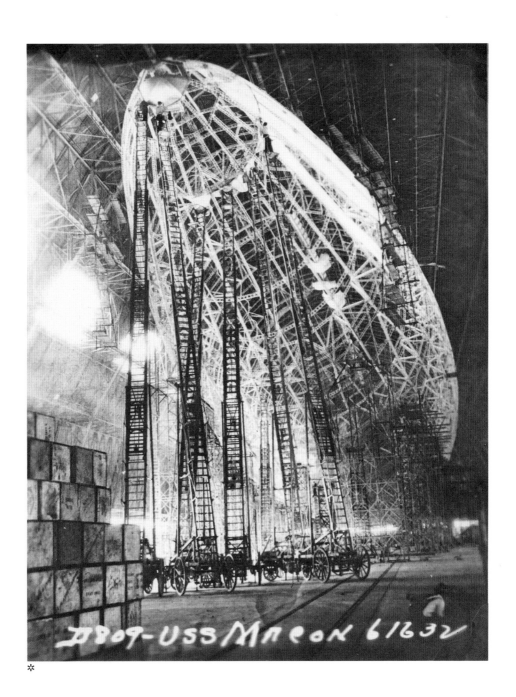

✳

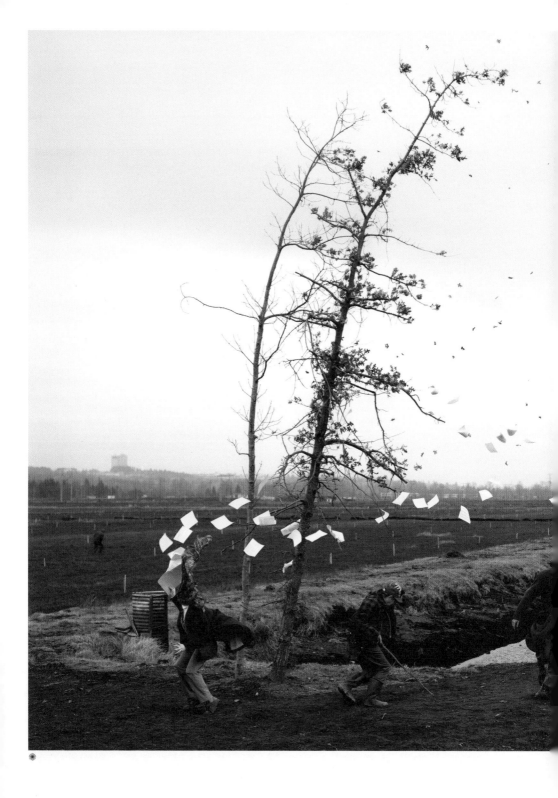

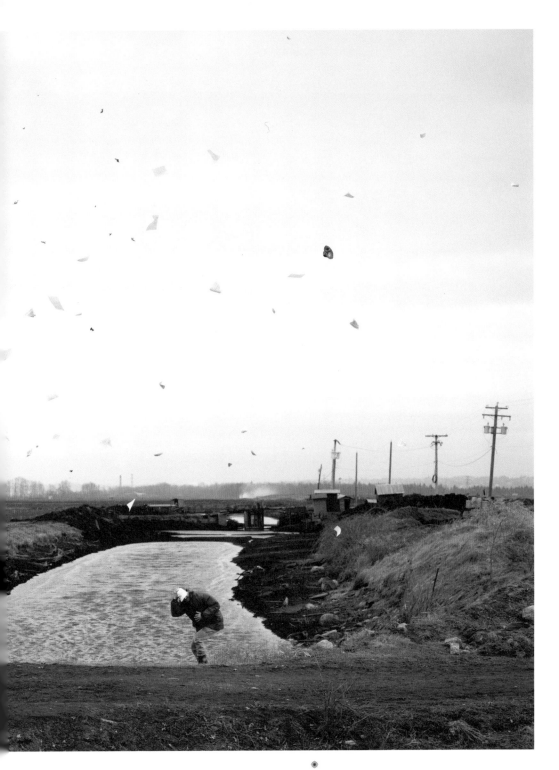

*A Sudden Gust of Wind (after Hokusai)*, Jeff Wall, 1993

*　*Breath/ng*, pollutant-absorbing
installation, Kengo Kuma and
Associates, 2018

*　Autochrome photograph of hot
air balloons, Grand Palais, Paris,
France, Léon Gimpel, 1909

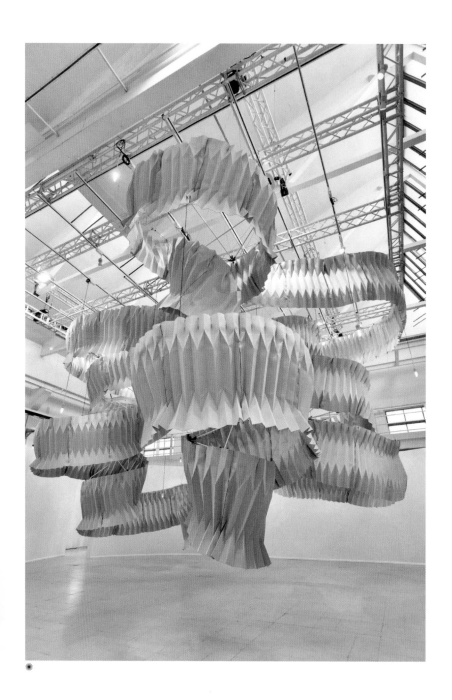

*

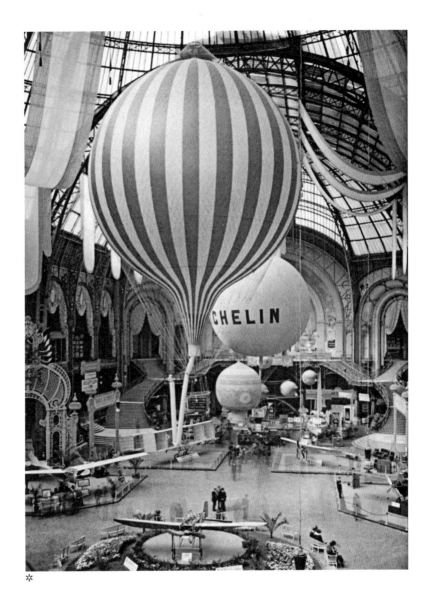

*

THE FIRST HOT AIR BALLOON was developed by French brothers
Joseph and Étienne Montgolfier. On 4 June 1783, in front of a group
of dignitaries, their globe-shaped balloon of sackcloth containing
790 cu m (28,000 cu ft) of air was launched at Annonay, France,
carried aloft by a fire of wool and damp straw underneath. It flew
for ten minutes. In collaboration with wallpaper manufacturer
Jean-Baptiste Réveillon, they constructed a balloon that was large
enough to carry a person in a basket attached underneath, and, on
15 October 1783, Étienne Montgolfier was the first person to be lifted
from the ground in a tethered test flight from the Réveillon workshop.

✳

Illustration of the four winds,
from *Bellifortis* ('War Fortifications'),
Konrad Kyeser, 1400–50

✳
*De rode wolk* ('The Red Cloud'),
Piet Mondrian, 1907

> *'Darkness swooped down from the sky.*
> *The East Wind and the South Wind and*
> *the tempestuous West Wind clashed together,*
> *and the North Wind came from the upper sky,*
> *rolling a great wave in front of it.'*

Homer, *The Odyssey*, c. 725–675 BCE, translated by E. V. Rieu

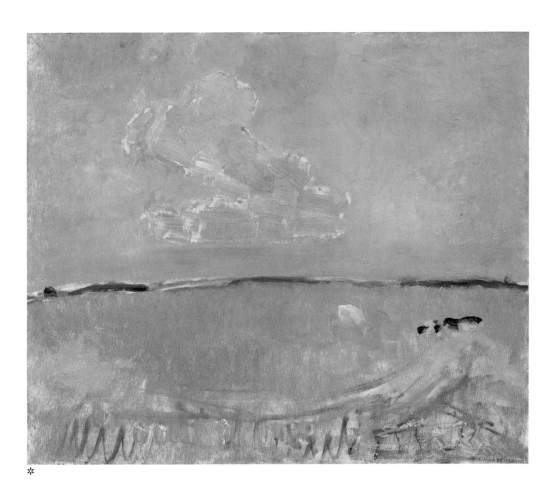

*

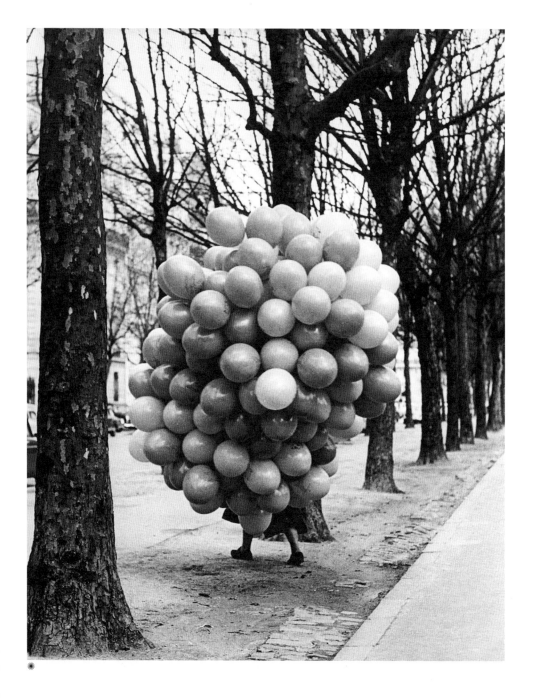

❋
Photograph of a balloon seller,
Serge de Sazo, probably early
1960s

✱
'Arethusa', from *Ars algebra
et analytica ac alma cabula*
(a book of cabbalistic alchemy),
Jodocus Müller, late 17th century

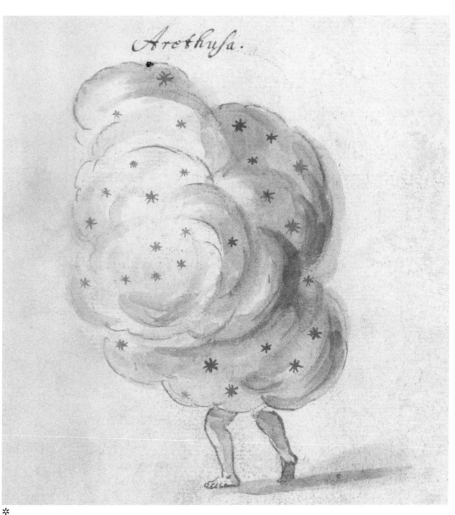

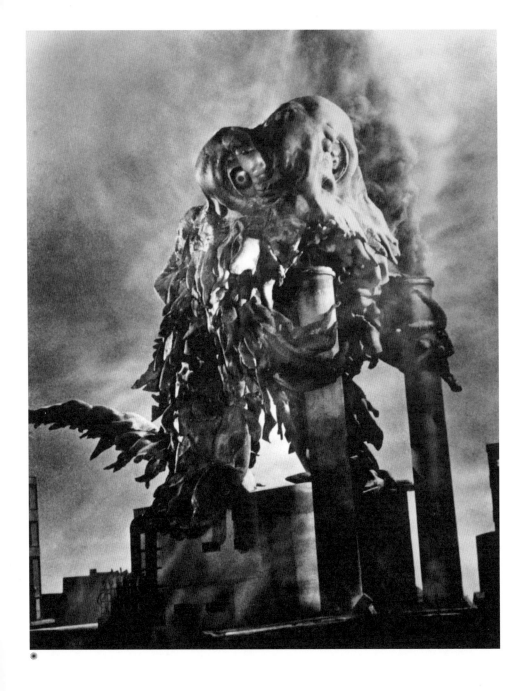

＊

*'All life doomed as a hideous monster
is spawned in the filth of pollution.'*

Tagline of *Godzilla vs Hedorah*, 1971

❋ Still from *Godzilla vs Hedorah*
(released in USA as *Godzilla
vs the Smog Monster*), 1971

✳ *Equivalent* (A3 of series A1),
gelatin silver print, Alfred Stieglitz,
1926

✳

# 4.  Fire

*'Fire is a natural symbol of life and passion, though it is the one element in which nothing can actually live. Its mobility and flare, its heat and color, make it an irresistible symbol of all that is living, feeling and active.'* *

*
*Fire, F67,* charred paper
on board, Yves Klein, 1962

*
Susanne K. Langer,
*Philosophy in a New Key:
A Study in the Symbolism of
Reason, Rite and Art,* 1942

Destructive and creative in equal measure, fire has terrified and sustained humankind since ancient times. In the 6th century BCE, Greek philosopher, Heraclitus of Ephesus, believed that it was the original element from which all other elements were derived. For him, everything in the universe was constantly changing and taking on other forms. He theorized in *On Nature* that fire changes into water (rain), which changes into earth, and equal amounts of earth and water change back into fire in a continuous cycle. He held that there is a constant flux between opposites, and thought it crucial that a balance must be maintained.

The destructive and creative sides of fire are reflected in mythologies around the world. Kagu-tsuchi was the Shinto god of fire, and is also known as Homusubi, 'he who starts fires'. According to the 8th-century CE *Kojiki* ('Record of Ancient Things') and *Nihon Shoki* ('Chronicle of Japan'), he was born of two Shinto creator gods, and his heat was so powerful that it killed his mother during birth. Horrified, his father beheaded him, and several new gods appeared from his blood. In another version of the story, his father cut him into eight pieces and spread them across the country; Japan's eight major volcanoes appeared where the pieces landed. Fire was a constant danger in a country where the buildings were constructed from wood and paper, and a ceremony known as *Ho-shizume-no-matsuri* was held twice a year in ancient Japan to placate Kagu-tsuchi and keep fire at bay. In Greek mythology, Hephaestus was the god of fire and metalworking, and made weapons for the gods. His Roman equivalent, Vulcan, was more closely associated with the destructive side of fire. Vulcan's followers made supplications to him in the hope of preventing conflagrations.

The theft of fire, often for the benefit of humans, is a common theme in ancient mythologies. The Greek Titan, Prometheus, stole fire from the Olympian forge to give to humans so that they could cook and keep warm. Ogun, the fire god of the Yoruba people of West Africa, was the patron of blacksmiths, iron and weapons, and is credited with sharing his knowledge of fire and metals with humans so that they could make implements for clearing forests and hunting animals. In Māori legend, the mythical hero Māui tricks his way into the underworld and persuades the fire god

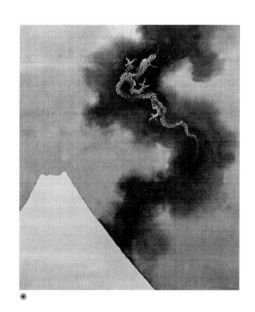

Mauike to show him how to create fire.
The resulting conflagration spreads through
the underworld, reaching the upper world,
where the people begin using the flames
for cooking. Māui then returns to the upper
world and passes on his knowledge of fire-
making to others.

Fire worship is central in some religions.
According to the Rig Veda, ancient Hindu
texts dating from *c.* 2000–1700 BCE, the
earliest mythological period was dominated
by Agni, the fire god, and Varuna, the sky
god. Agni is the personification of sacrificial
fire and carries messages between humans
and the gods through the smoke from
funeral pyres and ritual fires that carries
people's prayers upwards. He is represented
with two faces, several tongues, seven
arms and three legs, and his hair stands
up like tongues of flame. Today, followers
of the Hindu god Brahman honour Agni
by keeping a perpetual fire burning in the
hearth in their homes. Fire lies at the heart
of the Zoroastrian faith of Iran. Believing
that it was given to humans from heaven,
they regard fire as the light of wisdom that
banishes the darkness of ignorance. Priests
keep a sacred fire burning continuously in
Zoroastrian temples by adding sandalwood
to it daily. At home Zoroastrians keep a
fire burning in the hearth for the lifetime
of the head of the household.

Shinto rituals include a purifying fire
known as *kiri-bi*, which was traditionally
made by rubbing together pieces of *hinoki*
(cypress) wood. In the Hindu, Jain and
Buddhist religions, *homa* is a ceremonial
ritual that consists of offering food to fire.
The fire is lit in a square pit or altar (*kunda*),

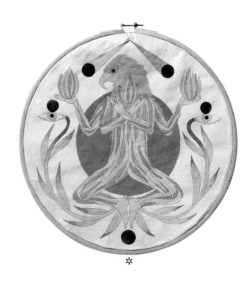

❊

the sides facing the four cardinal directions,
and people place offerings of herbs, seeds
and incense in the fire while repeating sacred
mantras. It is performed to celebrate life
events such as births, deaths and weddings.

The Platonic solid for fire is the tetrahedron.
With four triangular sides, it consists of
sharp points and angles. Its Aristotelian
qualities are hot and dry and its season
summer. According to the ancient Graeco-
Roman physician, Galen, fire corresponded
with the choleric temperament – quick-
witted and short-tempered. It is associated
with the solar plexus chakra, or *manipura*
('city of jewels'), and represents personal
power. For Wiccans, it is the purifying
masculine energy, and it can create or
destroy, heal or harm. In alchemy, fire is a
prime method of conversion, the first stage
in turning base materials into purer ones.
Everything that comes into contact with
it is changed for good or ill.

*'A dungeon horrible, on all sides round*
*As one great furnace flam'd, yet from those flames*
*No light, but rather darkness visible.'*

John Milton, *Paradise Lost*, Book I, 1674

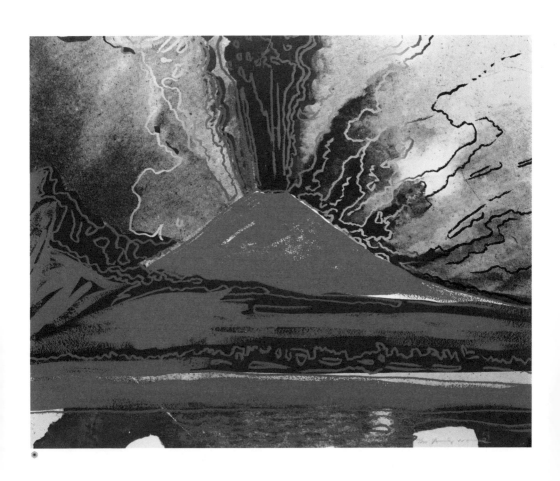

ELEMENTS

✳

✳
*Vesuvius*, Andy Warhol, 1985

✳
*El Fuego*, José Clemente Orozco,
1938

✳

MAJOR FIRE INCIDENTS, known as *edo no hana*, or flowers of Edo, became a regular occurrence in the city of Edo (modern-day Tokyo) between 1603 and 1868. Narrow, densely populated streets, together with predominantly wooden buildings, made fire a constant danger throughout the city. Firefighting in Edo was a communal effort: watchtowers littered the city, fire brigades were formed of local men from each district and shops kept buckets of water in anticipation. Respected but raucous and often heavily tattooed *Hikeshi*, or fire-fighters, often depicted in *ukiyo-e* woodblock prints, dressed in thick cotton gloves and quilted, elaborately decorated jackets soaked in water were tasked with destroying buildings that surrounded active fire, rather than extinguishing the flames.

'Enchû no tsuki' ('Moon and Smoke'),
image 68 from *Tsuki hyakushi*
(*One Hundred Aspects of the Moon*),
Tsukioka Yoshitoshi, 1885–92

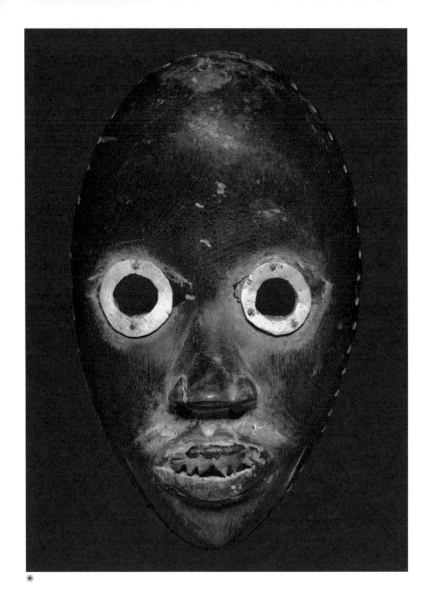

✳

MASKS ARE AN IMPORTANT ART FORM OF THE DAN PEOPLE
who inhabit the Ivory Coast and Liberia in Africa. Known as *gle* or *ge*,
each mask embodies a supernatural spirit force from the dark forest.
The nature and purpose of the supernatural spirit is first revealed
to an initiated member of the Dan in a dream, and the appropriate
mask and costume is created for that man to wear and perform
in a masquerade. There are four categories of sacred Dan masks:
*gore*, or ancestor, masks, *gesua*, or avenger, masks, miniature
masks and *sagbwe* masks used by runners and fire-watchers.

\* Face mask in the Dan style,
likely worn by a fire-watcher,
Côte d'Ivoire or Liberia,
Africa, early 20th century

\* *Al Ahmadi Oil Fields, Kuwait,*
Steve McCurry, 1991

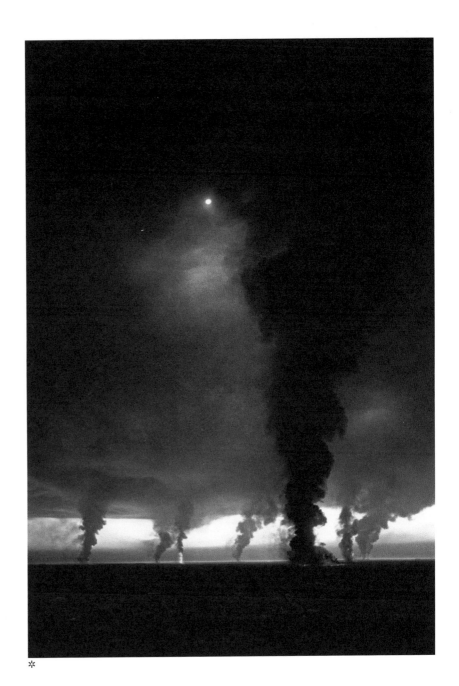

\*

PLATE 1.

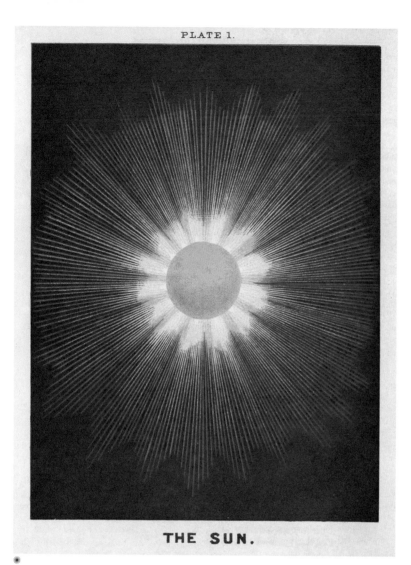

THE SUN.

'The Sun', plate 1 from
*Electro Astronomical Atlas*,
Joseph W. Spoor, 1874

*Dark Fire*, Ithell Colquhoun,
1980

ANCIENT GREEK PHILOSOPHER ANAXAGORAS (*c.* 500–*c.* 428 BCE) was among the first to propose a rational, scientific theory for the nature of the sun, moon and planets. While contemporary mythological beliefs held that the sun was the Greek god Helios, riding in his chariot around the Earth, Anaxagoras posited that it was in fact a material body, formed of 'red-hot stone', emitting light and heat. Further, he proposed scientific explanations for eclipses and theorized that the moon was made of 'earth' and did not itself emit light, but rather reflected the light emitted by the sun. He laid the foundations for scientific analysis of the cosmos, but his reward for challenging the prevailing beliefs of the time was imprisonment under charges of impiety. Although initially sentenced to death, Anaxagoras was eventually exiled from Athens.

✳

*Green Mountain*, Akio Takamori, 2015

✳
Illustration from Persian translation of
Zakariya al-Qazwini's *'Ajā'ib al-Makhlūqāt
va Gharā'ib al-Mawjūdāt* ('The Wonders
of Creation and Oddities of Existence'),
Shūmā, completed 1632

*'Soon these burning miseries will be extinct. I shall ascend my funeral pile triumphantly, and exult in the agony of the torturing flames. The light of that conflagration will fade away; my ashes will be swept into the sea by the winds.'*

Mary Shelley, *Frankenstein, or The Modern Prometheus*, 1818

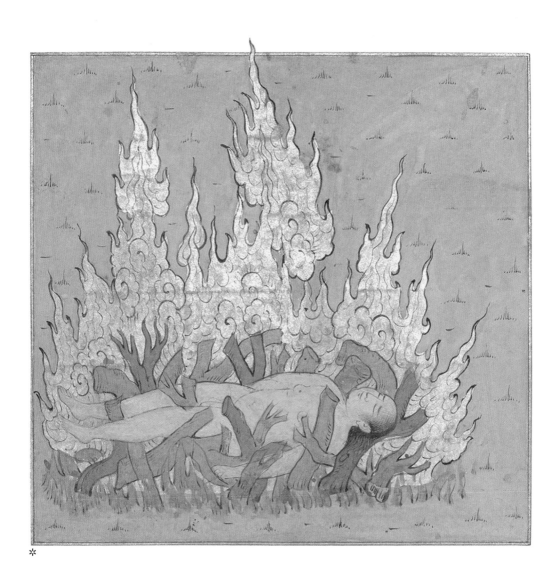

*

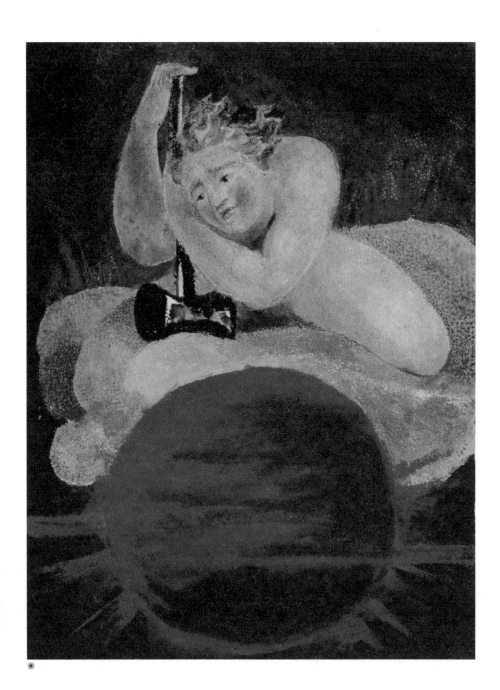

❋

Illustration of Los leaning on
his hammer, from *The Song of Los*,
William Blake, 1795

✱

*Fire Man*, Japan, hand-
coloured albumen silver print,
Kusakabe Kimbei, 1870s–90s

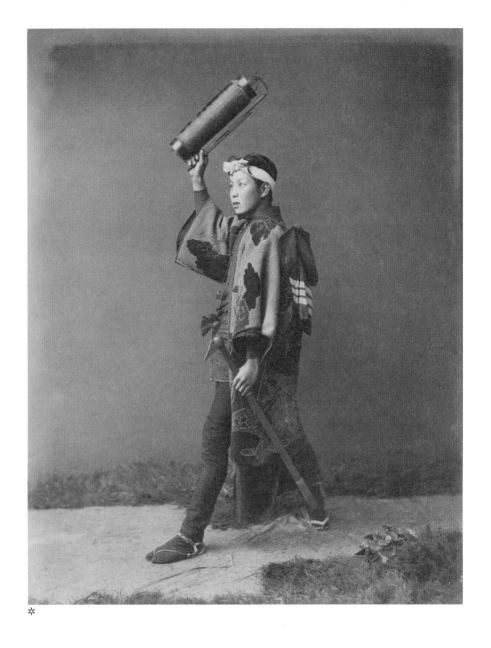

*

'The paynefull smith with force of fervent heat,
The hardest yron soone doth mollify;
That with his heavy sledge he can it beat,
And fashion it to what he it list apply.'

Edmund Spenser, Sonnet XXXI, *Amoretti*, 1595

*Fire*

'Zeus who thunders on high was stung in spirit,
and his dear heart was angered when he saw
amongst men the far-seen ray of fire.'

Hesiod, *Theogony, c.* 730–700 BCE, translated by Hugh G. Evelyn-White

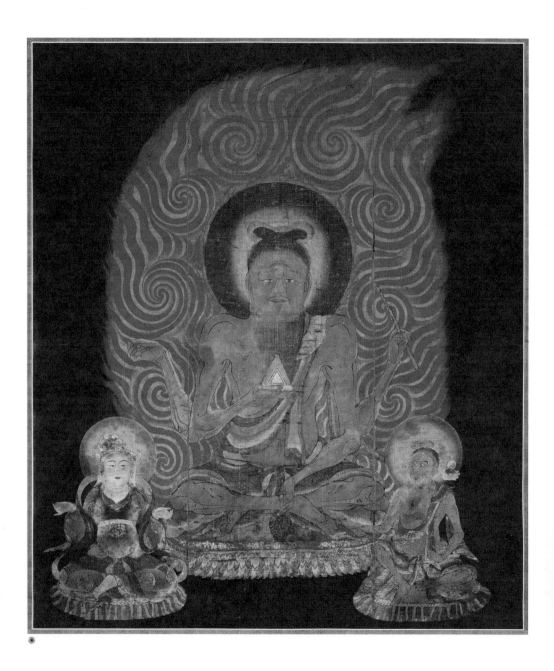

ELEMENTS

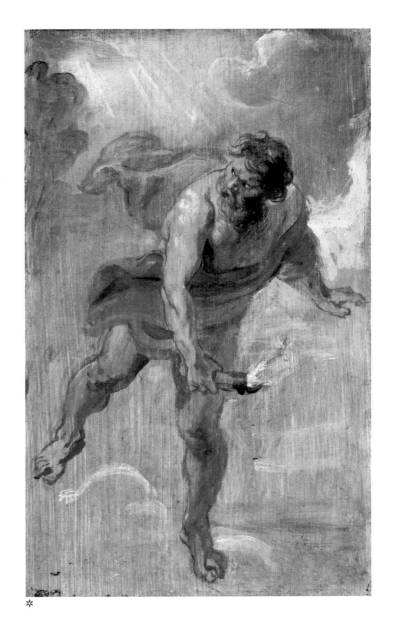

*Katen* (god of fire), one of a set of silk hanging scrolls depicting the twelve Devas, Kyoto, Japan, 1127

✳

*Prometheus*, Peter Paul Rubens, 1636

'A certain Syrian named Eunus ... incited slaves to arms and liberty. ... In order to prove that he was acting under divine inspiration, he secreted in his mouth a nut which he had filled with sulphur and fire, and, by breathing gently, sent forth a flame as he spoke.'

Florus, *Epitome of Roman History*, Book II, chapter vii, *c.* 1st century CE, translated by Edward Seymour Forster

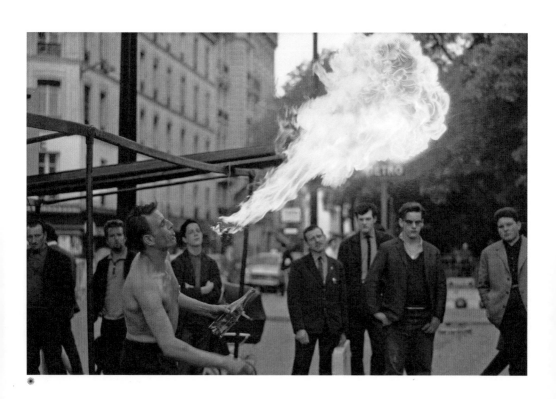

ELEMENTS

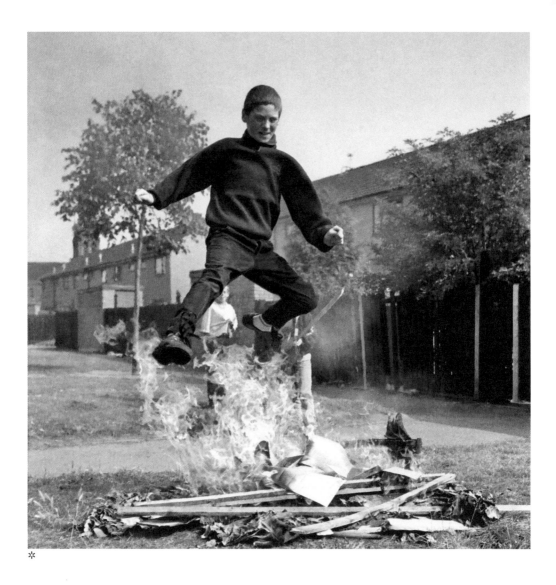

✳

*Paris, France, 1967*, dye transfer print,
Joel Meyerowitz, printed 1983

✳

*Birkenhead*, Nick Wynne, 1989

Illustrations from a firework catalogue,
Japan, *c.* 1880s

Painting of women lighting fireworks during
Diwali, Rajasthan, India, 18th century

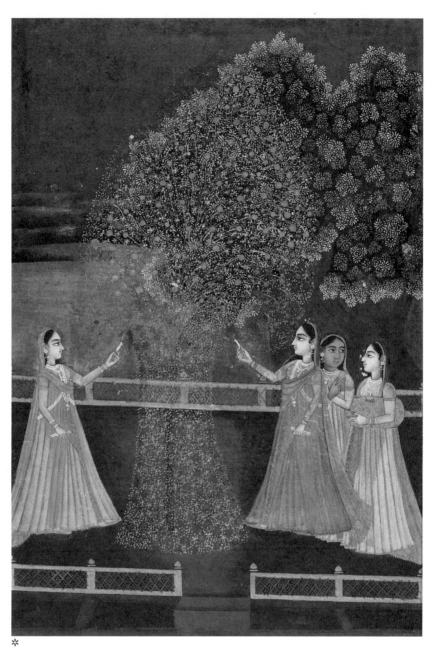

*

'At verandah's edge
two-penny fireworks
in the night'

Kobayashi Issa (1763–1828),
translated by David Lanoue

✳
Photograph of a building on fire,
Kankakee, Illinois, USA, albumen silver
print, Charles Knowlton, 1 May 1887

✳
Photograph of a fire brigade,
Istanbul, Turkey, albumen silver
print, 1850s–1890s

*

'No, no, I must live where there are no fires, no nightly alarms. ... The last man to burn will be he who has nothing to shelter him from the rain but the tiles.'

Juvenal, 'What shall Rome do?', *The Satires*, late 1st–early 2nd century CE, translated by G. G. Ramsay

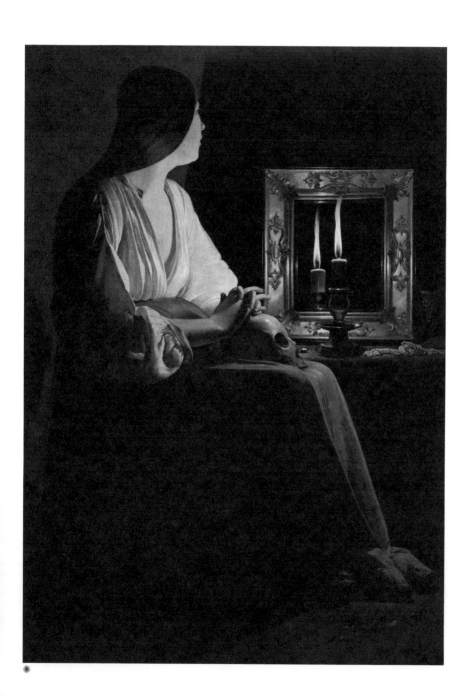

*

'They have been through the fire,
and what fire does not destroy, it hardens.'

Oscar Wilde, *The Picture of Dorian Gray*, 1890

✳

*Self-Portrait*, Ralph Bartholomew, 1940s

✳

'Mr. Tesla and his Marvelous Wireless
Light', published in 'An Interview
with Nikola Tesla, Electrical Wizard',
*Electrical Experimenter*, 1915

✳

*'A single ray of light from a distant star falling upon the eye of a tyrant in bygone times may have altered the course of his life ... may have transformed the surface of the globe, so intricate, so inconceivably complex are the processes in Nature.'*

Nikola Tesla, *Light and Other High Frequency Phenomena*, 1893

\*

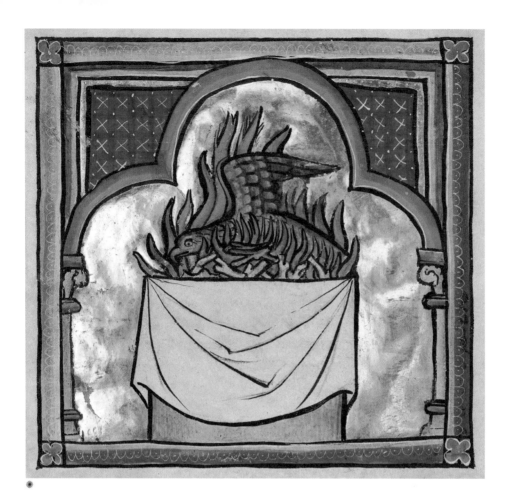

※
Illumination depicting a phoenix,
from the Bestiary of Hugh of
Fouilloy, France, *c.* 1270

✽
*Dark Water, Burning World,*
repurposed bicycle steel mudguards,
extinguished matches and clear resin,
Issam Kourbaj, 2016

'*Smoke veils the air like souls in drifting suspension, declining the war's insistence everyone move on.*'

Jayne Anne Phillips, *Lark and Termite*, 2009

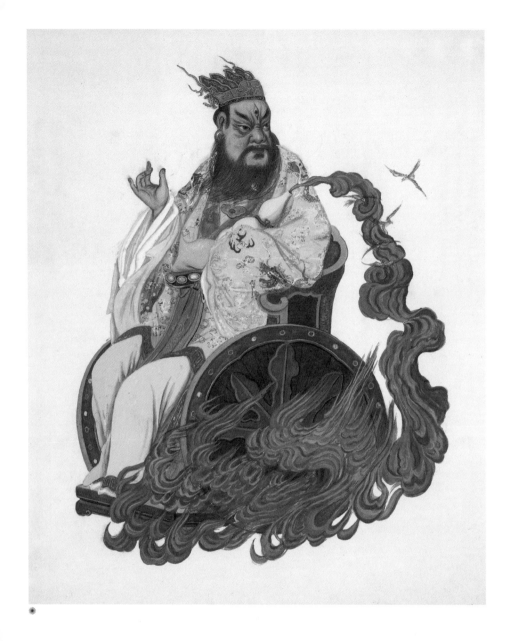

'Glory to him, who, as fire and the moon,
 is one with the cause of the universe;
 to the sun, that is charged with radiant heat.'

*The Vishnu Purana*, Book III, translated by H. H. Wilson

❋

Image depicting the spirit
of Mars, China, c. 1801–50

✳

Illustration of sacrificial
fire, from the 'Tula Ram'
*Bhagavata Purana*, c. 1720

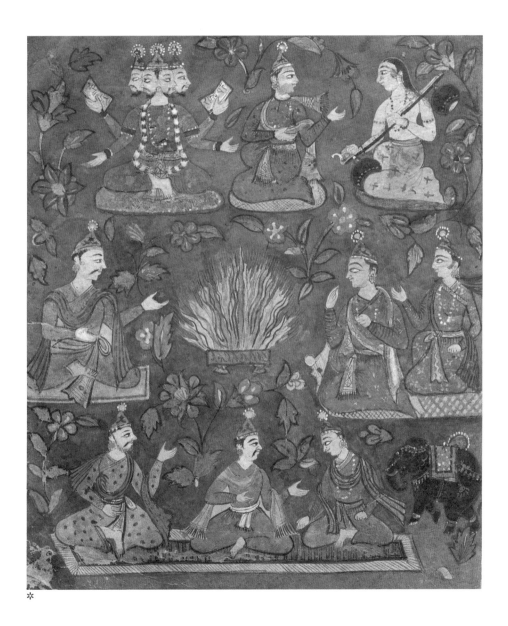

✳

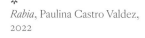

❋
*The Burning of the Houses of Lords
and Commons, 16 October 1834,*
Joseph Mallord William Turner, 1835

✱
*Rabia*, Paulina Castro Valdez,
2022

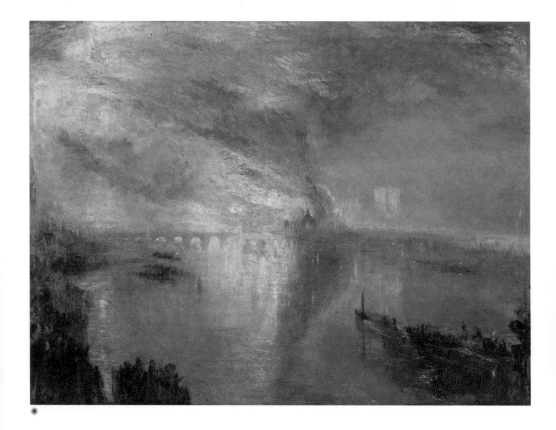

❋

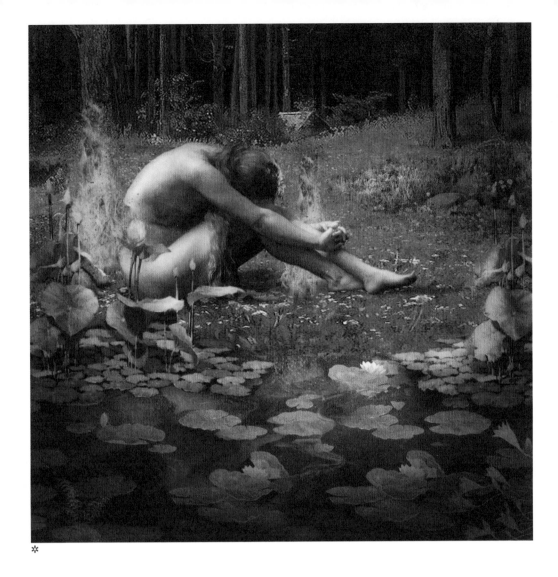

*

"*Ready must thou be to burn thyself in thine own flame; how couldst thou become new if thou have not first become ashes!*'

Friedrich Nietzsche, *Thus Spoke Zarathustra*, 1883, translated by Thomas Common

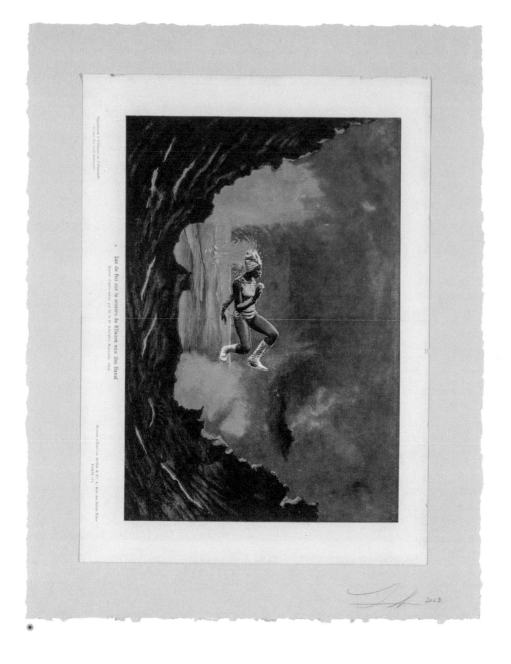

✳ *Volcano*, found photograph and
collage on paper, Lorna Simpson,
2023

✲ *Tod und Feuer* ('Death and Fire'),
oil and paste on burlap, Paul Klee,
1940

'*Dust art thou, and to dust again returnest,*
*A spark of fire within a beating clod.*'

Mary Coleridge, 'Self-question', 1892

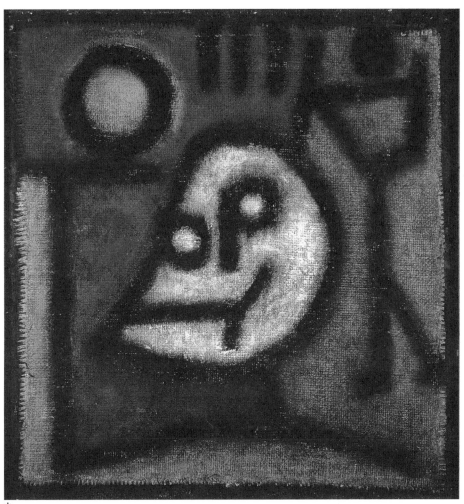

*

'Your strength and master-skill must now be tried.
Arms for a hero forge; arms that require
Your force, your speed, and all your forming fire.'

Virgil, *Aeneid*, Book VIII, 19 BCE, translated by John Dryden

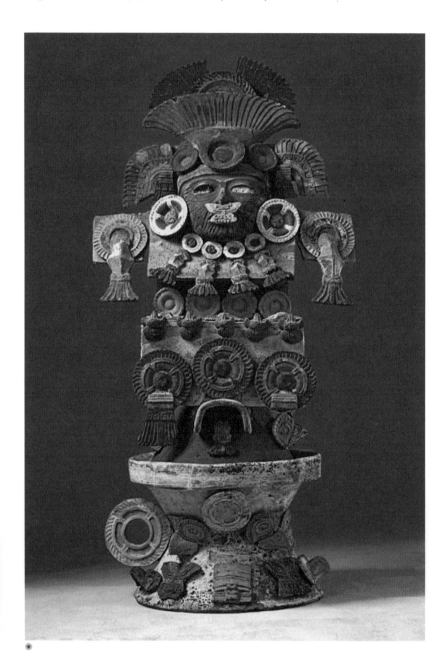

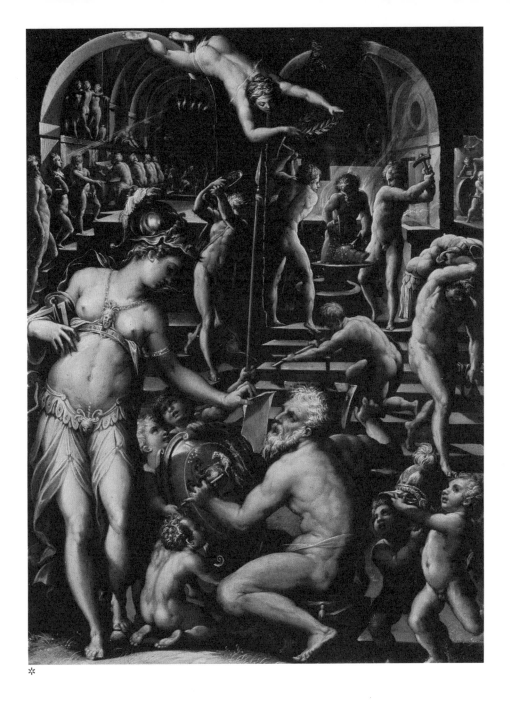

✳

✳
Censer depicting Quetzalpapalotl
(god of fire), Teotihuacan, Mexico,
200–700 CE

✻
*Vulcan's Forge*, Giorgio Vasari,
*c.* 1564

*Fire*

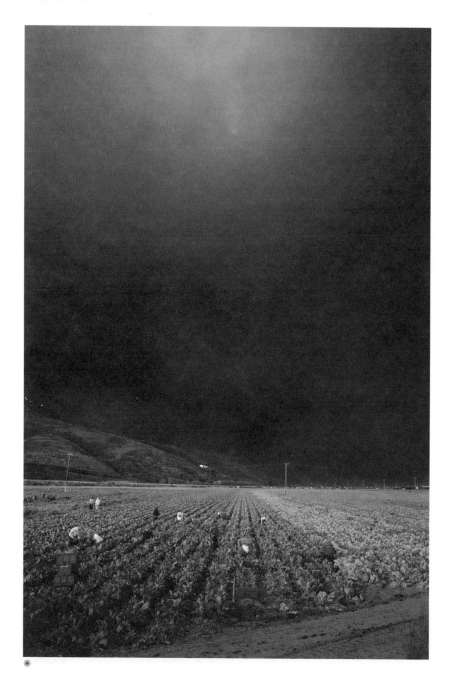

✳

❋
Photograph of farm workers
in Camarillo, California, during
the Woolsey Fire, Andy Holzman,
13 November 2018

✳
*Forest Fire*, Alexis Rockman,
2005

ELEMENTS

PYROPHYTIC PLANTS have evolved with unusual characteristics that enable them to withstand, and even thrive, in places prone to wildfires. Some of these resilient plants exhibit fire-resistant traits, such as thickened bark, exceptionally tall trunks and stems that can grow underground. Others, called pyrophile plants, also depend on fire in their life cycle. For example, the seeds of seritinous trees are protected by a resin that must be melted by high temperatures to be released for germination. Similarly, the seeds of the eucalyptus tree, concealed in bark, require fire for their germination, while highly flammable oils produced by the tree actively fuel the spread of fire.

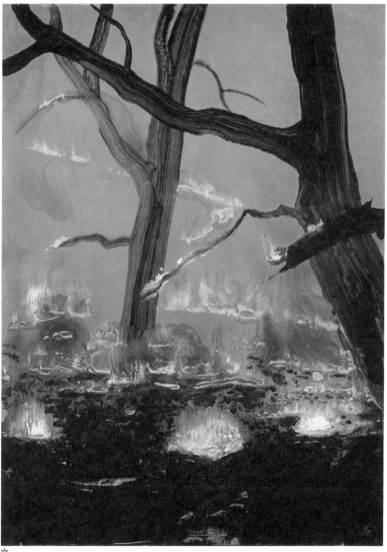

*

# 5.  Aether

'The world is filled with aether.
It permeates the interstices of atoms.
Aether is everywhere. How dense
is the aether? Is it fluid like water
or rigid like steel? How fast is
our earth moving through it?' *

＊
*Le chant du Tambour*,
Solange Knopf, 2015

❋
Sir Arthur Eddington,
*New Pathways in Science*, 1935

According to Aristotle, aether was an element from which the stars and other heavenly bodies were made. Hindus know it as *akasha*, or spirit, the essence of all things in the material world. For them it was the first element, followed by air, fire, water and earth. To the Japanese, it is known as the void or sky. To medieval alchemists, it was the *quinta essentia*, the luminous fifth element that bound the other four together. The word 'quintessence' is derived from it, meaning the purest essence of something. In Wicca, it is the bridge between the physical and spiritual realms, while in the microcosm, it is the bridge between the body and the soul. The Platonic solid associated with aether is the dodecahedron, its twelve sides representing the twelve constellations. It is related to the throat chakra, *vishuddha*, meaning to purify.

In ancient Greek mythology, Aether was a primordial deity, god of light and the sky. According to Hesiod, the 8th-century BCE author of *Theogony*, he was the son of Nyx, goddess of the night, and Erebus, god of darkness. Hemera, goddess of the day, was his sister. Being a primordial deity, he was not a personification of aether, but was believed to be the pure upper air of the heavens that was breathed by the gods. In the evening Nyx would draw a veil of dark mist across the sky, concealing Aether's presence, and in the morning Hemera would clear the mists away again.

The early Greek philosophers proposed several theories to account for the appearance of the heavens. Heraclitus (*c*. 500 BCE) described the heavenly bodies as fire-filled bowls that faced Earth. The sun burned the brightest and the moon slowly revolved, resulting in the lunar phases. In the 6th century BCE, Pythagoras accepted the four elements recognized by Empedocles and added a fifth, a very pure form of fire that had a circular orbit and 'flew' upwards to form the heavens. Anaxagoras (*c*. 500–*c*. 428 BCE) thought that the heavenly bodies were fiery stones, too far away for their heat to be felt on Earth.

Aristotle divided the universe into a terrestrial region below the moon and a celestial region above it filled with aether. He argued that aether is eternal and divine.

✳

It varies in purity, however, becoming less pure the closer it is to the sublunary realm and the four terrestrial elements. Aristotle accounted for the movement of the stars by arguing that the planets and stars are fixed to individual spheres, and that these spheres rotate, carrying the planets and stars with them. He also proposed that the stars appeared to twinkle at night due to human eyesight being poor at seeing objects from such a long distance away.

In the 17th century, the French philosopher René Descartes (1596–1650) used the word 'aether' to describe space. He thought that whirling currents in space brought together the particles that form matter and sculpted solid objects. Later, the term was used to refer to ideas about a substance that kept the stars and planets in place. In his researches into gravity, the English physicist Isaac Newton (1642–1727) proposed that a strong, elastic medium filled space, and wondered if it were a living force.

Both Plato and Aristotle had a sense of the existence of immaterial intelligent beings beyond the human realm. Aristotle believed that 'Intelligences' moved the planets in their orbits, and that beyond the outermost sphere of fixed stars was a realm unfathomable to humans. The Neoplatonists, looking for a link in the chain of being between God and humans, proposed the existence of messengers, or angels, who acted as mediators between the two.

The Italian theologian St Thomas Aquinas (*c.* 1225–1274) wrote extensively on angels in his *Summa contra gentiles*. He believed that they are pure spirit and divided them into three groups of three orders: seraphim, cherubim and thrones were the closest to

✳

God; then came dominations, virtues and powers; principalities, archangels and angels were the lowest orders and acted as messengers and protectors of humans.

Attempts to fathom the mysterious element continued into the modern era. In the wake of alienation caused by mass urbanization and migration in the later 19th century, combined with the massive loss of life caused by the American Civil War and the First World War, belief in spiritualism and theosophy became widespread. People were eager to believe that the spirit of a person lives on after death, and that the living can communicate with them. Combining ideas from esoteric philosophy, Buddhism and Hinduism, theosophy was founded on the idea that a spirit world underlies the terrestrial world, and that spirit guides can travel between the two. Most spirit guides have lived a series of past lives, while others exist as pure energy in the cosmic realm.

*Dance of the Moth*, Paul Klee, 1923      *Les Poissons noctambules*, Max Ernst, 1972

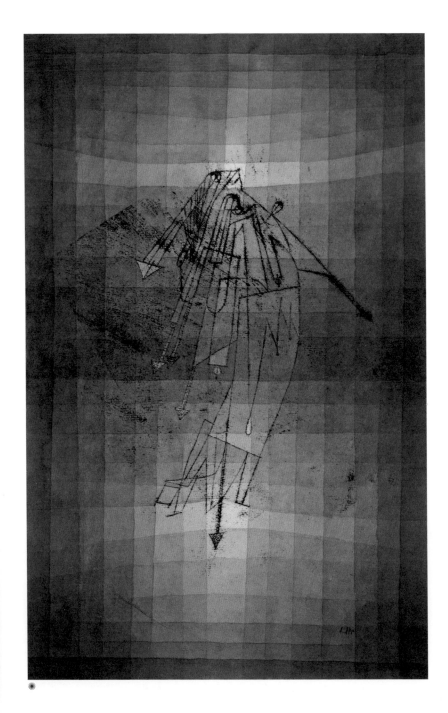

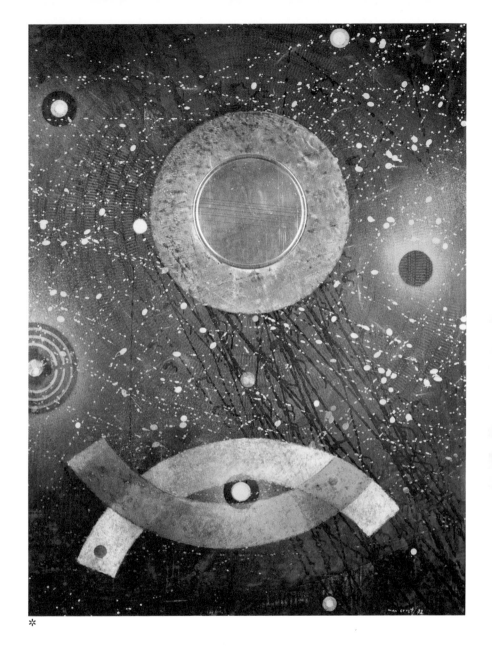

*

'We all dwell in a house of one room –
the world with the firmament for its roof.'

John Muir, journal entry, 18 July 1890

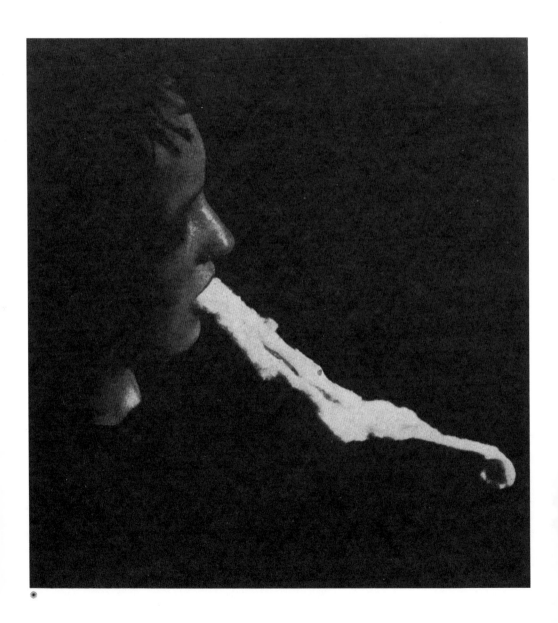

✳

✳
Photograph of Stanislawa P.
with ectoplasm during séance
of 25 January 1913, photograph
by Albert von Schrenk-Notzing

✳
*Rayograph*, gelatin silver print,
Man Ray, 1922

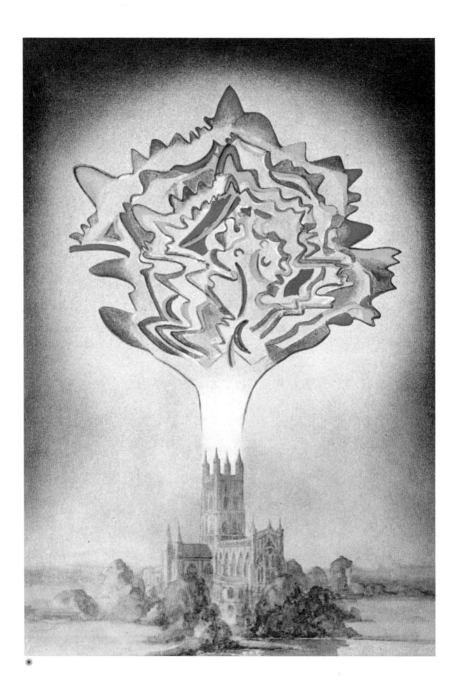

☀

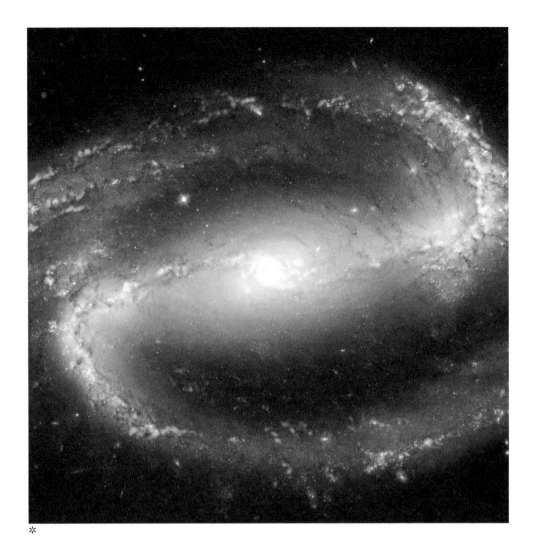

\*

ACCORDING TO THEOSOPHICAL BELIEF, THOUGHT FORMS are energetic manifestations of human thoughts that are emitted from the body in the astral plane and visible only to those with the gift of clairvoyance. Two leading figures in the Theosophical movement, after the death in 1891 of its founder Helena Blavatsky, were Annie Besant and Charles Webster Leadbeater. They co-wrote several books on theosophical belief, including *Thought Forms: A Record of Clairvoyant Investigation*, first published in 1905. According to Besant and Leadbeater, the colour, shape and outlines of the manifestations of human thoughts vary according to the quality of the thoughts and have a direct impact on human emotions, health and relationships, underlining our interconnectedness with one another, the spiritual world and the universe.

* Digital X-ray image
of wooden sculpture
of Archangel Michael
(1511–50), Finland

* Disc of music cut
onto X-ray film,
Hungary, 1930s

*

IN SOVIET RUSSIA during the Cold War period (1947–91), Western music, along with all music considered subversive, was banned by the state. In response, underground communities emerged determined to make the banned music available to Russian civilians. Using improvised equipment, they pressed bootlegged recordings into old X-ray film stolen from hospitals to create flexi disks that could be played on regular gramophones. Because of the X-rays visible on the film, the recordings were dubbed 'bone' music. The illicit music distributed in this manner included Western jazz and rock 'n' roll, together with music by Russian émigrés, gypsy romance songs and songs romanticizing the criminal subculture.

'Everything that has form, everything that is the result of combination, is evolved out of this Akasha. ... It is the Akasha that becomes the sun, the earth, the moon, the stars, the comets.'

Swami Vivekananda, *Raja-Yoga*, 1896

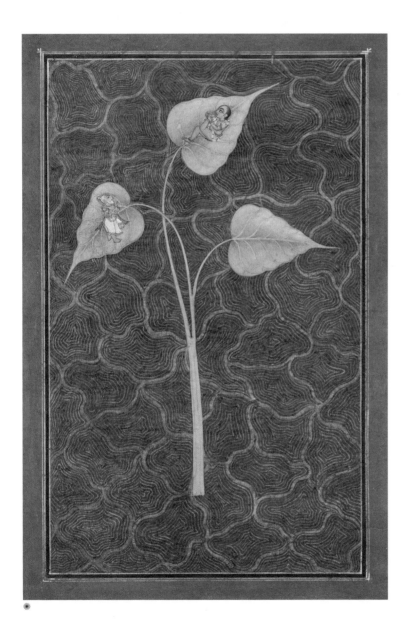

＊

Image of Markandeya viewing Krishna in the cosmic ocean, Basholi, Jammu and Kashmir, India, *c.* 1680

✳

*Tjatjati*, Miriam Baadjo, 2020

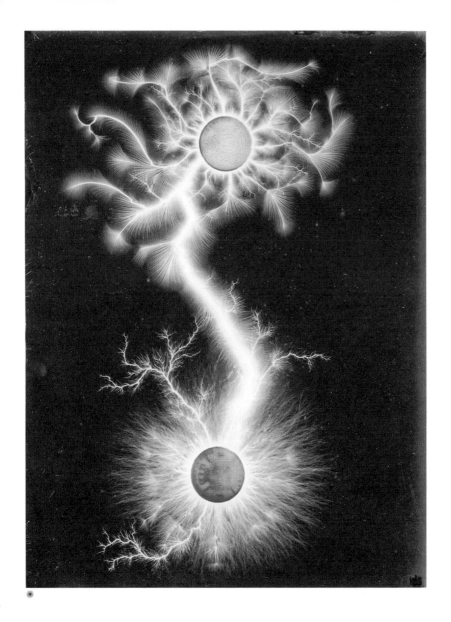

'The spirit-world around this world of sense
Floats like an atmosphere, and everywhere
Wafts through these earthly mists and vapours dense
A vital breath of more ethereal air.'

Henry Wadsworth Longfellow, 'Haunted Houses', 1858

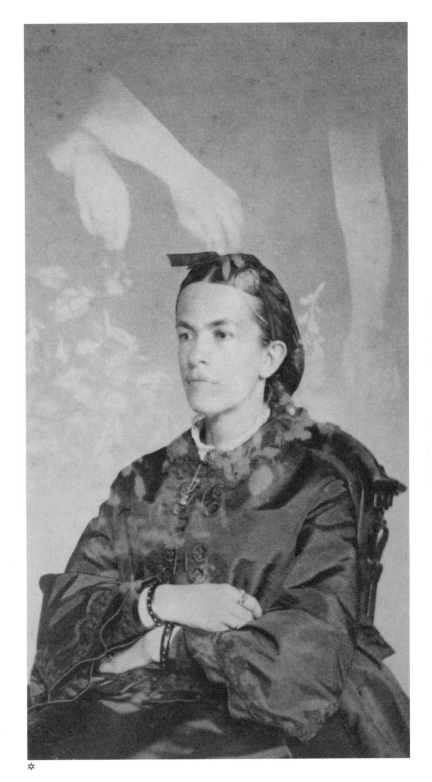

*
Photograph of electric
discharges from two
coins, obtained with
a Ruhmkorff coil or
Wimshurst machine,
also known as a
'Trouvelot figure',
Étienne Léopold
Trouvelot, *c.* 1888

✳
Photograph of an
unidentified woman
with the arms of a spirit
over her head, William
H. Mumler, 1869–78

✳

*'And all my days are trances,*
*And all my nightly dreams*
*Are where thy grey eye glances,*
*And where thy footstep gleams –*
*In what ethereal dances,*
*By what eternal streams.'*

Edgar Allan Poe, 'To One in Paradise', 1843

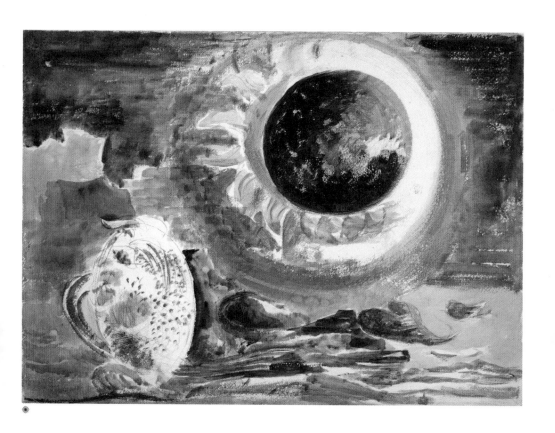

＊

The Eclipse of the Sunflower, Paul Nash, 1945

✳

Talismanic shirt with painted decoration
including the entire Qur'an written
inside, Northern India or Deccan, India,
15th–early 16th century

*

'*Possidonius defineth a Star, a divine body,
consisting of aethericall fire, splendid and fiery,
never resting, but alwaies moving circularly.*'

Thomas Stanley, *The History of Philosophy*, 1656

✳
'The Sun, constituted by spirals of
metallic and other vapours and forming
the guiding centre of the great vortex
of aether', from *Sur les tourbillons,
trombes, tempêtes et sphères tournantes*
('On Whirlwinds, Waterspouts, Storms
and Turning Spheres'), Charles-Louis
Weyher, 1889

✳

*Lightning Fields Composed 004*,
Hiroshi Sugimoto, 2008

'There is no space without aether, and no aether which does not occupy space.'

Sir Arthur Eddington, *New Pathways in Science*, 1935

KIRLIAN PHOTOGRAPHY was discovered in 1939 by Soviet inventor and researcher Semyon Kirlian (1898–1978) and his wife, teacher and journalist, Valentina Kirlian (1904–1971). They noticed a glow appear between a patient's skin and the electrodes attached to an electro-therapy device. They discovered that by placing photographic film on top of a metal plate and then placing an object, such as a leaf, on top of the film and running a high voltage current through it for a very short period, a photograph could be made of the glow, or aura, that appeared around the edges. The Kirlians discovered that a leaf photographed in this way at fixed intervals gradually exhibited less of a pronounced aura as it withered, and posited that Kirlian photography could provide an indication of a person's health. In fact, the aura was created by a coronal discharge, an electrical discharge caused by ionization of fluid in the air surrounding an object that is electrically charged. The diminishing water content in the leaf meant that the coronal discharge was reduced at each interval.

ELEMENTS

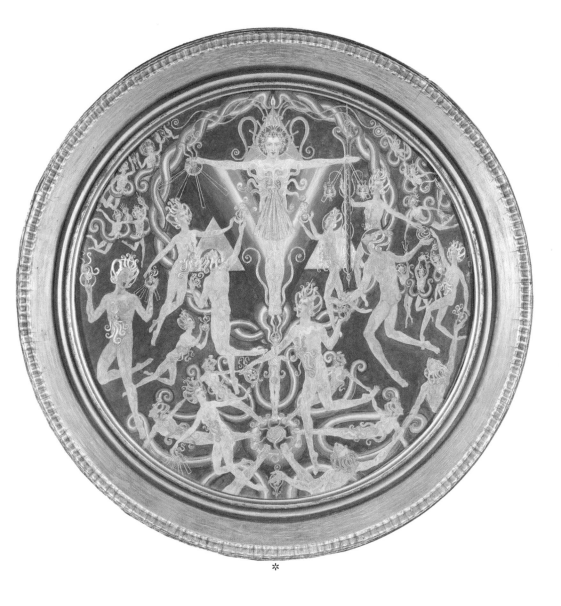

✳

✴
Kirlian photograph,
Wojciech Domagała, 2016

✲
*A Goodly Company*,
Ethel Le Rossignol, 1933

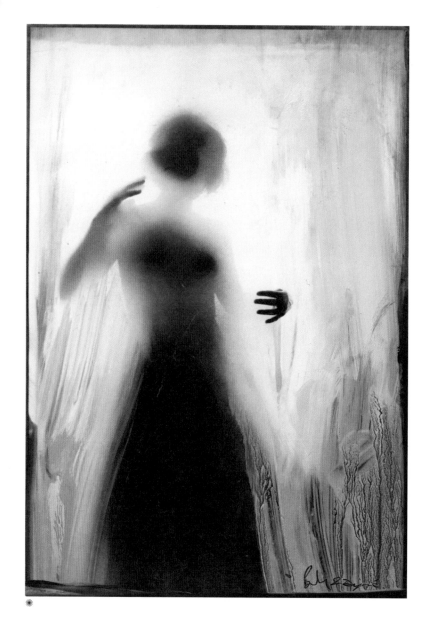

✳

"Divine light penetrates through our universe ...
Oh Trinal Light, which in a single star, scintillating
on their sight, dost so satisfy them, look down here
upon our tempest!'

Dante Alighieri, 'Paradiso' ('Paradise'), *Commedia* (*The Divine Comedy*),
completed 1321, translated by Charles Eliot Norton

*

*Rayon*, Bensley and Dipré, 2021

*

Illustration from Dante Alighieri's
'Paradiso' ('Paradise'), *Commedia*
(*The Divine Comedy*), Canto XXXI,
verses 1–3, Gustave Doré, 1861

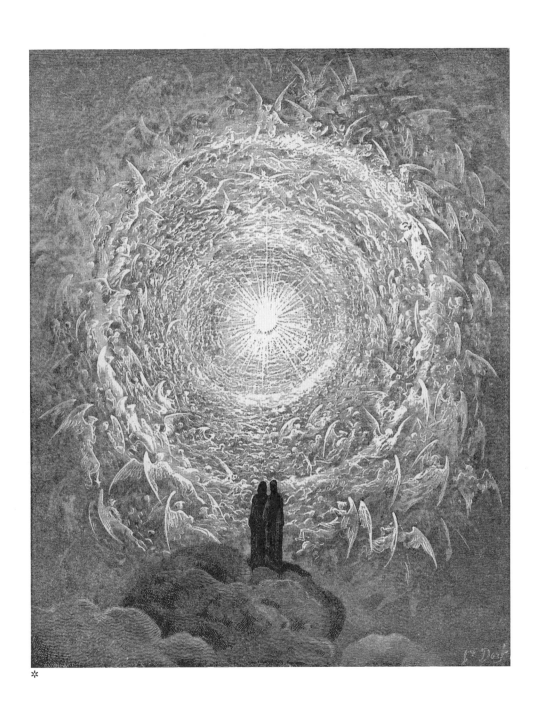

*

THE HUBBLE TELESCOPE was launched into space in 1990, more than forty years after its conception. Pioneered by astrophysicist Lyman Spitzer (1914–1997), the telescope is powered by solar panels and orbits the Earth above its atmosphere, photographing the universe and transmitting the images back to Earth. Spitzer was among the first to propose a space-based telescope in order to overcome the limitations of ground-based telescopes. The Earth's atmosphere absorbs ultra-violet and infrared light, preventing it from reaching telescopes on the ground, and also causes a 'twinkling' effect that makes the view less clear. The Hubble telescope is able to capture celestial images with a clarity unafforded to ground-based telescopes and has drastically advanced our understanding of the formation of the cosmos. Launched in 2021, the new James Webb Space Telescope is so sensitive that we can now view objects that are too old, faint and far away to be observed by the Hubble telescope.

ELEMENTS

*

*Dark Heart*, Conrad Shawcross, 2007

✳

Image of the globular cluster of stars
designated NGC 6652 in the Sagittarius
constellation of the Milky Way, observed
from the NASA/ESA Hubble Space
Telescope, released 2023

*

'Whate'er exists hath properties that spread
Beyond itself, communicating good,
A simple blessing, or with evil mixed;
Spirit that knows no insulated spot,
No chasm, no solitude; from link to link
It circulates, the Soul of all the worlds.'

William Wordsworth, *The Excursion*, Book IX, 1814

❋
Tantra painting, natural pigments
on vintage paper, *c.* 1980–2014

✳
*Group VI, Evolution, No. 9,*
Hilma af Klint, 1908

'We know that the universe is made up of 95% dark matter but the strange thing is nobody gets excited about this. I think our world has become blurred, stupid, dulled, unless somewhere out there there's a Hilma af Klint painting it all so in a hundred years we will see what we've missed.'

Ernst Peter Fischer, 2020

✽

'The bright sun was extinguish'd, and the stars
Did wander darkling in the eternal space.'

Lord Byron, 'Darkness', 1816

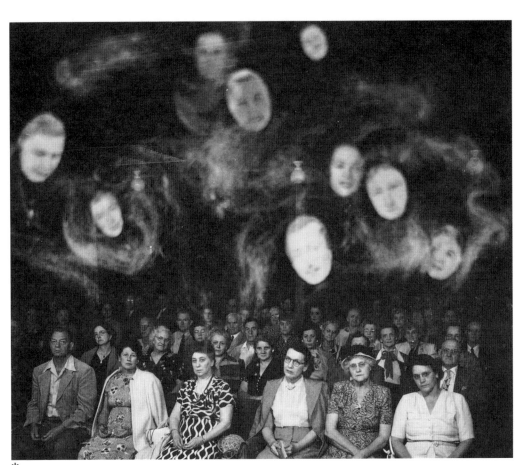

*

SPIRIT PHOTOGRAPHY became prevalent in the mid- to late 19th century with the rise of the spiritualist movement and the use of the glass plate negative. Photographer William Mumler (1832–1884) was credited with creating the first spirit photograph when, in 1862, he presented a photograph of himself standing alongside the ghost of his deceased cousin. Distraught relatives of soldiers killed in the American Civil War immediately began approaching him for similar photographs. In 1872, Mumler produced a photograph of Mary Todd Lincoln, purporting to show the ghost of her dead husband, Abraham Lincoln, standing behind her. This was eventually recognized as a hoax created using double exposure.

*Untitled*, Shane Drinkwater, 2023

✲
Roundel with endless knot motif,
silk embroidery on silk satin,
China, 1850–1900

'What now, dear reader, shall we make out of our telescope? Shall we make a Mercury's magic-wand to cross the liquid ether with, and, like Lucian, lead a colony to the uninhabited evening star, allured by the sweetness of the place?'

Johannes Kepler, *Dioptrics*, 1611

\*

'For the warp and woof of flowers
are worked by perpetual moving spirits.
For flowers are good both
for the living and the dead.
For there is a language of flowers.'

Christopher Smart, 'Jubilate Agno', Fragment B, part iii, written 1758–63

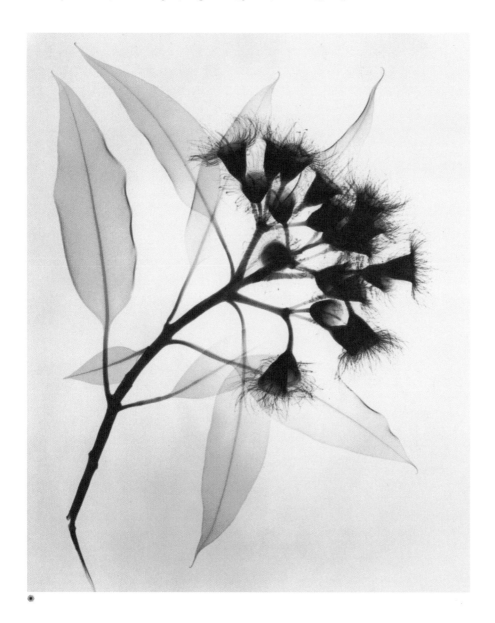

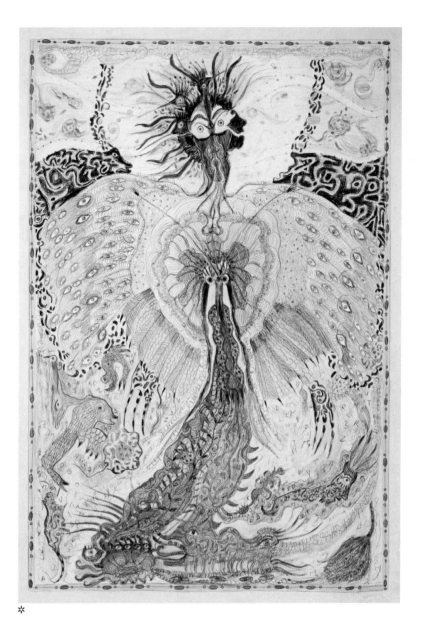

✳

✴ *Eucalyptus*, gelatin silver print,
Dr Dain L. Tasker, 1932

✳ *Femme papillon*, Solange Knopf,
2014

'The aether is the solitary tenant of the universe,
save for that infinitesimal fraction of space
which is occupied by ordinary matter.'

E. T. Whittaker, *A History of the Theories of Aether and Electricity*, 1910

✳

❋
*The Flower of Catherine Emily Stringer*,
Georgiana Houghton, 7 April 1866

✳
Painting of Chakrasamvara and
his consort Vajravarahi, 1450–1500

> *'My hand has been entirely guided by Spirits –
> no idea being formed in my own mind as to
> what was going to be produced.'*

Georgiana Houghton, statement introducing 'Spirit Drawings
in Watercolours' at the New British Gallery, London, 1871

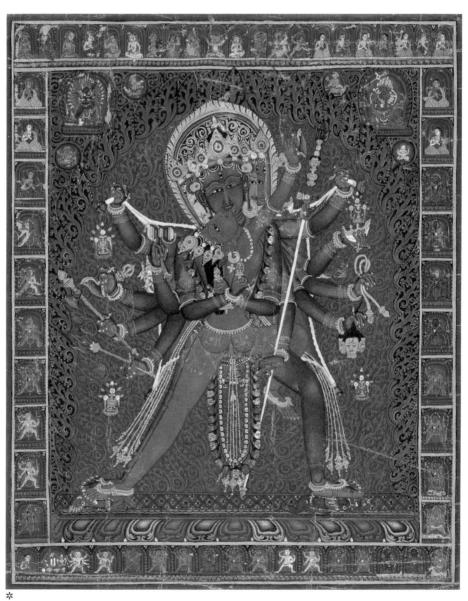

*

ELEMENTS

✷
Artist's concept of a planet (dark silhouette) passing
in front of the red dwarf star AU Microscopii, based on
measurements made by the NASA/ESA Hubble space
telescope, Joseph Olmsted (STScI), released 2023

# Bibliography

Adamson, Peter, *A History of Philosophy Without Any Gaps*, 6 vols (Oxford: Oxford University Press, 2016–22)

Agrippa, Heinrich Cornelius, *Three Books of Occult Philosophy*, trans. Eric Purdue (Rochester, VT: Inner Traditions, 2021)

Aldersey-Williams, Hugh, *Periodic Tales: The Curious Lives of the Elements* (London: Penguin Books, 2011)

Alighieri, Dante, *The Divine Comedy*, ed. David H. Higgins, trans. C. H. Sisson (Oxford: Oxford University Press, 2008)

Al-Khalili, Jim, *Pathfinders: The Golden Age of Arabic Science* (London: Penguin Books, 2010)

Annas, Julia, *Ancient Philosophy: A Very Short Introduction*, rev. edn (Oxford: Oxford University Press, 2023)

Apollodorus, *The Library of Greek Mythology*, trans. Robin Hard (Oxford: Oxford University Press, 2008)

Aquinas, Thomas, *Selected Writings* (London: Penguin Books, 1998)

Archive for Research in Archetypal Symbolism (author), *The Book of Symbols: Reflections on Archetypal Images* (Cologne: Taschen, 2022)

Aristotle, *The Metaphysics* (London: Penguin Books, 1998)

Ball, Philip, *The Elements: A Very Short Introduction* (Oxford: Oxford University Press, 2004)

Ball, Philip, *The Elements: A Visual History of Their Discovery* (London: Thames & Hudson, 2021)

Barnes, Jonathan, *Aristotle: A Very Short Introduction* (Oxford: Oxford University Press, 2000)

Barrow, John D., *The Book of Nothing: Vacuums, Voids, and the Latest Ideas about the Origins of the Universe* (New York: Pantheon Books, 2001)

Battistini, Matilde, *Astrology, Magic, and Alchemy in Art* (Los Angeles, CA: Getty Publications, 2008)

Battistini, Matilde, *Symbols and Allegories in Art* (Los Angeles, CA: Getty Publications, 2006)

Berlekamp, Persis, *Wonder, Image, and Cosmos in Medieval Islam* (New Haven, CT: Yale University Press, 2011)

Blake, William, *Blake: The Complete Poems*, ed. W. H. Stevenson (Harlow: Longman, 2007)

Bohm, David, *Wholeness and the Implicate Order* (Abingdon: Routledge, 1983)

Boyle, Robert, *The Sceptical Chymist* (London: Printed by J. Cadwell for J. Crooke, 1661)

Brier, Bob, *Ancient Egyptian Magic* (New York: Quill, 1980)

Browne, Sir Thomas, *The Major Works*, ed. C. A. Patrides (London: Penguin Books, 1977)

Bunnin, Nicholas and Jiyuan Yu, *The Blackwell Dictionary of Western Philosophy* (Oxford: Blackwell Publishing Ltd, 2008)

Bynum, William, *The History of Medicine: A Very Short Introduction* (Oxford: Oxford University Press, 2008)

Bynum, William, Janet Browne and Roy Porter, *Dictionary of The History of Science* (Princeton, NJ: Princeton University Press, 1981)

Calasso, Roberto, *The Marriage of Cadmus and Harmony* (London: Jonathan Cape, 1993)

Campbell, Joseph, *The Masks of God*, 4 vols (New York: Viking Press, 1959–68)

Carson, Rachel, *The Sea Around Us* (Oxford: Oxford University Press, 1951)

Carson, Rachel, *Silent Spring* (New York: Houghton Mifflin, 1962)

Cicero, *The Nature of the Gods*, trans. P. G. Walsh (Oxford: Oxford University Press, 2008)

Clulee, Nicholas H., *John Dee's Natural Philosophy: Between Science and Religion* (Abingdon: Routledge, 2014)

Cooper, J. C., *An Illustrated Encyclopaedia of Traditional Symbols* (London: Thames & Hudson, 1979)

Copleston, F., *Aquinas: An Introduction to the Life and Work of the Great Medieval Thinker* (London: Penguin Books, 1991)

Cornford, Francis M., *Plato's Cosmology: The Timaeus of Plato Translated with a Running Commentary* (Mansfield, CT: Martino Publishing, 2014)

Dalai Lama (introd.), *Science and Philosophy in the Indian Buddhist Classics*, ed. Jinpa Thupten, Richard Dechen, David Lopez et al., 4 vols (Somerville, MA: Wisdom Publications, 2017–23)

Dickinson, Emily, *The Complete Poems* (London: Faber and Faber Ltd, 2016)

Dijksterhuis, Eduard Jan, *The Mechanization of the World Picture* (Princeton, NJ: Princeton University Press, 1969)

Dijksterhuis, Eduard Jan and Robert James Forbes, *A History of Science and Technology*, 2 vols (London: Penguin Books, 1963)

Donne, John, *The Major Works*, ed. John Carey (Oxford: Oxford University Press, 2008)

Edward, Paul (ed.), *The Encyclopedia of Philosophy*, 8 vols (New York: Macmillan and The Free Press, 1967)

Eliot, T. S., *Four Quartets* (London: Faber and Faber Ltd, 1941)

Eliot, T. S., *The Waste Land and Other Poems* (London: Faber and Faber Ltd, 1940)

Emilsson, Eyjólfur K., *Plotinus* (Abingdon: Routledge, 2017)

Feynman, Richard P., *The Character of Physical Law*, introd. Paul Davies (London: Penguin Books, 1992)

Feynman, Richard P., Matthew Sands and Robert B. Leighton, *Six Easy Pieces: Essentials of Physics Explained by Its Most Brilliant Teacher* (New York: Basic Books, 1994)

Fortey, Richard, *The Earth: An Intimate History* (London: HarperCollins, 2004)

Franz, Marie-Louise von, *Alchemy: An Introduction to the Symbolism and the Psychology* (Toronto: Inner City Books, 1984)

Frazer, Sir James George, *The Golden Bough: A Study in Magic and Religion*, 12 vols, 3rd edn (London: Macmillan, 1906–15)

Frazer, Sir James George, *Myths of the Origin of Fire* (London: Macmillan, 1930)

Galen (Claudius Galenus), *On the Natural Faculties*, trans. Arthur John Brock (Scotts Valley, CA: CreateSpace, 2016)

*Gilgamesh*, ed. and trans. Sophus Helle (New Haven, CT: Yale University Press, 2022)

Grant, Edward, *Physical Science in the Middle Ages* (New York: Wiley, 1971)

Graves, Robert, *The Greek Myths*, 2 vols (London: Penguin Books, 1955)

Graves, Robert, Felix Guirand et al., *The New Larousse Encyclopaedia of Mythology* (London: Hamlyn, 1963)

Gray, Douglas (ed.), *The Oxford Book of Late Medieval Verse and Prose* (Oxford: Oxford University Press, 1985)

Hall, James, *Hall's Dictionary of Subjects and Symbols in Art* (London: John Murray, 1974)

Hall, Manly P., *The Secret Teachings of All Ages: An Encyclopedic Outline of Masonic, Hermetic, Qabbalistic and Rosicrucian Symbolical Philosophy* (Mineola, NY: Dover Publications, 2011)

Hazen, Robert M., *The Story of Earth: The First 4.5 Billion Years, from Stardust to Living Planet* (New York: Viking Press, 2012)

Heraclitus, *Fragments*, trans. Haxton Brooks (London: Penguin Books, 2003)

Herodotus, *The Histories*, trans. Aubrey De Selincourt (London: Penguin Books, 2003)

Hesiod, *Theogony and Works and Days*, trans. M. L. West (Oxford: Oxford University Press, 2008)

Hippocrates, *Hippocratic Writings*, ed. G. Lloyd, trans. J. Chadwick et al. (London: Penguin Books, 1983)

Homer, *The Odyssey*, trans. Robert Fagles, introd. Bernard Knox (London: Penguin Books, 2006)

Hornblower, Simon, Anthony Spawforth and Esther Eidinow (eds), *The Oxford Companion to Classical Civilization*, 2nd edn (Oxford: Oxford University Press, 2014)

Jung, Carl G., *The Red Book: Liber Novus*, ed. and introd. Sonu Shamdasani (New York: W. W. Norton & Company, 2009)

Jung, Carl G., Marie-Louise von Franz, Joseph L. Henderson et al., *Man and His Symbols* (New York: Doubleday, 1969)

Kaku, Michio, *The God Equation: The Quest for a Theory of Everything* (London: Allen Lane, 2021)

Kaptchuk, Ted J., *The Web That Has No Weaver: Understanding Chinese Medicine* (New York: Congdon & Weed, 1983)

Kirk, G. S., J. E. Raven and M. Schofield, *The Presocratic Philosophers* (Cambridge: Cambridge University Press, 1983)

Lao Tzu, *Tao Te Ching*, trans. Darrell D. Lau (London: Penguin Books, 1974)

Lemprière, John, *Lemprière's Classical Dictionary* (London: Henry G. Bohn, 1853)

Leonardo da Vinci, *Notebooks* (Oxford: Oxford University Press, 2008)

Lévi, Éliphas, *The History of Magic* (1859), trans. A. E. Waite, 2nd edn (London: William Rider & Son Ltd., 1922)

Linden, Stanton J., *The Alchemy Reader: from Hermes Trismegistus to Isaac Newton* (Cambridge: Cambridge University Press, 2003)

Liu Lihong, *Classical Chinese Medicine*, ed. Heiner Fruehauf, trans. Gabriel Weiss, Henry Buchtel with Sabine Wilms (Hong Kong: The Chinese University Press, 2021)

Lloyd, G. E. R., *Aristotle: The Growth and Structure of his Thought* (Cambridge: Cambridge University Press, 1968)

Lovelock, James, *Gaia: A New Look at Life on Earth* (Oxford: Oxford University Press, 1979)

Lucretius, *The Nature of Things*, introd. Richard Jenkyns, trans. Alicia Stallings (London: Penguin Books, 2007)

*The Mahabharata*, ed. and trans. J. D. Smith (London: Penguin Books, 2009)

Mahsood, Ehsan, *Science and Islam: A History*, 2nd edn (London: Icon Books, 2017)

Moran, Bruce T., *Paracelsus: An Alchemical Life* (London: Reaktion Books, 2019)

Nath, Samir, *Encyclopaedic Dictionary of Buddhism* (New Delhi: Sarup & Sons, 1998)

Newton, Isaac, *Philosophiæ naturalis principia mathematica* (London: The Royal Society, 1687)

Ovid, *Metamorphoses*, trans. Mary M. Innes (London: Penguin Books, 1955)

Plato, *Gorgias*, ed. Chris Emlyn-Jones, trans. Walter Hamilton (London: Penguin Books, 2004)

Plato, *Timaeus and Critias*, introd. Andrew Gregory, trans. Robin Waterfield (Oxford: Oxford University Press, 2008)

Pliny the Elder, *Natural History: A Selection*, introd. and trans. John Healey (London: Penguin Books, 1991)

Plotinus, *The Enneads*, ed. John Dillon, trans. Stephen MacKenna (London: Penguin Books, 1991)

Porter, Roy (ed.), *The Cambridge History of Medicine* (Cambridge: Cambridge University Press, 2006)

*The Ramayana*, trans. M. Valmiki (London: Penguin Books, 2000)

*The Rig Veda*, ed. Wendy Doniger (London: Penguin Books, 2005)

Roberts, J. M., *Mythology of the Secret Societies* (London: Paladin Books, 1974)

Roob, Alexander, *Alchemy & Mysticism* (Cologne: Taschen, 2014)

Russell, Bertrand, *History of Western Philosophy, and Its Connection with Political and Social Circumstances from the Earliest Times to the Present Day* (London: George Allen & Unwin Ltd, 1946)

Shields, Christopher, *Ancient Philosophy: A Contemporary Introduction* (Abingdon: Routledge, 2022)

Spenser, Edmund, *Edmund Spenser's Poetry*, ed. Anne Lake Prescott and Andrew Hadfield, 4th edn (New York: W. W. Norton & Company, 2013)

Strathern, Paul, *Mendeleyev's Dream: The Quest for the Elements* (New York: St. Martin's Press, 2001)

Tesla, Nikola, *My Inventions and Other Writings* (London: Penguin Books, 2012)

Tester, Jim, *A History of Western Astrology* (Boydell & Brewer: Woodbridge, 1999)

Thomas, Keith, *Religion and the Decline of Magic* (London: Weidenfeld & Nicolson, 1971)

Tillyard, E. M. W., *The Elizabethan World Picture* (London: Penguin Books, 1972)

Trismosin, Solomon, *Splendor Solis: A.D. 1582. Alchemical Treatises of Solomon Trismosin, Adept And Teacher of Paracelsus (The Splendour of the Sun)*, ed. J. K. (Chicago, IL: Yogi Publications Society, 1976)

*The Upanishads*, trans. Juan Mascaró (London: Penguin Books, 2005)

Vitruvius, *The Ten Books on Architecture* (New York: Dover Publications, 2000)

Waite, A. E., *The Secret Tradition in Alchemy: Its Development and Records* (Abingdon: Routledge, 2013)

Washington, Peter, *Madame Blavatsky's Baboon: Theosophy and the Emergence of the Western Guru* (London: Secker & Warburg, 1993)

Waterfield, Robin (ed. and trans.) *The First Philosophers: The Presocratics and Sophists* (Oxford: Oxford University Press, 2000)

Whitman, Walt, *The Complete Poems*, ed. and introd. Francis Murphy (London: Penguin Books, 2004)

Wilson, Colin, *The Occult: A History* (London: Hodder & Stoughton, 1971)

Wilson, Edward O., *The Diversity of Life* (London: Allen Lane, 1992)

Yates, Frances A., *The Art of Memory* (London: Routledge & Kegan Paul, 1966)

Yeats, William Butler, *Collected Poems* (London: Macmillan, 1935)

Yeats, William Butler, *A Vision* (London: Macmillan, 1925)

Zalasiewicz, Jan, *Geology: A Very Short Introduction* (Oxford: Oxford University Press, 2018)

Zalta, Edward N. (ed.), *Stanford Encyclopedia of Philosophy*, autumn 2020 edn (Stanford, CA: Stanford University Press); https://plato.stanford.edu/archives/fall2020/ [accessed 3 June 2024]

# Sources of Quotations

INTRODUCTION

9  Heinrich Cornelius Agrippa, *Three Books of Occult Philosophy*, Book I: *Natural Magic*, trans. J. F., ed. Willis F. Whitehead (Chicago: Hahn & Whitehead, 1898), p. 55

14  Henry Wadsworth Longfellow, *The Works of Henry Wadsworth Longfellow*, Vol. VII: *Outre-Mer and Drift-Wood* (Cambridge, MA: Riverside Press, 1886), p. 405

20  William Blake, *Jerusalem*, ch. 2, pl. 32 [36], ll. 31–2. In: *The Complete Poetry and Prose of William Blake*, ed. David V. Erdman (Berkeley, CA: University of California Press, 2008), p. 178

30  W. B. Yeats, 'Rosa Alchemica', *The Savoy*, No. 2 (April 1896), pp. 56–70, p. 56

32  Pliny the Elder, *The Natural History*, Vol. I, trans. John Bostock and Henry T. Riley (London: H. G. Bohn, 1855), Book II, ch. iv, p. 19

CHAPTER 1

35  The Bible, Job 28:5–6, King James Version, www.bible.com [accessed 23 May 2024]

42  Titus Lucretius Carus, *On the Nature of Things*, trans. Anthony M. Esolen (Baltimore, MD: John Hopkins University Press, 1995), Book V, ll. 257–60, p. 166

44  Thomas Stanley, *The History of Philosophy, The Eighth Part: Containing the Stoick Philosophers* (London: H. Moseley and T. Dring, 1656), p. 110

46  Rumi, *Collected Poetical Works of Rumi* (Hastings: Delphi Classics, 2015), p. 327

48  Emily Dickinson, *Poems by Emily Dickinson*, Section III: Nature, poem 1, published 1890. In: *Emily Dickinson: Collected Poems* (Philadelphia, PA: Courage Books, 1991), p. 46

51  Bob Randall, 'The Land Owns Us', *Global Oneness Project* [video], uploaded 27 February 2009, YouTube, www.youtube.com [accessed 23 May 2024]

55  Walt Whitman, *Leaves of Grass*, 1892 version; The Poetry Foundation, www.poetryfoundation.org [accessed 23 May 2024]

57  T. S. Eliot, *Collected Poems 1909–1962* (London: Faber and Faber Ltd, 2002)

58  *Dylan Thomas, Collected Poems 1934–1953*, ed. Walford Davies and Ralph Maud (London: J. M. Dent & Sons, 1992), p. 13

60  Walt Whitman, *Leaves of Grass*, 1892 version; The Poetry Foundation, www.poetryfoundation.org [accessed 23 May 2024]

64  *Egyptian Religious Poetry*, trans. Margaret A. Murray (London: John Murray, 1949), Section II: *The Pharaoh*, No. 22, p. 75

66  'To Earth the Mother of All', Hesiod, *The Homeric Hymns and Homerica*, trans. Hugh G. Evelyn-White (London: William Heinemann Ltd, 1914)

69  Robert Herrick, *The Poetical Works of Robert Herrick*, ed. F. W. Moorman (London: Oxford University Press, 1957), p. 68

71  Walt Whitman, *Leaves of Grass*, 1892 version; The Poetry Foundation, www.poetryfoundation.org [accessed 23 May 2024]

CHAPTER 2

73  Quoted in: *Oxford Essential Quotations*, ed. Susan Ratcliffe, 5th edn (Oxford: Oxford University Press, 2017); www.oxfordreference.com [accessed 23 May 2024]

76  Claude Monet, *Monet by Himself: Paintings, Drawings, Pastels, Letters* (Boston, MA: Little Brown, 1990), p. 198

81  William Shakespeare, *Antony and Cleopatra*, ed. Barbara Mowat, Paul Werstine, Michael Poston, and Rebecca Niles, Act V, scene ii, ll. 108–10; Folger Shakespeare Library, www.folger.edu [accessed 23 May 2024]

82  Quoted in: Theodor H. Gaster, 'The Battle of the Rain and the Sea: An Ancient Semitic Nature-Myth', *Iraq*, Vol. 4, No. 1 (Spring 1937), pp. 21–32, p. 26

88  Albert Szent-Gyorgyi, *The Living State: With Observations on Cancer* (New York: Academic Press, 1972), p. 9

91  Henry David Thoreau, *The Writings of Henry Thoreau*, Vol. VII, Journal I: 1837–1846, ed. Bradford Torrey (Boston, MA: Houghton, Mifflin & Co., 1906), p. 26

92  Hermann Hesse, *Siddhartha*, trans. Hilda Rosner (London: Pushkin Press, 2023)

95  T. S. Eliot, *Collected Poems 1909–1962* (London: Faber and Faber Ltd, 2002)

98  Herman Melville, *Moby-Dick, or The Whale* (New York: Harper & Brothers, 1851), p. 3

101  'The Java Horror: Official Reports Received by the Dutch Government', *The San Diego Union* (2 September 1883), p. 1

105  A. M. Worthington, *The Splash of a Drop* (London: Society for Promoting Christian Knowledge, 1895), p. 7

106  Valmiki, *The Rámáyan of Válmíki* (known as the *Ramayana*), trans. Ralph T. H. Griffith (London: Trübner & Co., 1870–74), Book 4, canto xxviii, p. 1272

109  Paracelsus, *The Hermetic and Alchemical Writings of Aureolus Philippus Theophrastus Bombast, of Hohenheim, called Paracelsus the Great*, Vol. I, trans. A. E. Waite (London: James Elliott and Co., 1894), p. 232

112  Rachel Carson, *Silent Spring* (London: Penguin Books, 2002)

114  Quoted in: *The Jade Mountain: A Chinese Anthology, Being Three Hundred Poems of the Tang Dynasty, 618–907*, trans. Witter Bynner (New York: Alfred A. Knopf, 1967), p. 195

116  Thomas Traherne; The Poetry Foundation, www.poetryfoundation. org [accessed 23 May 2024]

CHAPTER 3

119  Wilbur and Orville Wright, *The Papers of Wilbur and Orville Wright*, Vol. II: 1906–1948, ed. Marvin W. McFarland (Salem, NH: Ayer Company, Publishers, Inc., 1990), p. 934

122  Margaret Cavendish, *New Blazing World and Other Writings*, ed. Kate Lilley (New York: New York University Press, 1992), pp. 138–9

130  Black Elk, as told through John G. Neihardt, *Black Elk Speaks: Being the Life Story of a Holy Man of the Oglala Sioux* (New York: Simon & Schuster Inc., 1972), pp. 15–16

133  Kahlil Gibran, *The Prophet* (New York: Alfred A. Knopf, 1923)

134  Percy Bysshe Shelley, *Prometheus Unbound, a Lyrical Drama in Four Acts with Other Poems* (London: C. & J. Ollier, 1820), p. 199

136 Dafydd ap Gwilym, 'The Wind',
trans. Gwyneth Lewis, *POETRY*,
Vol. 205, No. 2 (2014), pp. 104–5, p. 104

138 Pliny the Elder, *The Natural History*,
Vol. I, Book II, ch. xxxviii, p. 65

140 William Shakespeare, *King Lear*,
ed. Barbara Mowat, Paul Werstine,
Michael Poston, and Rebecca Niles,
Act III, scene ii, ll. 1–11; Folger
Shakespeare Library, www.folger.edu
[accessed 23 May 2024]

144 Quoted in: Steven D. Carter (ed.
and trans.), *Waiting for the Wind: Thirty-
Six Poets of Japan's Late Medieval Age*
(New York: Columbia University
Press, 1989), p. 135

148 Christina Rossetti, *The Complete Poems
of Christina Rossetti* (Baton Rouge,
LA: Louisiana State University Press,
1979), p. 42

150 'Zep set to hop from L.A.; flies over
city tonight', *Los Angeles Evening
Express*, Vol. LIX, No. 131 (26 August
1929), p. 1

157 Homer, *The Odyssey*, trans. E. V. Rieu,
rev. trans. D. C. H. Rieu (London:
Penguin Books, 2003), Book V, p. 70

159 Philip Freneau, *The Last Poems of Philip
Freneau*, ed. Lewis Leary (Westport,
CT: Greenwood Press, 1970), p. 8

160 Quoted on: WikiZilla, www.wikizilla.
org/wiki/Godzilla_vs._Hedorah
[accessed 23 May 2024]

CHAPTER 4

163 Susanne K. Langer, *Philosophy in
a New Key: A Study in the Symbolism
of Reason, Rite and Art*, 3rd edn
(Cambridge, MA: Harvard University
Press, 1957)

166 John Milton, *Paradise Lost* (Dublin:
W. and W. Smith, P. Wilson and T.
Ewing, 1767), Book I, ll. 61–3, p. 3

175 Mary Shelley, *Frankenstein, or The
Modern Prometheus*, 1818 version,
ed. Marilyn Butler (Oxford: Oxford
University Press, 1998), p. 191

177 Edmund Spenser, *The Complete
Works of Edmund Spenser*, ed. R. Morris
(London: Macmillan & Co., 1893),
p. 577

178 Hesiod, *Theogony*, ll. 561–84.
In: *Hesiod, The Homeric Hymns and
Homerica*

180 Florus, *Epitome of Roman History*, trans.
Edward Seymour Forster (London:

William Heinemann Ltd, 1929),
Book II, ch. vii, pp. 237–9

183 Haiku of Kobayashi Issa, www.haiku
guy.com/issa/ [accessed 23 May 2024]

185 Juvenal, 'The Satires of Juvenal:
Satire 3', *Juvenal and Persius*, trans.
G. G. Ramsay (London: William
Heinemann Ltd, 1924), p. 47

187 Oscar Wilde, *The Picture of Dorian
Gray* (New York: Airmont Publishing
Co., 1964), p. 180

189 Nikola Tesla, *Light and Other High
Frequency Phenomena* (New York: The
National Electric Light Association,
1893), p. 9

191 Jayne Anne Phillips, *Lark and Termite*
(New York: Alfred A. Knopf, 2009),
p. 5

192 *The Vishnu Purana*, trans. H. H. Wilson
(1840), Book III, ch. v; Internet
Sacred Text Archive, www.sacred-
texts.com/ [accessed 23 May 2024]

195 Friedrich Nietzsche, *Thus Spoke
Zarathustra*, trans. Thomas Common
(New York: Random House Inc.,
1917), p. 67

197 Mary Coleridge, *The Collected Poems
of Mary Coleridge*, ed. Theresa Whistler
(London: Rupert Hart-Davis, 1954),
p. 152

198 *Virgil's Aeneid*, trans. John Dryden
(New York: P. F. Collier & Son Co.,
1909) Book VIII

CHAPTER 5

203 Sir Arthur Eddington, *New Pathways
in Science* (Cambridge: Cambridge
University Press, 1935), p. 38

207 John Muir, *John of the Mountains:
The Unpublished Journals of John Muir*,
ed. Linnie Marsh Wolfe (Madison,
WI: The University of Wisconsin
Press, 1979), p. 321

208 C. E. Bechhofer Roberts (ed.),
*The Trial of Mrs. Duncan* (London:
Jarrolds, 1945), p. 29

214 Swami Vivekananda, *The Complete
Works of Swami Vivekananda*, Vol. I,
10th edn (Calcutta: Advaita Ashrama,
1957), p. 147

216 Henry Wadsworth Longfellow,
www.hwlongfellow.org [accessed
23 May 2024]

218 Edgar Allan Poe; The Poetry
Foundation, www.poetryfoundation.org
[accessed 23 May 2024]

220 Thomas Stanley, *The History of
Philosophy, The Eighth Part: Containing
the Stoick Philosophers*, p. 105

223 Sir Arthur Eddington, *New Pathways
in Science*, pp. 38–9

226 Dante Alighieri, 'Paradise',
*The Divine Comedy of Dante Alighieri*,
trans. Charles Eliot Norton (Boston,
MA: Houghton, Mifflin & Co., 1902),
Canto XXXI, p. 239

231 William Wordsworth, *The Excursion*,
Book IX. In: *The Poetical Works of
William Wordsworth*, 'The Excusion,
The Recluse: Part I, Book I', ed. E.
de Selincourt and Helen Darbishire
(Oxford: Clarendon Press, 1949),
pp. 286–7

233 Quoted in: '"They called her a crazy
witch": did medium Hilma af Klint
invent abstract art?', *The Guardian*
(6 October, 2020)

235 Lord Byron; The Poetry Foundation,
www.poetryfoundation.org [accessed
23 May 2024]

239 Johannes Kepler and Galileo Galilei,
*The Sidereal Messenger of Galileo Galilei:
And a Part of the Preface to Kepler's
Dioptrics*, trans. Edward Stafford
Carlos (London: Rivingtons, 1880),
p. 103

240 Christopher Smart, 'Jubilate Agno',
Fragment B, part iii. In: Roger
Lonsdale (ed.), *The Oxford Book
of Eighteenth-Century Verse* (Oxford:
Oxford University Press, 2009), p. 435

242 E. T. Whittaker, *A History of the Theories
of Aether and Electricity* (Dublin: Dublin
University Press, 1910), p. 1

245 Georgiana Houghton, statement
introducing 'Spirit Drawings in
Watercolours' at the New British
Gallery, London. In: 'A Public
Exhibition of Spirit Drawings', *The
Spiritual Magazine*, Vol. VI (June 1871),
p. 263

ACKNOWLEDGMENTS

256 Plotinus, *The Six Enneads*, Stephen
Mackenna and B. S. Page; The
Internet Classics Archive, https://
classics.mit.edu/Plotinus/enneads.
html [accessed 23 May 2024]

256 Thomas Browne, *Hydriotaphia, Urn
Burial; with an account of some urns
found at Brampton in Norfolk* (London:
Chiswick Press, 1893), p. 7

# Sources of Illustrations

Key: a=above, b=below, c=centre, l=left, r=right

1 Getty Research Institute 2 Wellcome Collection, London 4a The John Rylands Research Institute and Library, The University of Manchester 4c Rippon Boswell & Co. GmbH 4b The Metropolitan Museum of Art, New York, Rogers Fund, 1919 5a (detail) Photo Georgia O'Keeffe Museum, Santa Fe/Art Resource/Scala, Florence. © Georgia O'Keeffe Museum/DACS 2024 5ca (detail) Christie's Images/Bridgeman Images. © 2024 The Andy Warhol Foundation for the Visual Arts, Inc./Licensed by DACS, London 5cb Bibliothèque nationale de France 5b NASA, ESA, Joseph Olmsted (STScI) 7 The Stapleton Collection/Bridgeman Images 8 Cooper Hewitt, Smithsonian Design Museum 10 The Metropolitan Museum of Art, New York. Rogers Fund and Edward S. Harkness Gift, 1922 11 Digital Collections of the Bamberg State Library 12–13 University of Stirling Art Collection. © Estate of John Craxton. All Rights Reserved, DACS 2024 14 The John Rylands Research Institute and Library, The University of Manchester 15 Courtesy of the artist 16 The Metropolitan Museum of Art, New York, Purchase, Fletcher Fund and funds from various donors, 2003 17 Wellcome Collection, London 18 Rabanus Flavus 19 Science Museum Group 20 Rare Book Division, The New York Public Library. "And the Divine Voice was heard...." The New York Public Library Digital Collections. 1804 – 1808 21 Courtesy of the artist 22 Getty Research Institute 23 From the British Library archive/Bridgeman Images 24 The John Rylands Research Institute and Library, The University of Manchester 25 Bibliothèque nationale de France 26–7 Musée du Louvre, Dist. RMN-Grand Palais/Photo Martine Beck-Coppola 28 SLUB Dresden/Deutsche Fotothek 29 Christie's Images/Bridgeman Images 30 Photo Moderna Museet, Stockholm.

By courtesy of The Hilma af Klint Foundation 31 Bibliothèque nationale de France. Bibliothèque de l'Arsenal. Ms-975 réserve 32 Universitätsbibliothek Tübingen, Geometria Et Perspectiva, 1567, El 54.4 33 David Rumsey Map Collection, David Rumsey Map Center, Stanford Libraries 34 Bibliothèque nationale de France 36 The Cleveland Museum of Art, Purchase from the J. H. Wade Fund 1959.187 37 Courtesy of the artist 38 Metropolitan Museum of Art, Rogers Fund, 1930 39 Courtesy of the artists 40 Rippon Boswell & Co. GmbH 41 © National Portrait Gallery, London 42 Courtesy of Alexander Gorlizki 43 Courtesy of the artist 44 Courtesy of the artist 45 © Tracey Emin. All rights reserved, DACS/Artimage 2024 46 Courtesy of the artist 47 The Picture Art Collection/Alamy Stock Photo 48 Courtesy of the artist 49 Courtesy of the artist 50 Bridgeman Images 51 Courtesy of the artist 52 The Cleveland Museum of Art, Gift in honor of Madeline Neves Clapp; Gift of Mrs. Henry White Cannon by exchange; Bequest of Louise T. Cooper; Leonard C. Hanna Jr. Fund; From the Catherine and Ralph Benkaim Collection 2013.319 53 Album/Alamy Stock Photo 54 Courtesy of the artist 55 Photo by Ollie Hammick, courtesy of Canopy Collections 56 Courtesy of the artist 57 Courtesy Cavin-Morris Gallery. Photo Jurate Veerate 58 Courtesy of the artists 59 Courtesy of the artist 60 Art Resource/Scala, Florence/© Walker Evans Archive, The Metropolitan Museum of Art 61 Christie's Images/Bridgeman Images. © The Joseph and Robert Cornell Memorial Foundation/VAGA at ARS, NY and DACS, London 2024 62 British Mineralogy, James Sowerby, Printed by R. Taylor and Co., London, 1802 63 ARTGEN/Alamy Stock Photo 64 Courtesy of the estate of Dan Hillier 65 Courtesy Darédo 66 Courtesy of the artist and Victoria Miro, London. Photo Genevieve Hanson 67 Published by Magnolia Editions. Photograph courtesy Magnolia Editions. Courtesy Pace Gallery. © Kiki Smith 68 The J. Paul Getty Museum, Los Angeles, 84.XM.638.53 69 Rijksmuseum, Amsterdam 70 Bauhaus-Archiv Berlin. © DACS 2024 71 Courtesy of the artist 72 The Metropolitan Museum of Art, New York, Rogers Fund, 1919 74 Bibliothèque nationale de France

75 The Cleveland Museum of Art, Gift of Amelia Elizabeth White 1937.898 76 Artefact/Alamy Stock Photo 77 Album/Alamy Stock Photo 78 National Maritime Museum, Greenwich, London, Gibson's of Scilly Shipwreck Collection 79 Flug Und Wolken, Manfred Curry, Verlag F. Bruckmann, Munchen, 1932. P. 65. NOAA Photo Library 80 Courtesy of James Fuentes Gallery, © Didier William 81 Image courtesy Dallas Museum of Art, gift of Mr. and Mrs. James H. Clark. Barbara Hepworth © Bowness 82 Courtesy of the artist 83 The Picture Art Collection/Alamy Stock Photo 84–5 © Wolfgang Tillmans, courtesy Maureen Paley, London 86 Christie's Images/Bridgeman Images. © DACS 2024 87 © Nick Brandt 88 The Nature Notes/Alamy Stock Photo 89 Kunstformen der Natur, Ernst Haeckel, 1904 90 Gift of Mrs. Nicholas H. Noyes, Eskenazi Museum of Art, Indiana University 71.40.2 91 Staatliche Kunsthalle Karlsruhe 92 The Art Institute of Chicago, Clarence Buckingham Collection 93 The Metropolitan Museum of Art, New York, Henry L. Phillips Collection, Bequest of Henry L. Phillips, 1939 94 Brigham Young University, Harold B. Lee Library 95 Yale Center for British Art, Paul Mellon Fund, B1997.10. 96 The J. Paul Getty Museum, Los Angeles, 86.XM.604 97 Library of Congress, Washington, DC 98 The Cleveland Museum of Art, John L. Severance Fund 1962.295 99 The Art Institute of Chicago, Gift of Marilynn B. Alsdorf 100 Kyodo News Stills via Getty Images 101 steeve-x-art/Alamy Stock Photo 102 Bishop Museum 103 Courtesy of the artist 104 Digital image, The Museum of Modern Art, New York/Scala, Florence 105 The J. Paul Getty Museum, Los Angeles. © Man Ray 2015 Trust/DACS, London 2024 106 The Metropolitan Museum of Art, H. O. Havemeyer Collection, Bequest of Mrs. H. O. Havemeyer, 1929 107 Los Angeles County Museum of Art, Gift of Paul F. Walter (M.87.278.15) 108 The Walters Art Museum, Acquired by Henry Walters 109 Penta Springs Limited/Alamy Stock Photo 110 Kimbell Art Museum/Bridgeman Images 111 CPA Media Pte Ltd/Alamy Stock Photo 112 Courtesy of Contour Gallery, and Saïdou Dicko. © ADAGP, Paris and DACS, London 2024 113 © Saul

Leiter Foundation 114 Album/Alamy Stock Photo 115 Courtesy of The Ingram Collection, Photo John-Paul Bland. © The Estate of Keith Vaughan. All rights reserved, DACS 2024 116 Yale University Art Gallery, Robert W. Carle, B.A. 1897, Fund 117 Bernhard Lang 118 Bibliothèque nationale de France 120 Museum of Fine Arts, Boston. All rights reserved/Scala, Florence 121 Boston Public Library 122 Photo Georgia O'Keeffe Museum, Santa Fe/Art Resource/Scala, Florence. © Georgia O'Keeffe Museum/DACS 2024 123 From the British Library archive/Bridgeman Images 124 Hulton Archive/Getty Images 125 Carl Sutton/Picture Post/Hulton Archive/Getty Images 126 Courtesy Cavin-Morris Gallery. Photo Jurate Vecerate 127 Minneapolis Institute of Art, The John R. Van Derlip Fund; purchase from the collection of Elizabeth and Willard Clark 128–9 incamerastock/Alamy Stock Photo 130 Fenimore Art Museum, Cooperstown, New York, Gift of Eugene V. and Clare E. Thaw, Thaw Collection, T0086. Photo John Bigelow Taylor 131 Rijksmuseum, Amsterdam 132 Margaret Bourke-White/The LIFE Picture Collection/Shutterstock 133 Digital image, The Museum of Modern Art, New York/Scala, Florence. © The Estate of Edward Steichen/ARS, NY and DACS, London 2024 134 © Albarrán Cabrera 135 National Gallery of Art, Washington, Collection of Mr. and Mrs. Paul Mellon 136 ETH-Bibliothek Zürich, Bildarchiv/Ans_10391-P04-011/ Photo Franz Max Osswald 137 akg-images/Universal Images Group/Underwood Archives 138 Fine Art Images/Bridgeman Images 139 From the British Library archive/Bridgeman Images 140 American Museum of Natural History 141 Courtesy of the artist 142 The Metropolitan Museum of Art, New York. Harris Brisbane Dick Fund, 1924 143 Installation view, 'English Magic', British Pavillion, Giardini de Castello, Venice Biennale, Venice. Courtesy of the artist, The Modern Institute/Toby Webster Ltd. Photo Cristiano Corte, British Council 144–5 Pictures from History/Bridgeman Images 146 Library of Congress, Washington, DC 147 The Metropolitan Museum of Art/Art Resource/Scala, Florence. © Richard and John Buckham 148 Bridgeman Images 149 National Gallery of Art, Washington, Collection of Mr. and Mrs. Paul Mellon 150 Courtesy of the artist 151 Courtesy of the San Diego Air & Space Museum 152–3 Courtesy of the artist 154 Kengo Kuma and Associates. Photo Sebastien D'Halloy 155 Collection Société française de photographie (col. SFP), 2014. frSFP_0806im_A_1021 156 Besançon, Bibliothèque municipale, MS. 1360, fol. 4v 157 Kunstmuseum den Haag/© Mondrian/

Holtzman Trust/Bridgeman Images 158 Serge de Sazo/Gamma-Rapho via Getty Images 159 Wellcome Collection, London 160 Everett Collection Inc./Alamy Stock Photo 161 The J. Paul Getty Museum, Los Angeles, 84.XM.217.6 162 Adagp Images, Paris/SCALA, Florence. © Succession Yves Klein c/o ADAGP, Paris and DACS, London 2024 164 J Marshall – Tribaleye Images/Alamy Stock Photo 165 Courtesy of Rithika Merchant 166 Christie's Images/Bridgeman Images. © 2024 The Andy Warhol Foundation for the Visual Arts, Inc./Licensed by DACS, London 167 Museum of Fine Arts, Boston. All rights reserved/Scala, Florence 168 Zentralbibliothek Zurich 169 Library of Congress, Washington, DC 170 The Cleveland Museum of Art, Gift of Katherine C. White 1972.331 171 Steve McCurry/Magnum Photos 172 Library of Congress, Washington, DC 173 Tate. © Ithell Colquhoun 174 Estate of Akio Takamori and James Harris Gallery, Dallas 175 The John Rylands Research Institute and Library, The University of Manchester 176 Library of Congress, Washington, DC 177 The J. Paul Getty Museum, Los Angeles, 84.XA.700.4.61 178 Kyoto National Museum 179 The Picture Art Collection/Alamy Stock Photo 180 © Joel Meyerowitz, Courtesy Howard Greenberg Gallery 181 © Nick Wynne/British Culture Archive 182 Yokohama City Central Library 183 © Victoria and Albert Museum, London 184 The J. Paul Getty Museum, Los Angeles, 84.XP.1406.2 185 The J. Paul Getty Museum, Los Angeles, 84.XA.755. 7.89 186 The Metropolitan Museum of Art, New York, Gift of Mr. and Mrs. Charles Wrightsman, 1978 187 Photo courtesy of Through the Flower Archives. © Judy Chicago. ARS, NY and DACS, London 2024 188 Los Angeles County Museum of Art, The Audrey and Sydney Irmas Collection. © Museum Associates/LACMA 189 Tesla Universe 190 The J. Paul Getty Museum, Los Angeles, Ms. Ludwig XV 3 (83.MR.173), fol. 74v 191 © Issam Kourbaj 2016. Photo Sami Kourbaj 192 The Trustees of the British Museum 193 The Cleveland Museum of Art, Gift of John D. Proctor 1990.40 194 The Cleveland Museum of Art, Bequest of John L. Severance 1942.647 195 Courtesy of the artist 196 Courtesy of the artist and Hauser & Wirth. Photo James Wang. © Lorna Simpson 197 Photo Scala, Florence/bpk, Bildagentur fuer Kunst, Kultur und Geschichte, Berlin 198 MCLA Collection/Alamy Stock Photo 199 Bridgeman Images 200 Andy Holzman 201 Courtesy of the artist 202 Courtesy Cavin-Morris Gallery. Photo Jurate Vecerate 204 Cooper Hewitt, Museum purchase from Au Panier Fleuri Fund

205 Courtesy Cavin-Morris Gallery. Photo Jurate Vecerate 206 Aichi Prefectural Museum of Art 207 Centre Pompidou, MNAM-CCI, Dist. RMN-Grand Palais/Photo Jacqueline Hyde. © ADAGP, Paris and DACS, London 2024 208 Boston Public Library 209 Digital image, The Museum of Modern Art, New York/Scala, Florence. © Man Ray 2015 Trust/DACS, London 2024 210 Courtesy of Sacred Bones Books, New York; their edition faithfully reproduced the first edition of *Thought Forms* 211 Science: NASA, ESA, ESO-Chile, ALMA, NAOJ, NRAO; image processing: Alyssa Pagan (STScI) 212 The National Museum of Finland, Historical collections (Id. H1180:3). Photo Henni Reijonen 213 X-Ray Audio Project 214 The Cleveland Museum of Art, Gift of Dr and Mrs. Sherman E. Lee 1967.241 215 Courtesy Cavin-Morris Gallery. Photo Jurate Vecerate 216 Musée des arts et métiers-Cnam, Paris. Photo P. Faligot 217 The J. Paul Getty Museum, Los Angeles, 84.XD.760.1.17 218 Victoria and Albert Museum, London 219 The Metropolitan Museum of Art, New York, Purchase, Friends of Islamic Art Gifts, 1998 220 Courtesy Tajan. Photo Romain Courtemanche 221 Bibliothèque nationale de France 222–3 Courtesy Lisson Gallery. © Hiroshi Sugimoto 224 Wojciech Domagała 225 Collection of The College of Psychic Studies, London 226 Courtesy of the artists 227 *The Divine Comedy* by Dante, Illustrated, Complete, London, Paris & Melbourne: Cassell & Company, 1892 228 Courtesy of the artist 229 ESA/Hubble & NASA, A. Sarajedini, G. Piotto 230 Kunstmuseum den Haag/© Mondrian/Holtzman Trust/Bridgeman Images 231 Courtesy Joost van den Bergh 232 Courtesy Cavin-Morris Gallery. Photo Jurate Vecerate 233 Photo Moderna Museet, Stockholm. By courtesy of The Hilma af Klint Foundation 234 © Sammy Lee Studio 235 Bibliothèque nationale de France 236 Minneapolis Institute of Arts, MN/Bridgeman Images 237 Courtesy Stephen Romano Gallery 238 Courtesy Cavin-Morris Gallery. Photo Jurate Vecerate 239 Los Angeles County Museum of Art, Gift of Mrs. Eloise Mabury Knapp (M.53.1.17a-d) 240 Dr Dain L. Tasker, Courtesy Joseph Bellows Gallery 241 Courtesy Cavin-Morris Gallery. Photo Jurate Vecerate 242 The Metropolitan Museum of Art, New York, Purchase, Joseph Pulitzer Bequest, 1935 243 © Emma Kunz Stiftung 244 Collection of The College of Psychic Studies, London 245 The Metropolitan Museum of Art, New York, Zimmerman Family Collection, Purchase, The Vincent Astor Foundation and the Zimmerman Family Gifts, 2017 246–7 NASA, ESA, Joseph Olmsted (STScI)

# Index

# Acknowledgments

*'All teems with symbol; the wise man is the man who in any one thing can read another.'*

Plotinus, 'The Second Ennead', *c.* 253–70 CE, translated by Stephen Mackenna and B. S. Page

This book is dedicated to Jackie, redeemer of lost causes and an undimmed source of light in an imperfect, shadow world, and to the memory of Dan Hillier (1973–2024), a true elemental force and a vanishingly rare 'gemme of the old rock'.*

*Thomas Browne, *Hydriotaphia, Urn Burial*, 1658

I would like to thank Jane Laing, Florence Allard, Georgina Kyriacou, Tristan de Lancey, Sadie Butler, Jo Walton and everyone at Thames & Hudson involved in the realization of this book. I am incredibly grateful to all of you for your invaluable contributions, insight, guidance and continued, tireless support.

I would also like to express my deep gratitude to all the artists, galleries, museums, institutions, collectors and estates who have so generously granted us permission to feature their work – the book would not exist without them.

## ABOUT THE AUTHOR

Renowned image alchemist Stephen Ellcock is a London-based curator, writer, researcher and online collector of images who has spent the last decade creating an ever-expanding virtual museum of art that is open to all via social media. His ongoing attempt at creating the ultimate social media 'Cabinet of Curiosities' has so far attracted more than 635,000 followers worldwide.

He is also the author of *Underworlds*, *The Cosmic Dance*, *All Good Things*, *The Book of Change*, *England On Fire*, with text by Mat Osman, and *Jeux de Mains*, a collaboration with Cécile Poimboeuf-Koizumi.

264 illustrations

FRONT COVER detail of illustration from *Alchymia naturalis occultissima vera* ('The True, Natural, Hidden Alchemy'), Hermes, 18th century. Image adapted from Sammlung Alchymistischer Schriften (German MS 3). The John Rylands Research Institute and Library, The University of Manchester

BACK COVER detail of illumination from MS 3469, a 15th-century manuscript of Aristotle's *Physica* (*Physics*). Bibliotheque Mazarine/© Archives Charmet/Bridgeman Images

SPINE & ENDPAPERS *Opticks #55007*, Albarrán Cabrera, 2019. Courtesy of Albarrán Cabrera

PAGE 1 Detail of illustration from *Utriusque cosmi historia* ('History of the Two Worlds'), Robert Fludd, 1617–21

PAGE 2 Illustration from *Gemma sapientiae et prudentiae*, ('The Jewel of Wisdom and Prudence'), *c.* 1735

First published in the United Kingdom in 2024 by Thames & Hudson Ltd, 181A High Holborn, London WC1V 7QX

First published in the United States of America in 2024 by Thames & Hudson Inc., 500 Fifth Avenue, New York, New York 10110

*Elements* © 2024 Thames & Hudson Ltd, London

Text © 2024 Stephen Ellcock

For image copyright information see pages 252–3

Designed by Daniel Streat, Visual Fields

British Library Cataloguing-in-Publication Data

A catalogue record for this book is available from the British Library

Library of Congress Control Number 2024934755

ISBN 978-0-500-02784-4

Printed and bound in China by C&C Offset Printing Co. Ltd

Be the first to know about our new releases, exclusive content and author events by visiting
thamesandhudson.com
thamesandhudsonusa.com
thamesandhudson.com.au